JOSEPH WRIGHT OF DERBY

Frontispiece *Self-portrait* c 1767–68
Charles Rogers-Coltman Cat 167

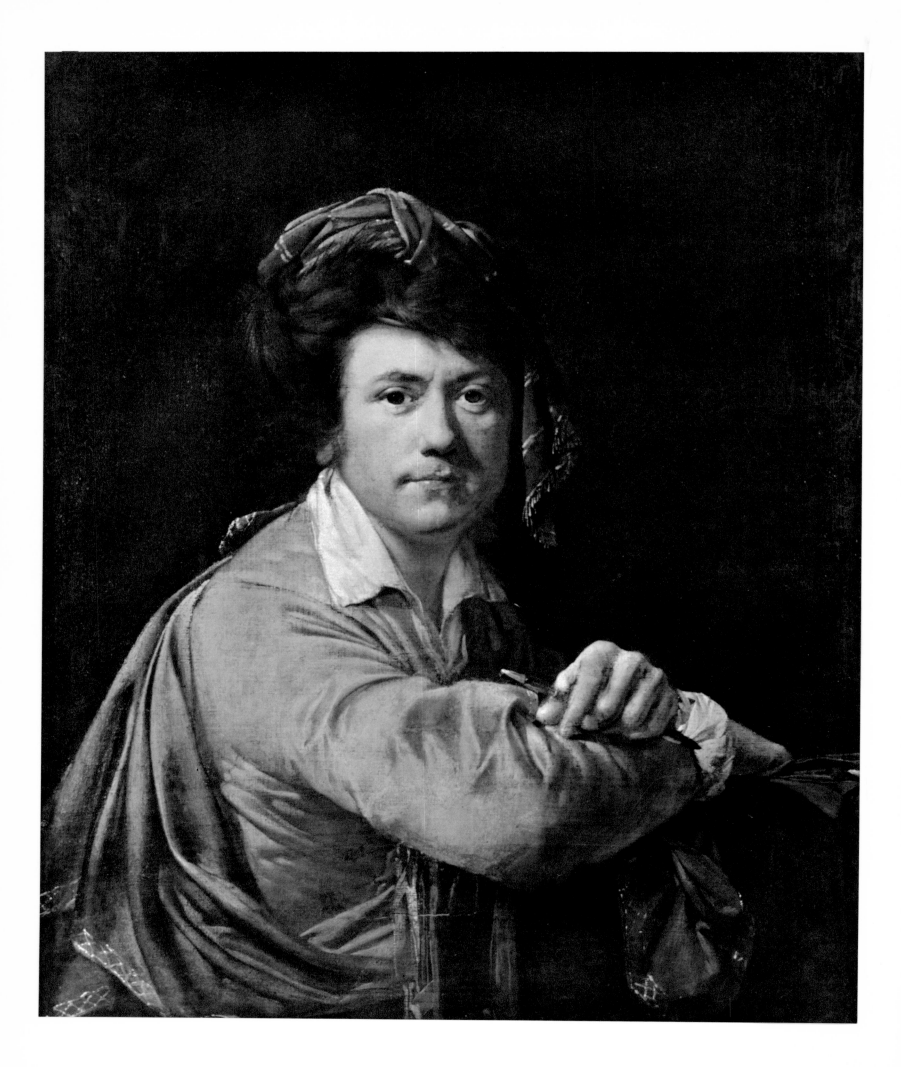

Joseph Wright of Derby

Painter of Light

Benedict Nicolson

Volume Two
Plates

STUDIES IN
BRITISH ART

The Paul Mellon Foundation for British Art 1968
London Routledge and Kegan Paul
New York Pantheon Books

First published in Great Britain 1968
by The Paul Mellon Foundation for British Art, 38 Bury Street,
London, S.W. 1 in association with Routledge & Kegan Paul Ltd.,
Broadway House, Carter Lane, London, E.C. 4

SBN 7100 6284 2
Library of Congress catalogue card no. 68-28393
Printed in the Netherlands by Joh. Enschedé en Zonen, Haarlem
Designed by Paul Sharp in the offices of
The Paul Mellon Foundation for British Art

List of Subjects

References are to the Catalogue (Volume 1, pp 171–272) and to the Plates, the latter in bold type. Reference is only made to Figures (Volume 1) when these provide significant details

PORTRAITS

Reference to these may most easily be made by consulting the catalogue in volume 1 (pp 175–231) where all portraits of identified sitters occur in alphabetical order.

SUBJECTS OTHER THAN PORTRAITS AND LANDSCAPES

List of Collections and Owners

The numbers refer to the catalogue entries in Volume 1 and the plate numbers in Volume 2. Plate numbers are shown in bold type.
Only works included in the catalogue are listed.

PUBLIC COLLECTIONS
UNITED KINGDOM

ABERYSTWYTH, University College of Wales Cat 274 **169**
BIRMINGHAM Art Gallery Cat 249 **166**
CAMBRIDGE, Fitzwilliam Museum Cat 6, 60, 310 **49, 64, 248**
Jesus College Cat 33 **202**
CARDIFF, National Museum of Wales Cat 260 **315**
DERBY Museum and Art Gallery Cat 16, 21, 22, 32, 40, 137, 151, 168, 178, 190, 195, 196, 217, 222, 237, 242, 243, 246, 247, 263 (loan), 265, 275, 276, 295 (loan), 298, 324, 336
30, 39, 54, 70, 79, 105, 106, 107, 113, 162, 163, 168, 220, 225, 229, 247, 256, 260, 279, 283 (loan) **303, 312** (loan) **322, 326, 347, 352**
LEEDS City Art Gallery and Temple Newsam House Cat 115, 160 **29, 335**
LEICESTER Museum and Art Gallery Cat 134, 307 **81, 212**
LIVERPOOL, Walker Art Gallery Cat 221, 234, 250, 264 **210, 246, 282, 344** (loan)
LIVERPOOL, University of (lent to Walker Art Gallery) Cat 342 **344**
LONDON, Kensington and Chelsea Public Libraries (Leighton House) Cat 291 **250**
National Portrait Gallery Cat 57
Tate Gallery Cat 20, 132, 192, 296 **58, 60** (loan), **72, 219, 313**
MACCLESFIELD, Parish Church of Christ Church Cat 126 **201**
MANCHESTER City Art Galleries Cat 19 **200**
SHEFFIELD City Art Galleries Cat 331 **249**
SOUTHAMPTON Art Gallery Cat 299 **309**

PUBLIC COLLECTIONS
OVERSEAS

Austria
VIENNA, Kunsthistorisches Museum Cat 17 **267**

New Zealand
AUCKLAND City Art Gallery Cat 23 **46**

U.S.A.
CHICAGO, Art Institute of Cat 290 **327**
DETROIT, Institute of Arts Cat 309 **218**
FITCHBURG Mass., Art Museum Cat 39 **63**
HARTFORD, Conn., Wadsworth Athenaeum Cat 220 **123**
KANSAS CITY, Mo., Nelson Gallery—Atkins Museum Cat 44 **86**

The Plates

The plates are arranged in an approximately chronological order. The choice of works for illustration in colour has been largely determined by their suitability for reproduction on a small scale. In the captions all question marks refer to dates.
The following plates have had to be made from old photographs and are therefore of inferior quality: plates 47, 189, 273, 300.

Plate 1 Copy of an engraving c 1748–50
Pencil and sepia wash 6 x 9⅞ in / 15.2 x 25 cm
Derby Museum and Art Gallery

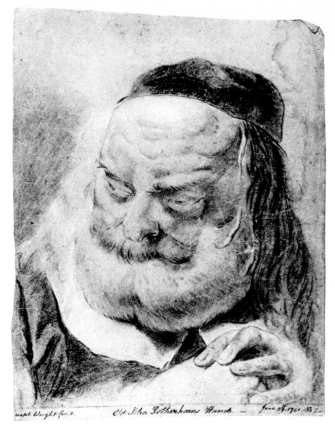

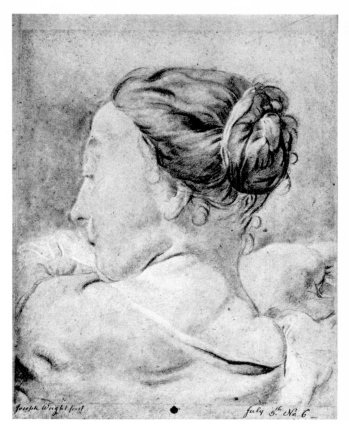

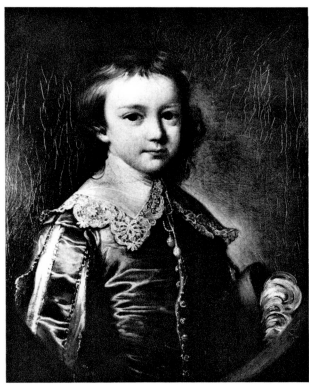

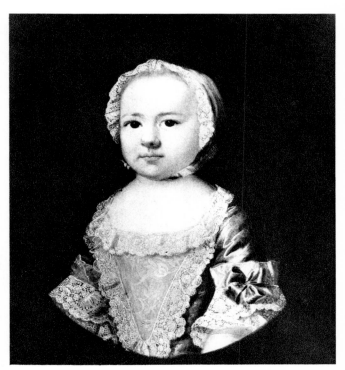

Plate 2 *Head of John Rotherham 1751*
Black chalk with white heightening
15¼ x 11⅜ in / 38.7 x 28.9 cm
Derby Museum and Art Gallery

Plate 4 *Nathaniel Curzon, 2nd Baron
Scarsdale* c 1755–56
19 x 15 in / 48.2 x 38.1 cm
Viscount Scarsdale Cat 48

Plate 3 *Head of Judith, from Piazzetta's Judith and
Holofernes* 1751
Black chalk with white heightening
15¼ x 11⅜ in / 38.7 x 28.9 cm
Michael and Elizabeth Ayrton

Plate 5 *Lady Caroline Curzon* c 1755–56
18 x 16⅛ in / 45.7 x 41.3 cm
Captain P. J. B. Drury-Lowe Cat 49

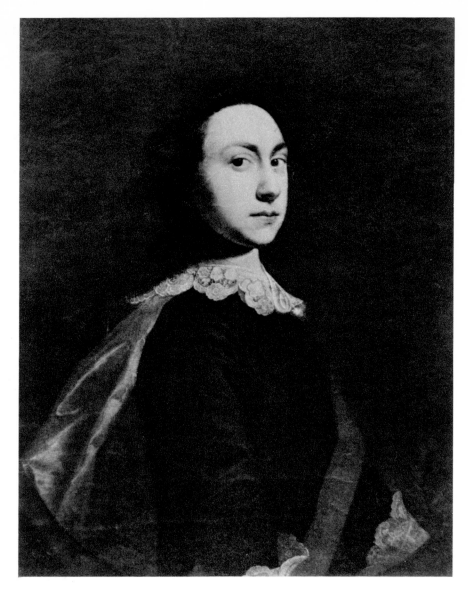

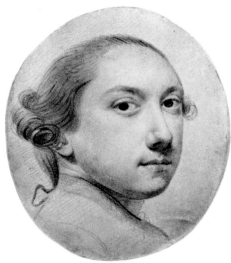

Plate 6 *Self-portrait* c 1758
30 x 25 in / 76.2 x 63.5 cm
Miss D. M. R. Cade Cat 164

Plate 7 *Self-portrait* c 1758
Pencil 4⅜ x 3¾ in / 11.1 x 9.5 cm
Fitzwilliam Museum, Cambridge

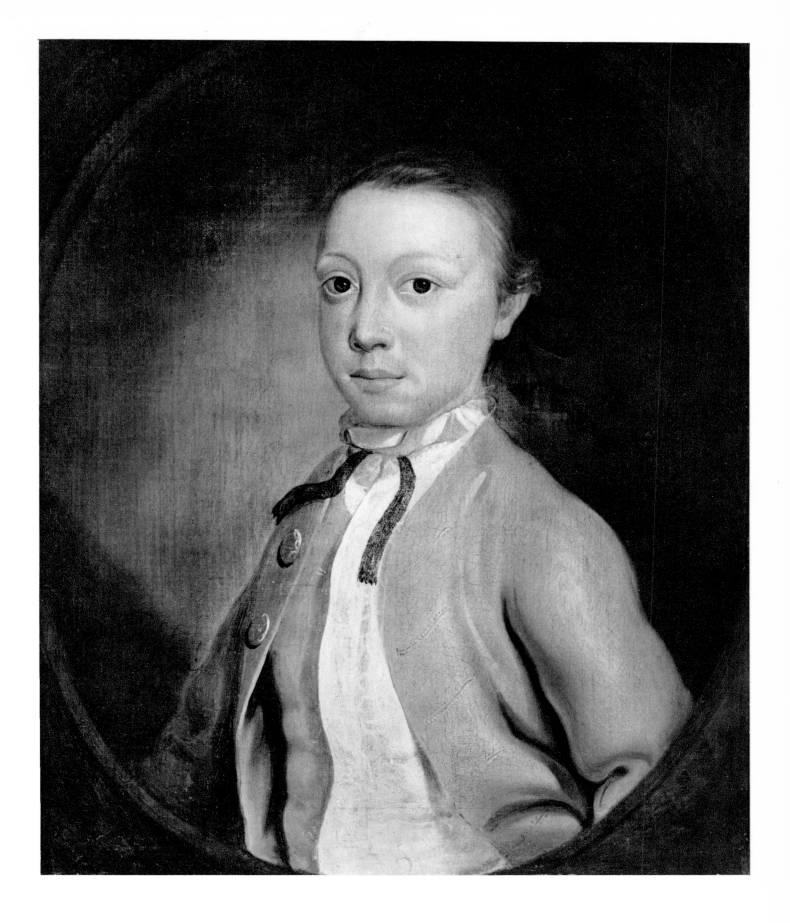

Plate 8 *Portrait of a Boy* 1758
22 x 18 in / 55.9 x 45.7 cm Mrs Karl F. Milde Cat 158

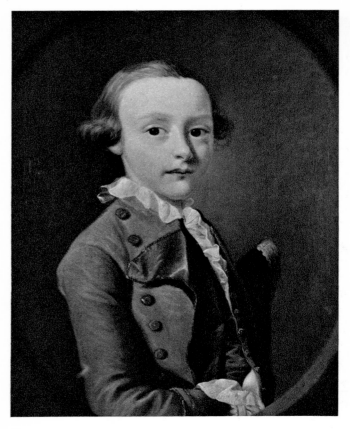

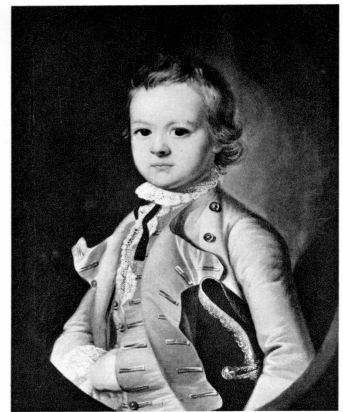

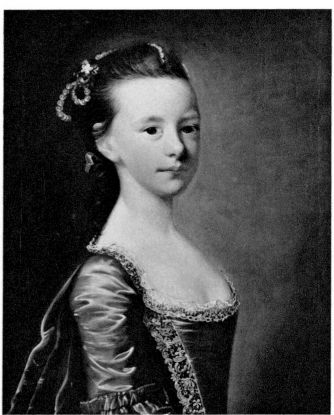

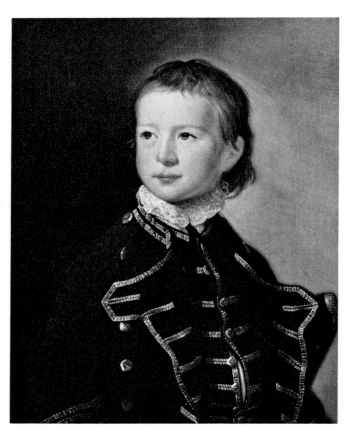

Plate 9 *Richard Staunton Wilmot* c 1760
20 x 16 in / 50.8 x 40.6 cm
Peter Wilmot-Sitwell Cat 142

Plate 10 *Harvey Wilmot* c 1760
20 x 16 in / 50.8 x 40.6 cm
Peter Wilmot-Sitwell Cat 147

Plate 11 *Dorothy Wilmot* c 1760
20 x 16 in / 50.8 x 40.6 cm
Peter Wilmot-Sitwell Cat 143

Plate 12 *Edward Sacheverell Wilmot* c 1760
20 x 16 in / 50.8 x 40.6 cm
Peter Wilmot-Sitwell Cat 144

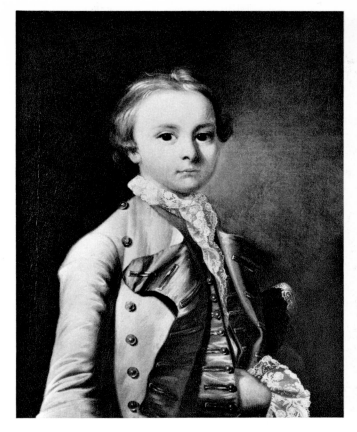

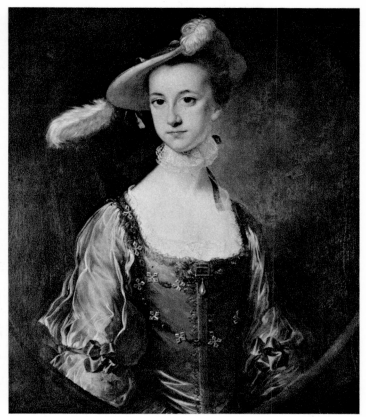

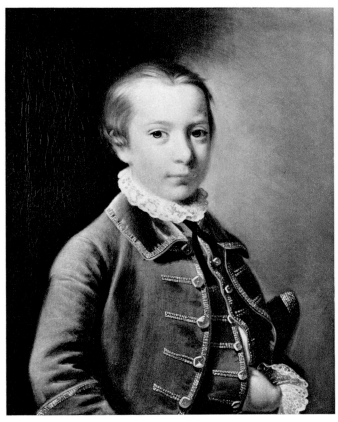

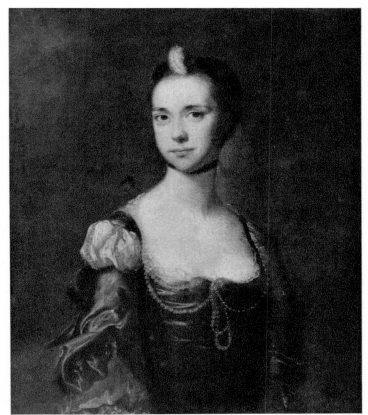

Plate 13 *Simon Wilmot* c 1760
20 x 16 in / 50.8 x 40.6 cm
Peter Wilmot-Sitwell Cat 146

Plate 15 *Robert Wilmot* c 1760
20 x 16 in / 50.8 x 40.6 cm
Peter Wilmot-Sitwell Cat 145

Plate 14 *Miss Elizabeth Lygon* c 1760
30 x 25 in / 76.2 x 63.5 cm
Private Collection U.K. Cat 103

Plate 16 '*Dorothy Anne, Wife of Col Charles Heathcote*' c 1760
? 30 x 25 in / 76.2 x 63.5 cm
Untraced Cat 80

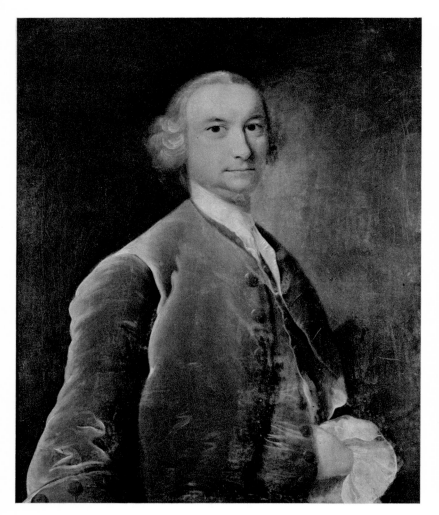

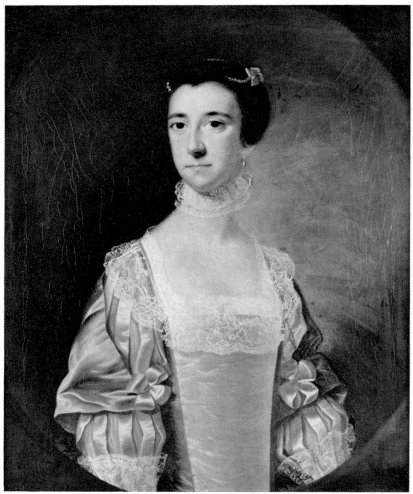

Plate 17 *Reginald Lygon* c 1760
30 x 25 in / 76.2 x 63.5 cm
Private collection U.K. Cat 101

Plate 18 *Mrs Susannah Lygon* c 1760
30 x 25 in / 76.2 x 63.5 cm
Private collection U.K. Cat 102

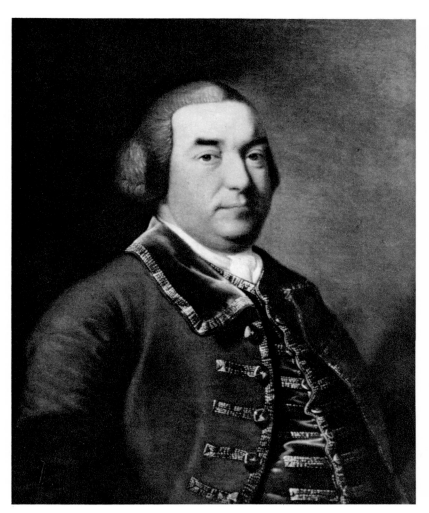

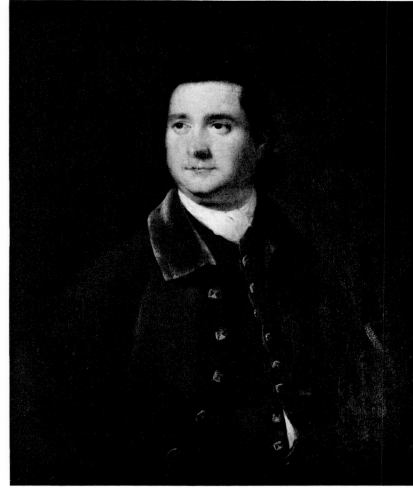

Plate 19 *William Kirke* 1759–60
30 x 25 in / 76.2 x 63.5 cm
Rear Admiral David Kirke Cat 98

Plate 20 *Nicholas Hutchinson* 1760
30 x 25 in / 76.2 x 63.5 cm
Jeremy Hutchinson Q. C. Cat 96

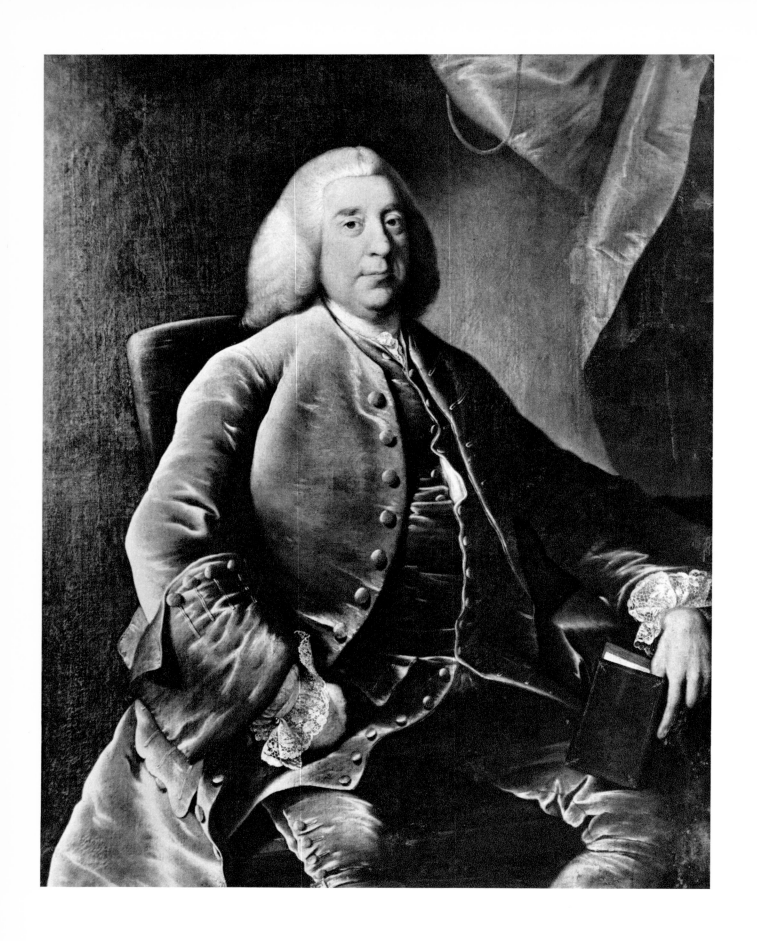

Plate 21 *William Brooke* 1760
50 x 40 in / 127 x 101.6 cm
R. D. Plant Cat 25

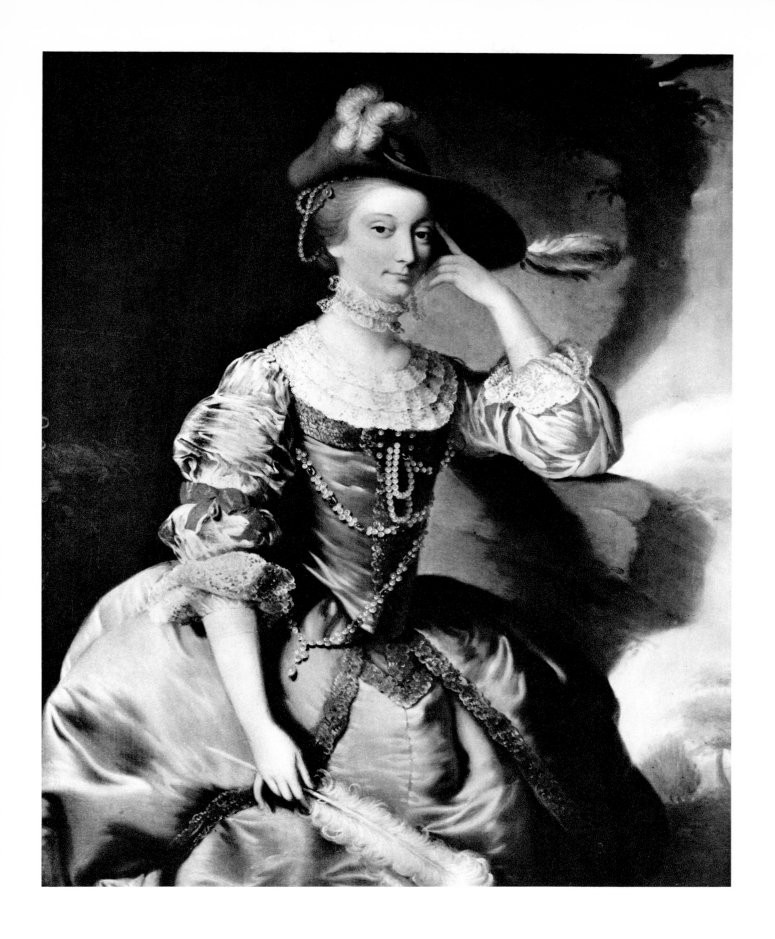

Plate 22 *Mrs Ann Carver* 1760
50 x 40 in / 127 x 101.6 cm
Mr and Mrs Ronald Tree Cat 28

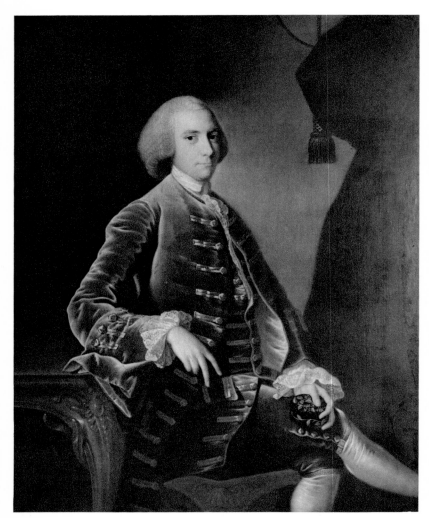 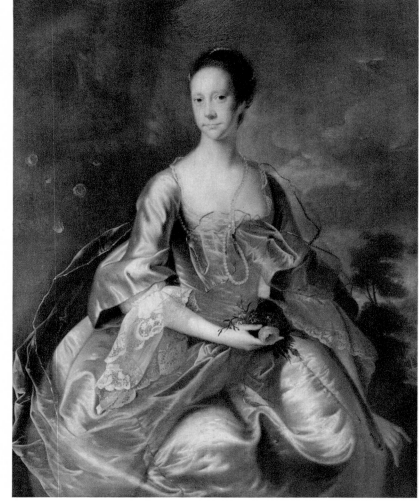

Plate 23 *William Pigot* 1760
50 x 40 in / 127 x 101.6 cm
R. D. Plant Cat 120

Plate 24 *Mrs William Pigot* 1760
50 x 40 in / 127 x 101.6 cm
R. D. Plant Cat 121

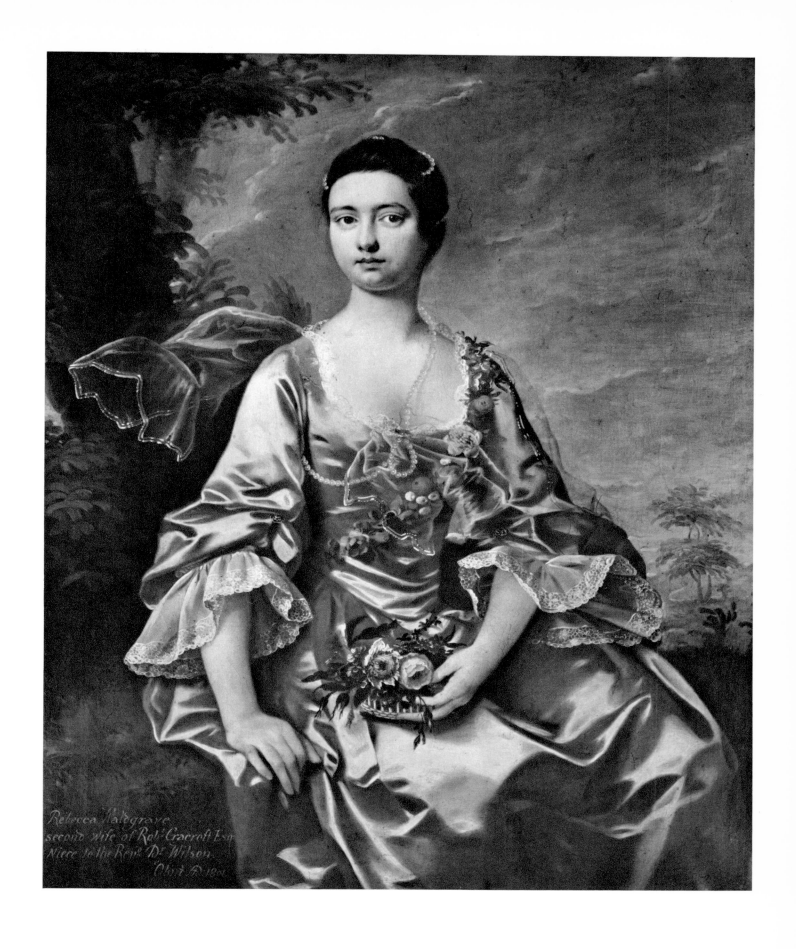

Plate 25 '*Rebecca*' *Cracroft* 1760
50 x 40 in / 127 x 101.6 cm
Private collection U.K. Cat 45

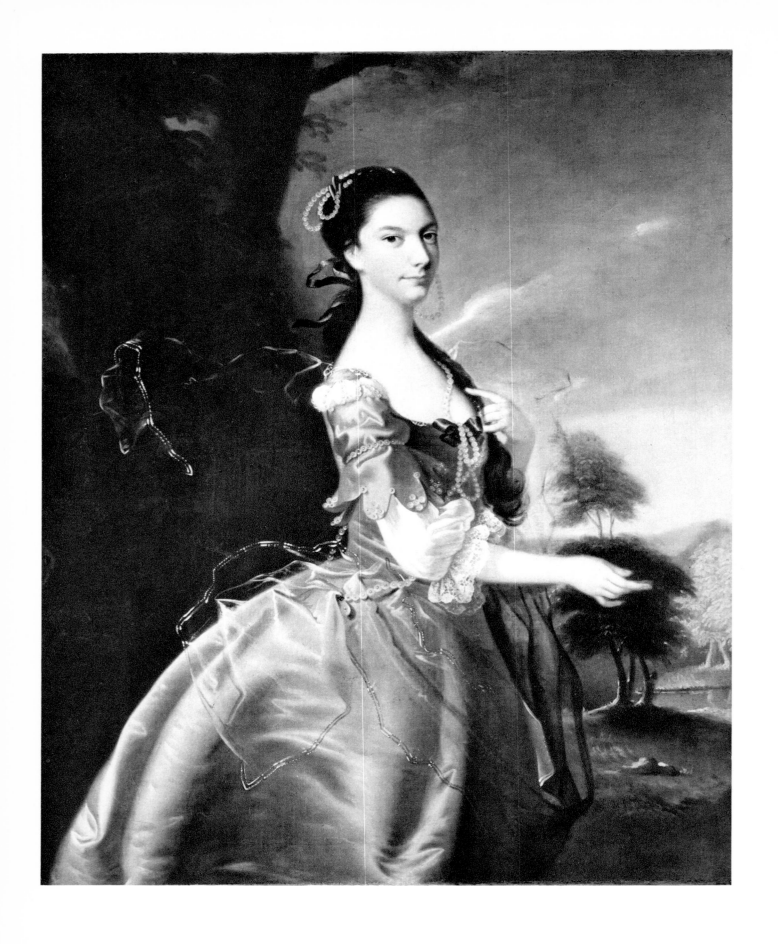

Plate 26 *Miss Ann Carver* 1760
50 x 40 in / 127 x 101.6 cm
Mr and Mrs Ronald Tree Cat 29

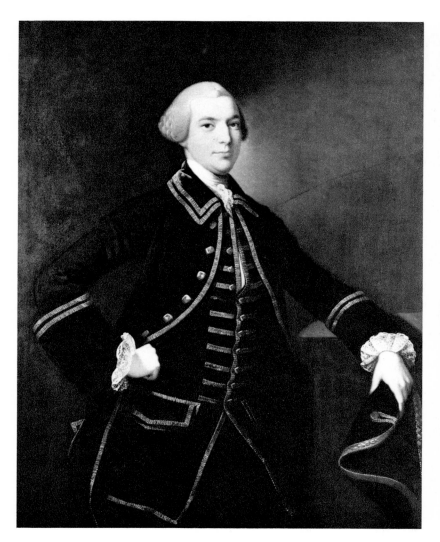

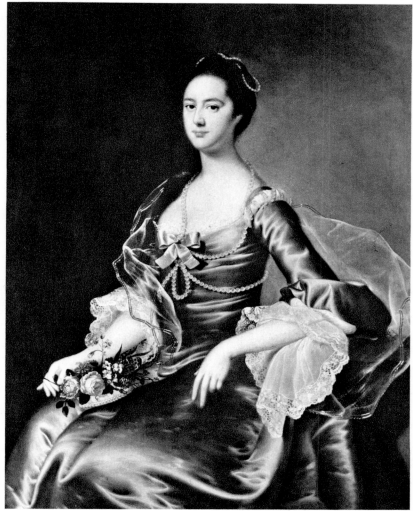

Plate 27 *Rev John C. Carver of Morthen* 1760
50 x 40 in / 127 x 101.6 cm
Formerly Athorpe Collection Cat 31

Plate 28 *Miss Elizabeth Carver* 1760
50 x 40 in / 127 x 101.6 cm
Formerly Athorpe Collection Cat 30

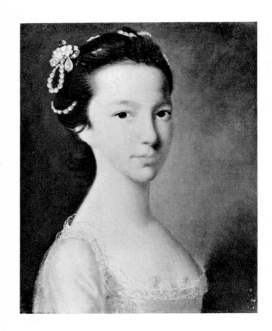

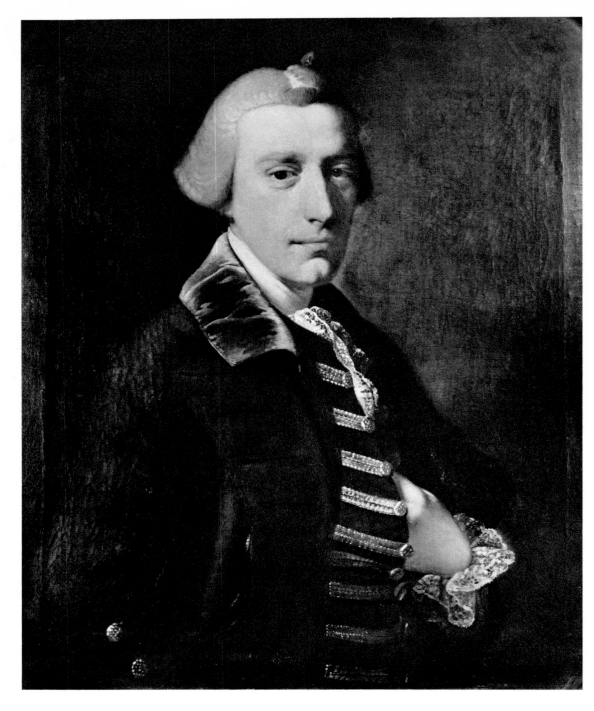

Plate 29 *Young Girl* c 1760
16 x 13 in / 40.6 x 33 cm
Leeds City Art Gallery and Temple
Newsam House Cat 160

Plate 30 *Thomas Bennett* c 1760
30 x 25 in / 76.2 x 63.5 cm
Derby Museum and Art Gallery Cat 16

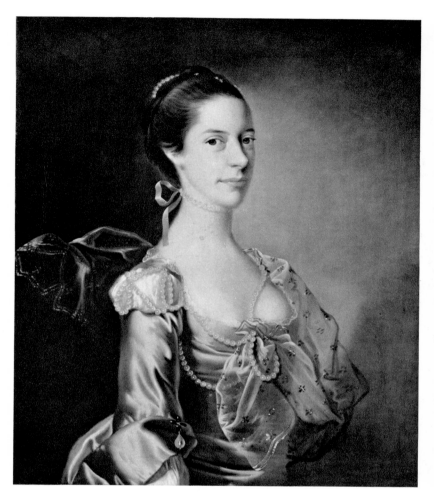

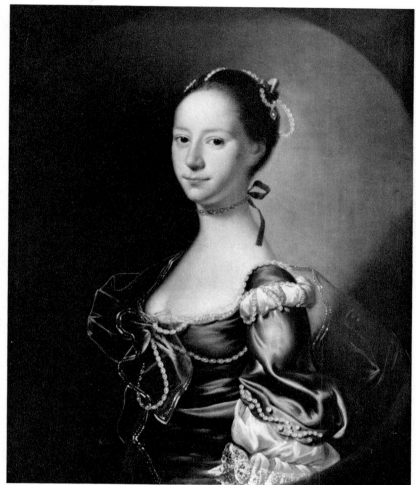

Plate 31 '*Miss Catton*' *or* '*Miss Cotton*' c 1760
50 x 40 in / 127 x 101.6 cm
City Art Museum of Saint Louis Cat 34

Plate 32 *Female Portrait* c 1760
30 x 25 in / 76.2 x 63.5 cm
Dr and Mrs Merlin L. Trumbull Cat 159

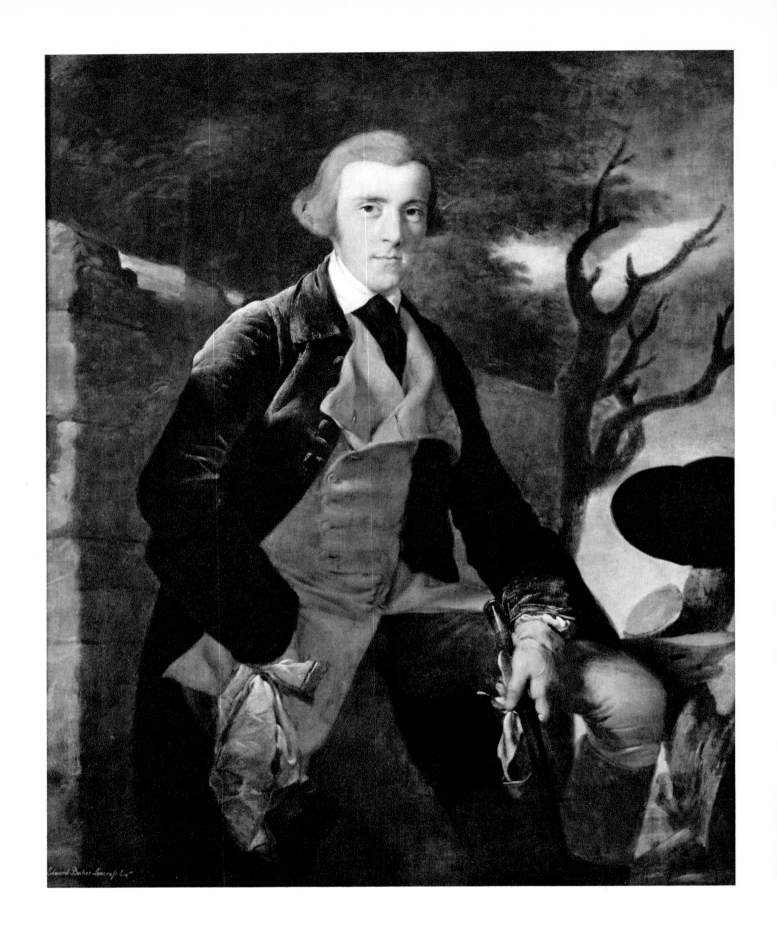

Plate 33 *Edward Becher Leacroft of Wirksworth* c 1762–63
50 x 40 in / 127 x 101.6 cm
Major Peter Miller Mundy Cat 99

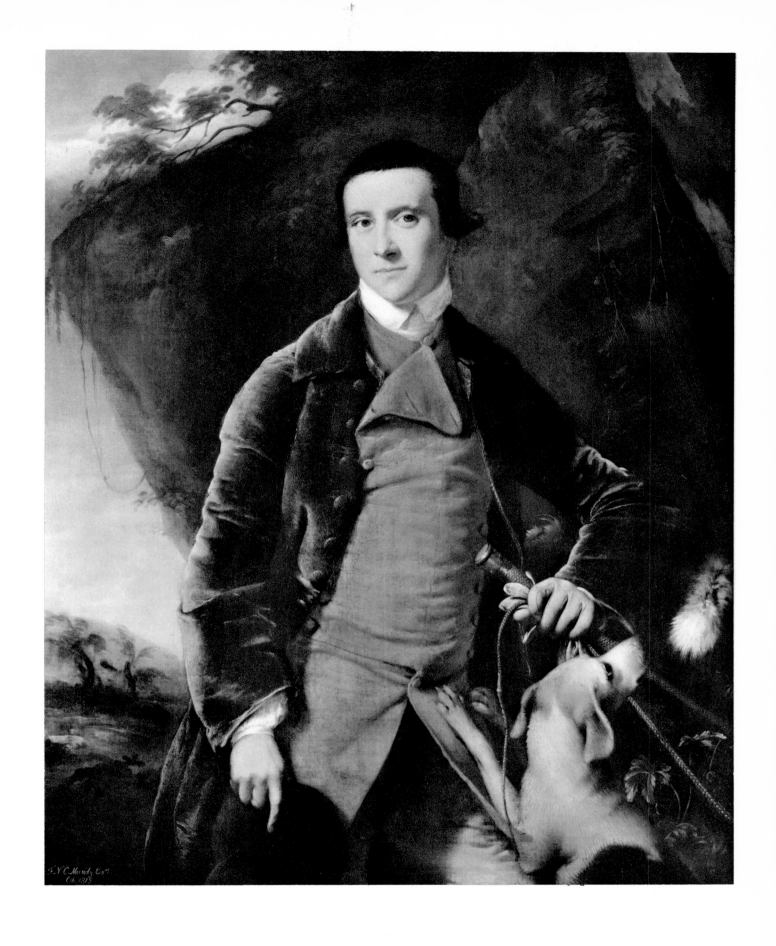

Plate 34 *Francis Noel Clarke Mundy of Markeaton* c 1762–63
50 x 40 in / 127 x 101.6 cm
Major Peter Miller Mundy Cat 110

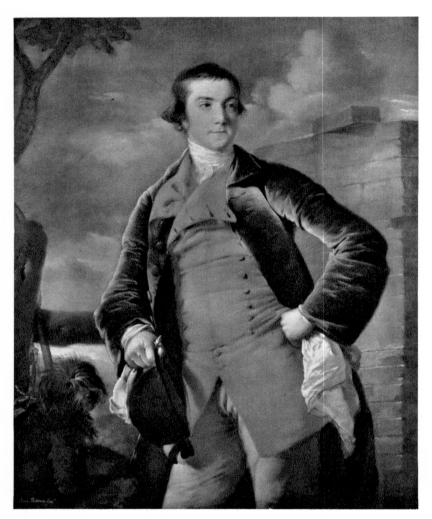

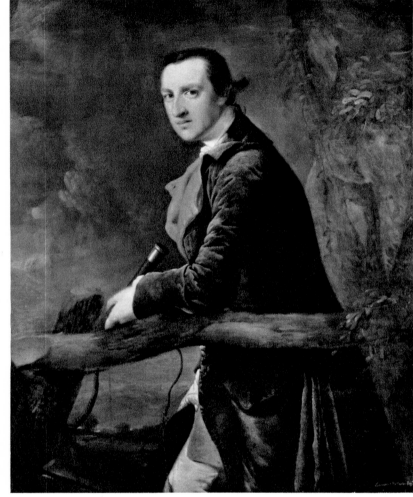

Plate 35 *Harry Peckham* c 1762–63
50 x 40 in / 127 x 101.6 cm
Major Peter Miller Mundy Cat 117

Plate 36 *Launcelot Rolliston* c 1762–63
50 x 40 in / 127 x 101.6 cm
Major Peter Miller Mundy Cat 127

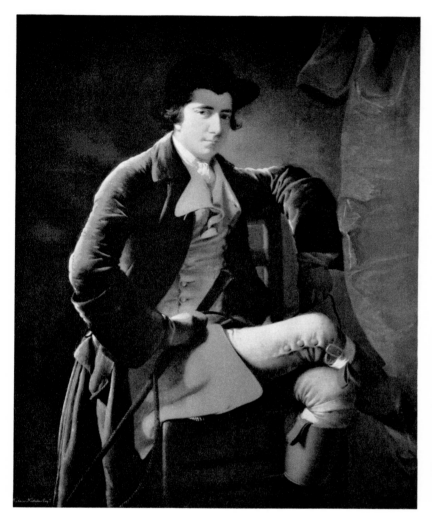

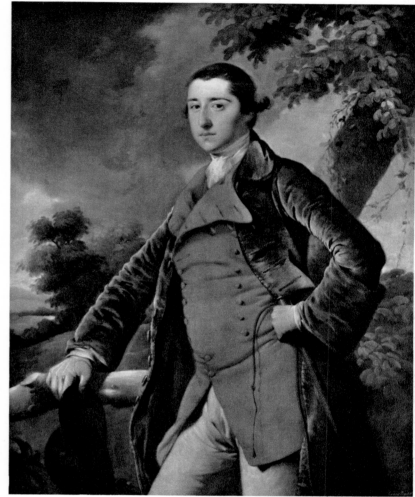

Plate 37 *Nicholas Heath* c 1762–63
50 x 40 in / 127 x 101.6 cm
Major Peter Miller Mundy Cat 77

Plate 38 *Francis Burdett of Foremark* c 1762–63
50 x 40 in / 127 x 101.6 cm
Major Peter Miller Mundy Cat 27

21

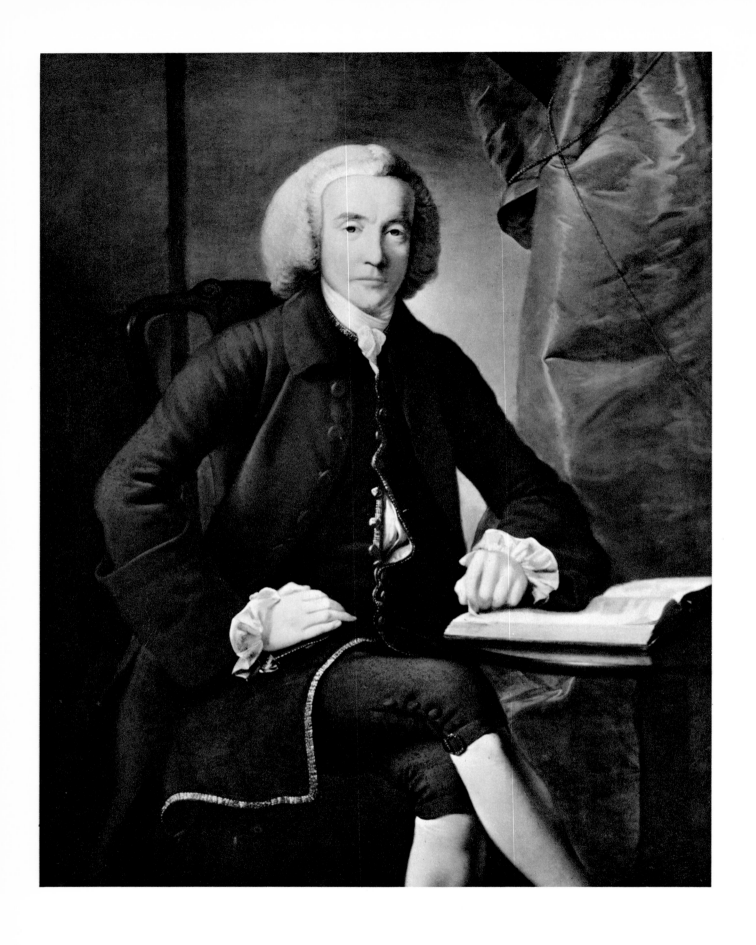

Plate 39 *Thomas Borrow* c 1762–63
50 x 40 in / 127 x 101.6 cm
Derby Museum and Art Gallery Cat 21

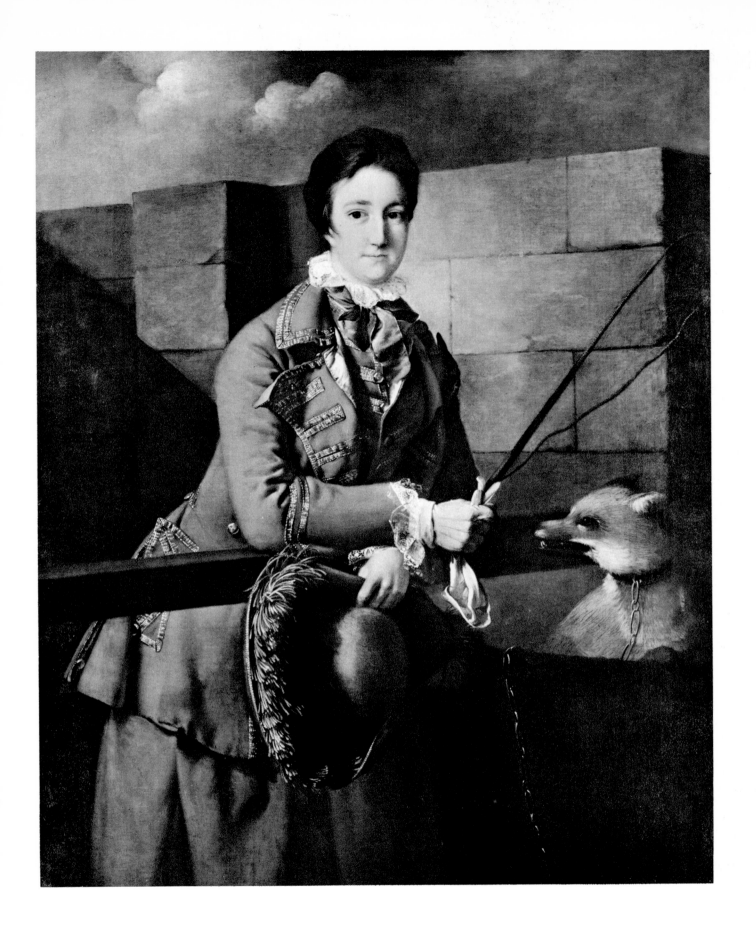

Plate 40 *Mrs Wilmot* c 1762–63
50 x 40 in / 127 x 101.6 cm
Sir Robert Wilmot Bt Cat 148

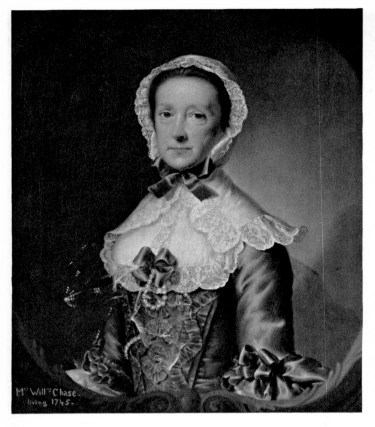

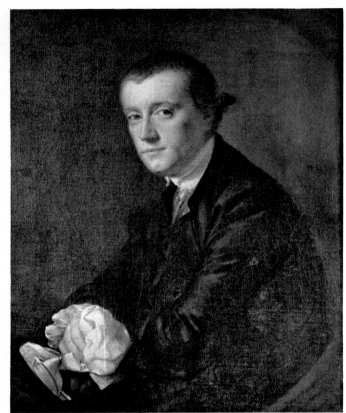

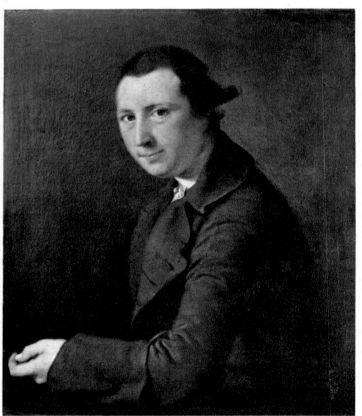

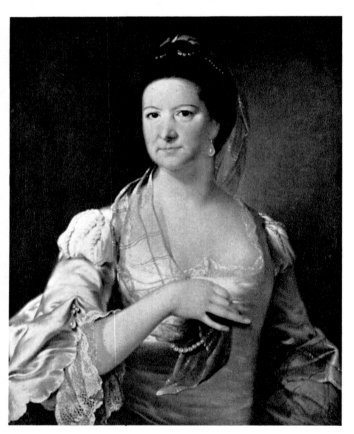

Plate 41 *Mrs William Chase* c 1761–63
30 x 25 in / 76.2 x 63.5 cm
Yale University Art Gallery; gift of Junius S. and Henry
S. Morgan Cat 36

Plate 43 '*Mr Mundy*' c 1762–64
30 x 25 in / 76.2 x 63.5 cm
Sir Gilbert Inglefield Cat 113

Plate 42 *Young Man* c 1762–64
30 x 25 in / 76.2 x 63.5 cm
Private collection U.K. Cat 157

Plate 44 '*Mrs Mundy*' c 1762–63
30 x 25 in / 76.2 x 63.5 cm
Sir Gilbert Inglefield Cat 112

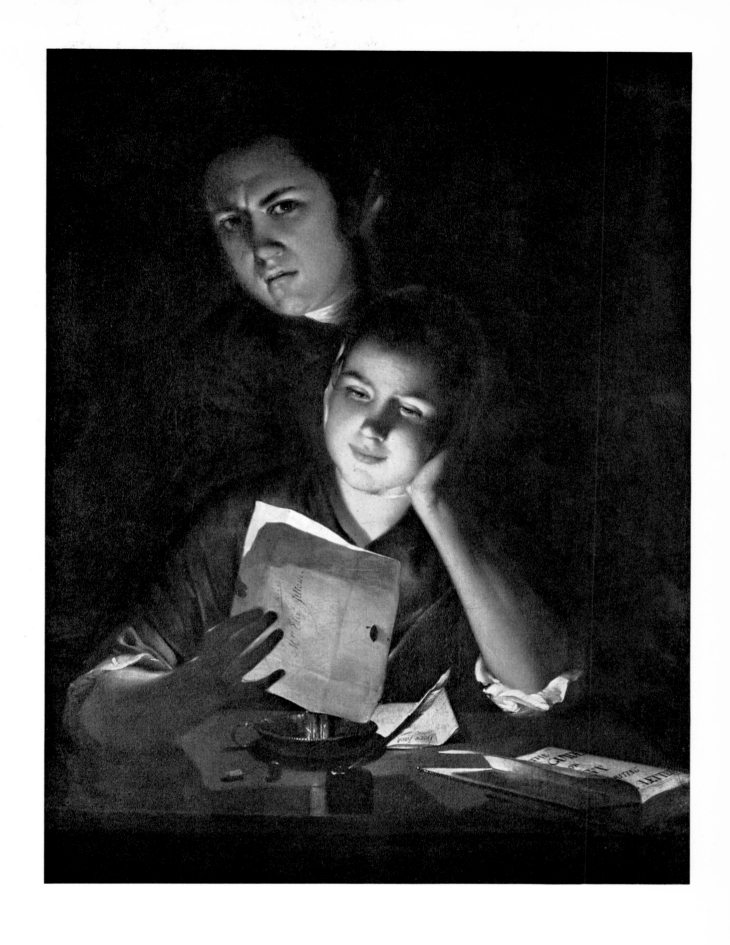

Plate 45 *A Girl reading a Letter by candlelight, with a
Young Man looking over her shoulder* c 1762–63
35 x 27½ in / 88.9 x 69.8 cm
Lt Col R. S. Nelthorpe Cat 207

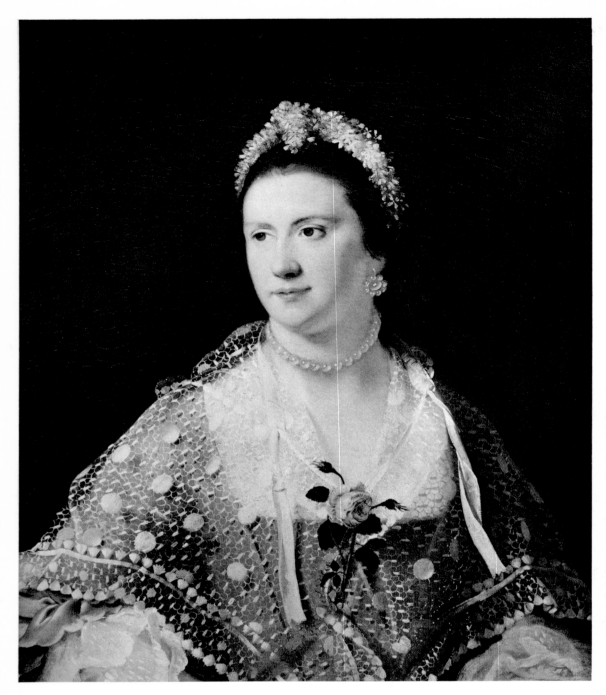

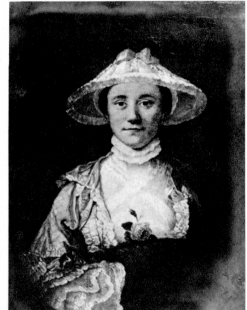

Plate 46 'Hon. Mrs Boyle' c 1761–63
30 x 25 in / 76.2 x 63.5 cm
The Mackelvie Collection, Auckland City Art Gallery
Cat 23

Plate 47 Female Portrait c 1761–63
Untraced Cat 162

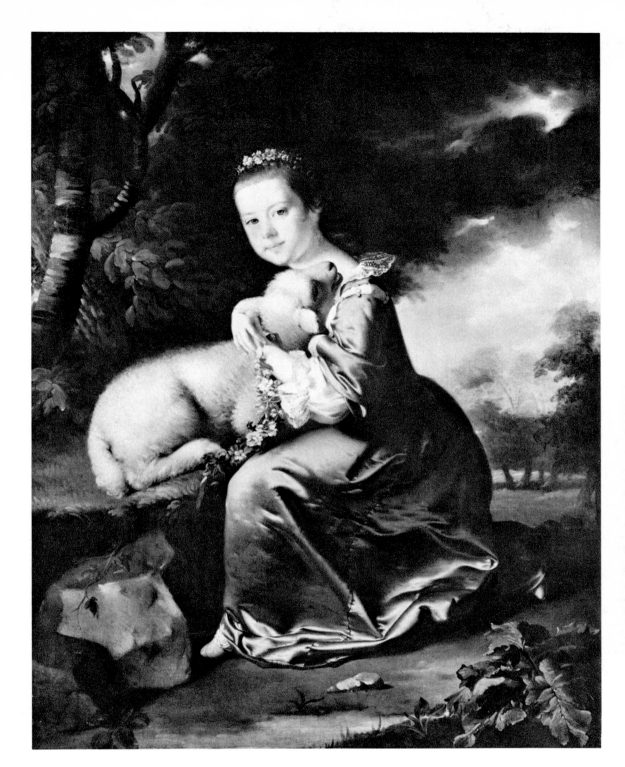

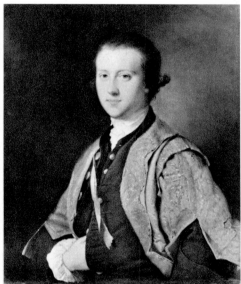

Plate 48 *Frances Warren* c 1762–64
50 x 40 in / 127 x 101.6 cm
Mrs Gerard Sweetman Cat 138

Plate 49 *Hon Richard Fitzwilliam, later
7th Viscount Fitzwilliam of Merrion* 1764
30 x 25 in / 76.2 x 63.5 cm
Fitzwilliam Museum, Cambridge
Cat 60

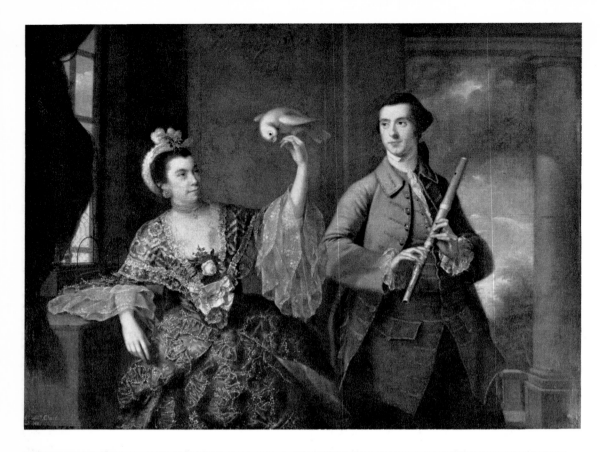

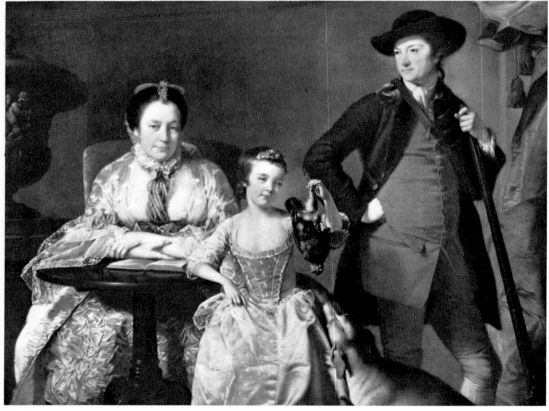

Plate 50 *Mr and Mrs William Chase* c 1762–3
54½ x 75 in / 138.4 x 190.5 cm
Lord Butler Cat 37

Plate 51 *James Shuttleworth, his Wife and Daughter* 1764
56 x 72 in / 142.2 x 182.9 cm
Lord Shuttleworth Cat 129

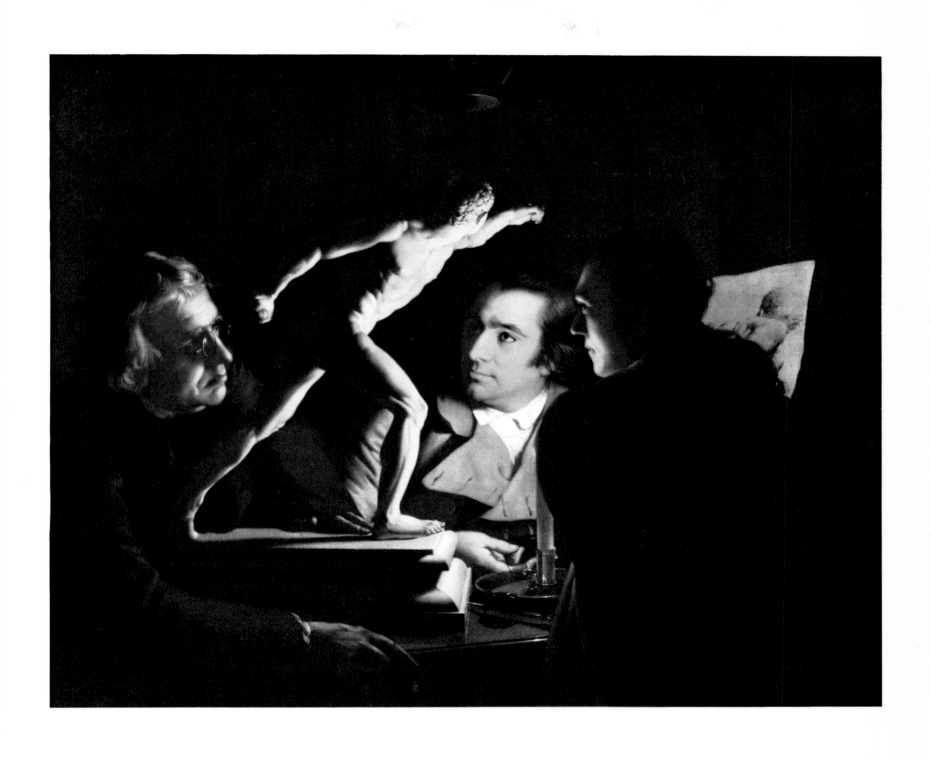

Plate 52 *Three Persons viewing the Gladiator by Candlelight* c 1764–65
40 x 48 in / 101.6 x 121.9 cm
Private collection, U.K. Cat 188

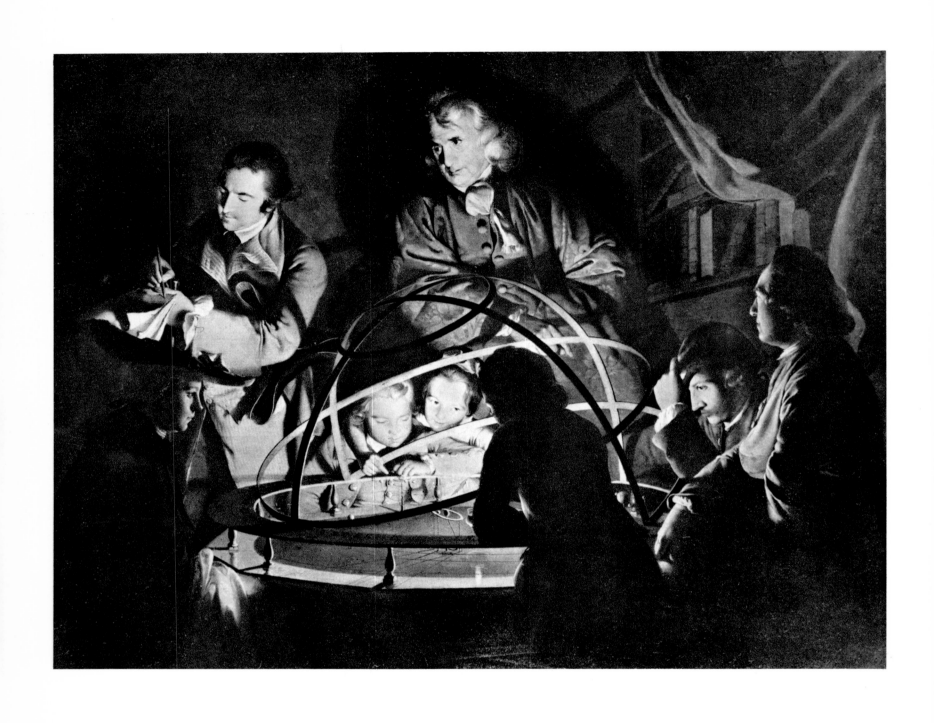

Plate 53 *A Philosopher giving a Lecture on the Orrery* c 1768
Monochrome study for engraving 17¾ x 23 in / 45 x 58.4 cm
Mr and Mrs Paul Mellon Cat 191

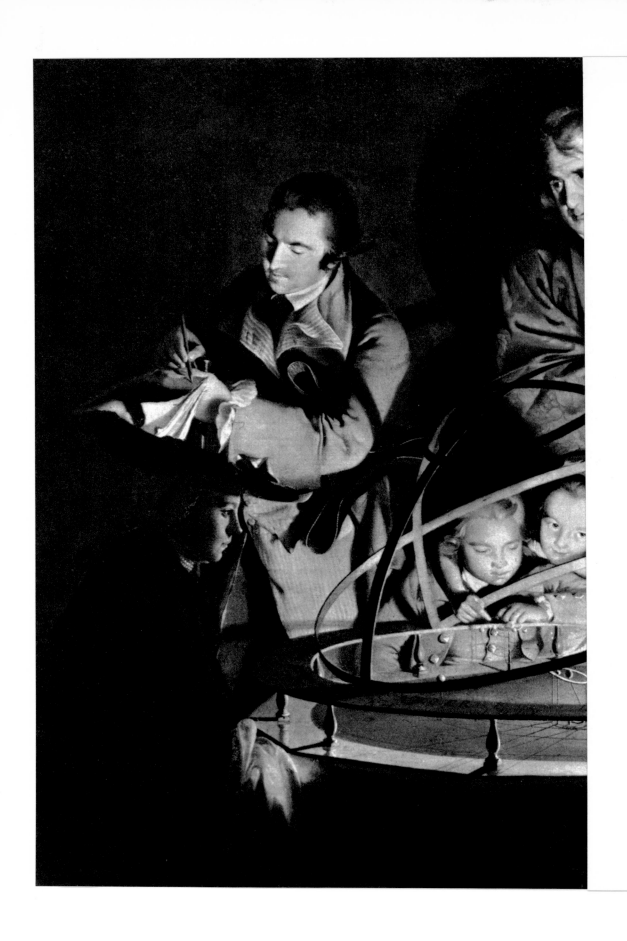

Plate 54 *A Philosopher giving a lecture on the Orrery* c 1764–66
58 x 80 in / 147.3 x 203.2 cm
Derby Museum and Art Gallery Cat 190

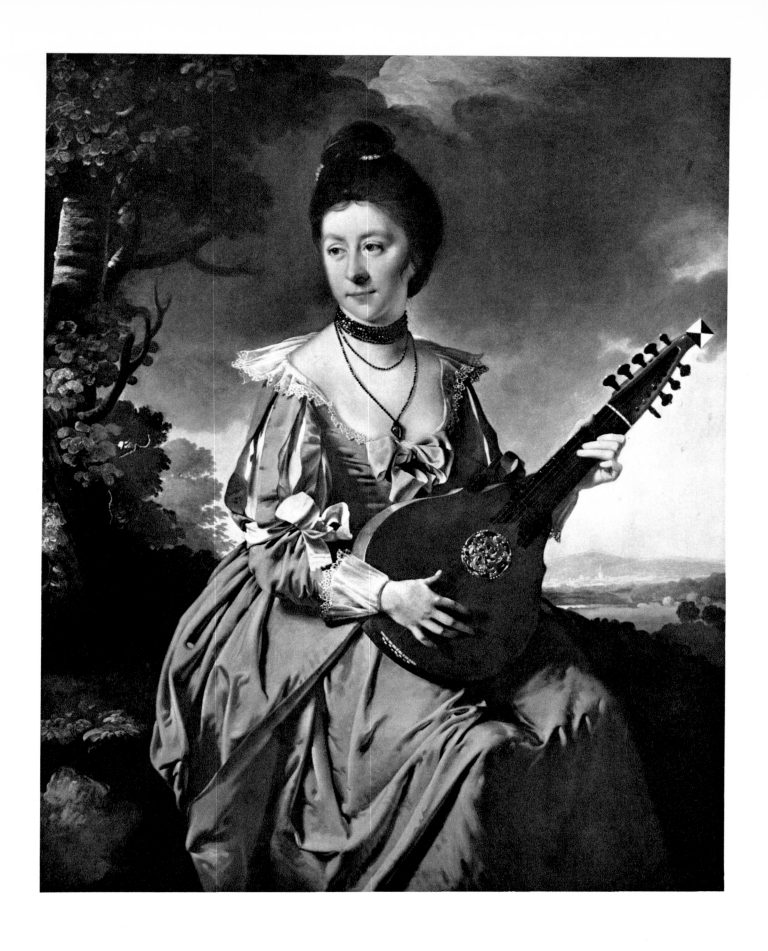

Plate 55 *Mrs Gwillym of Atherton* 1766
50 x 40 in / 127 x 101.6 cm
City Art Museum of Saint Louis Cat 69

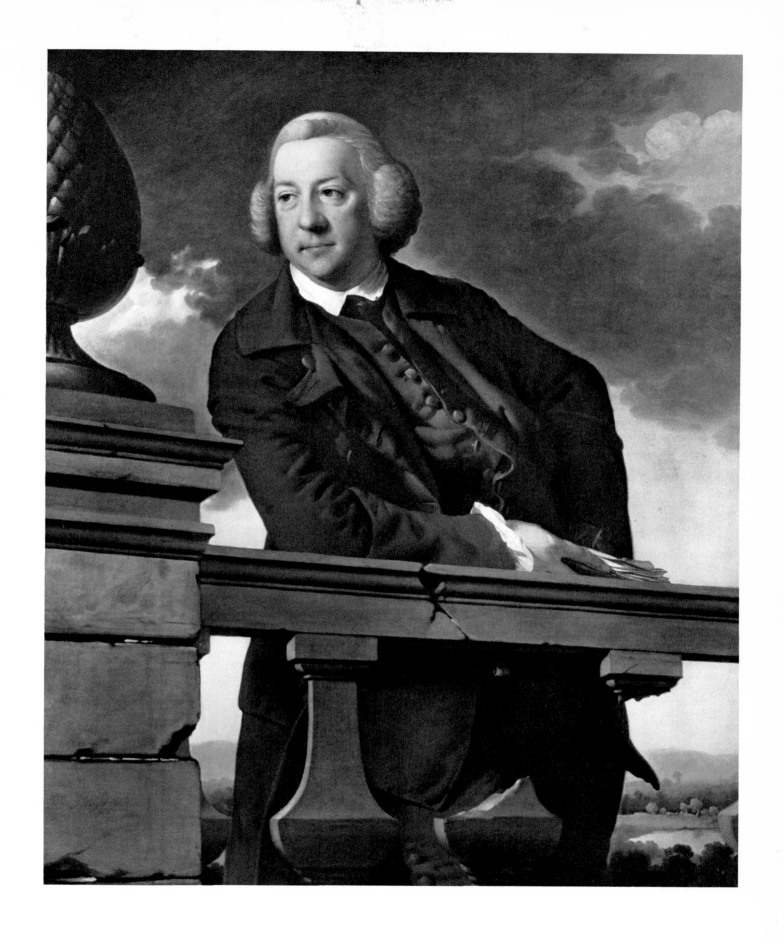

Plate 56 *Robert Vernon Atherton Gwillym* 1766
50 x 40 in / 127 x 101.6 cm
City Art Museum of Saint Louis Cat 68

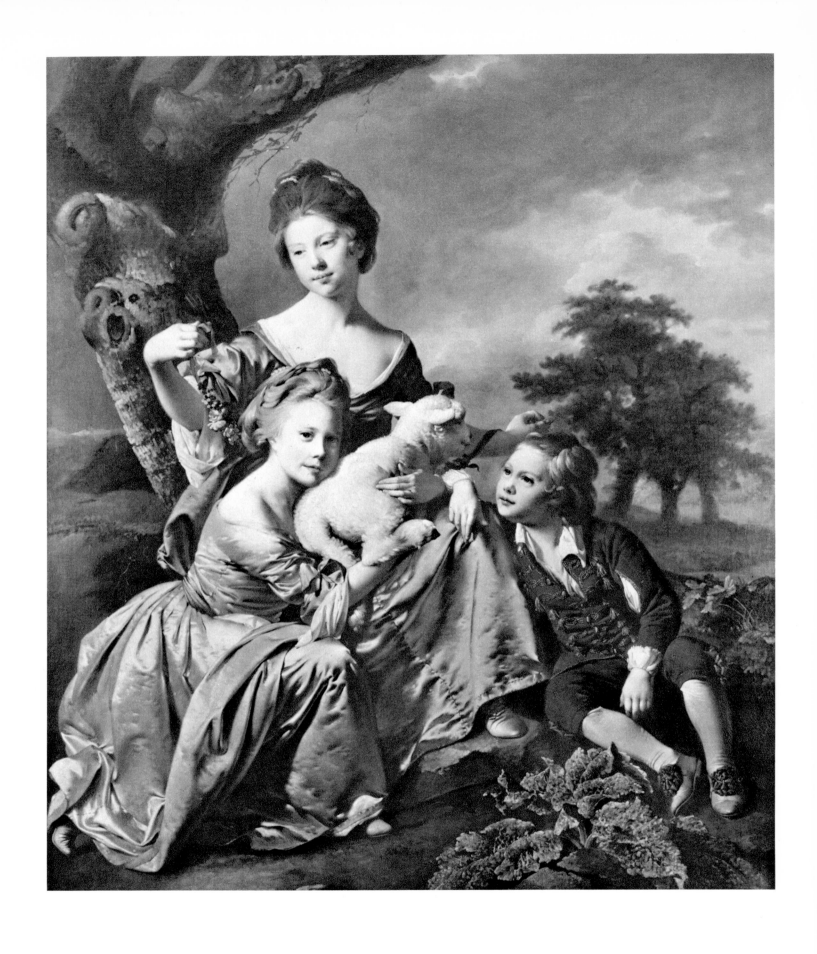

Plate 57 *Bradshaw Children* c 1766–68
63½ x 54 in / 161.3 x 137.2 cm
Peter Wilmot-Sitwell Cat 24

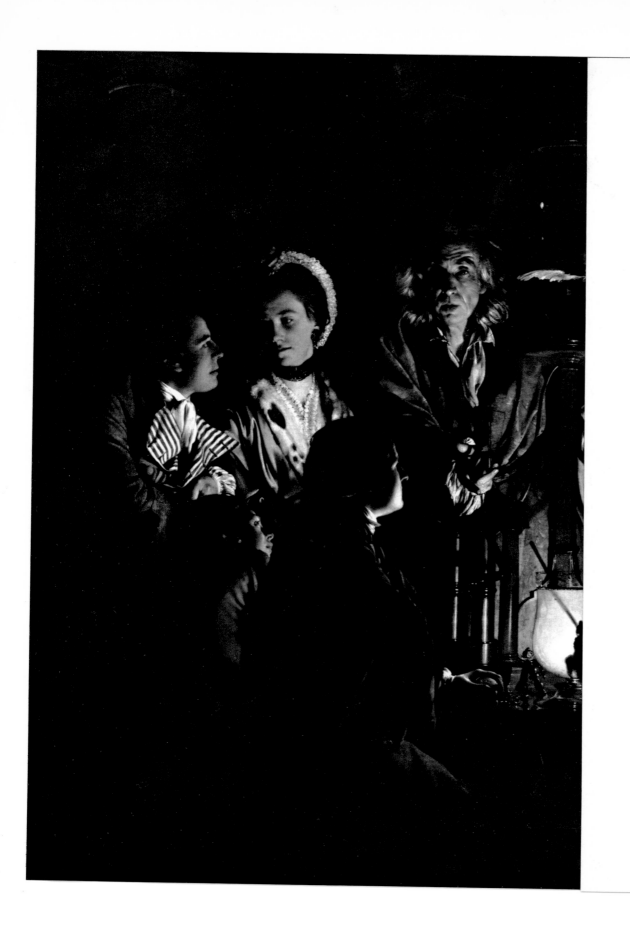

Plate 58 *An Experiment on a Bird in the Air Pump* c 1767–68
72 x 96 in / 182.9 x 243.8 cm
Tate Gallery Cat 192

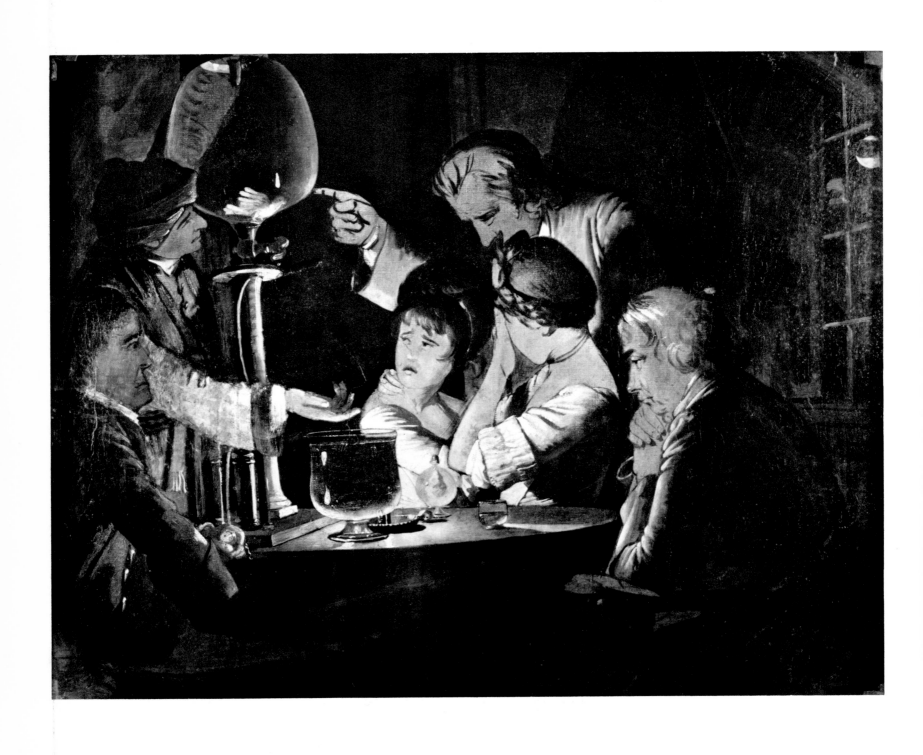

Plate 59 *Study for An Experiment on a Bird in the Air Pump*
(on reverse of *Self portrait—Frontispiece*) c 1767
24½ x 30 in / 62.2 x 76.2 cm
Charles Rogers–Coltman Cat 193

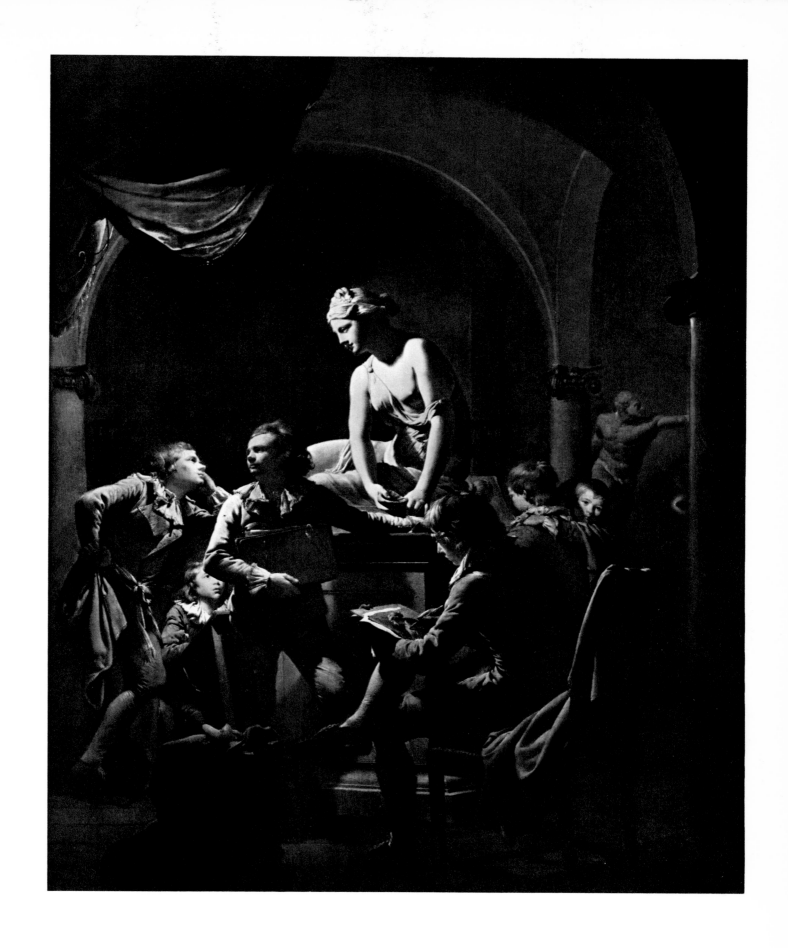

Plate 60 *An Academy by Lamplight* c 1768–69
50 x 39⅞ in / 127 x 101.2 cm
Mr and Mrs Paul Mellon
on loan to the Tate Gallery Cat 189

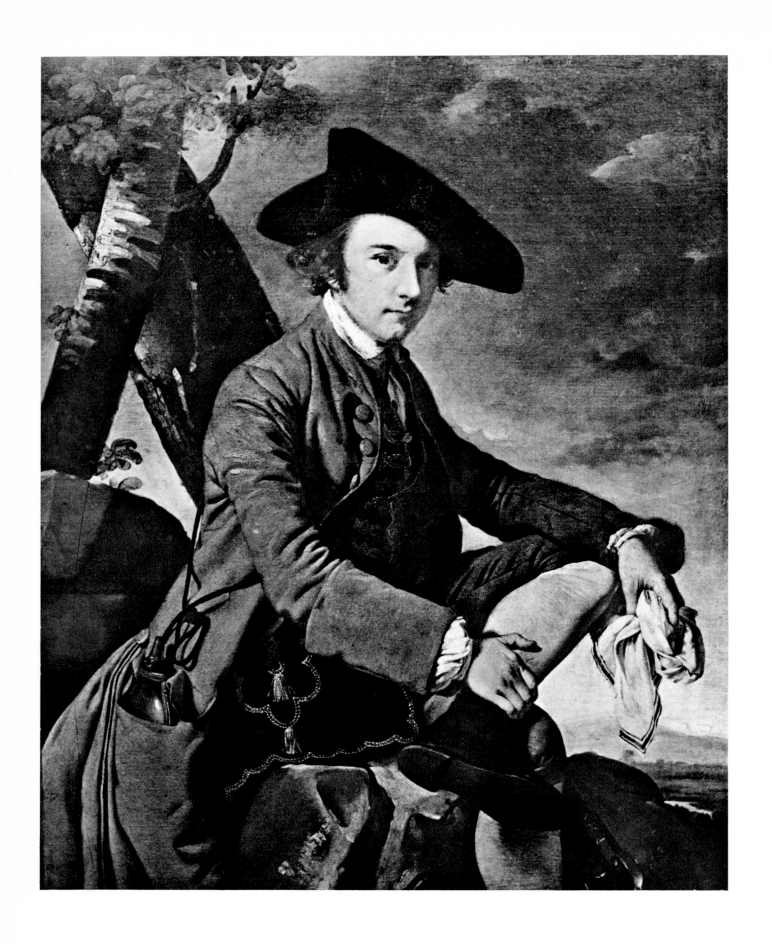

Plate 61 *Fleetwood Hesketh* 1769
50 x 40 in / 127 x 101.6 cm
Trustees of the Hesketh Settled Estate Cat 81

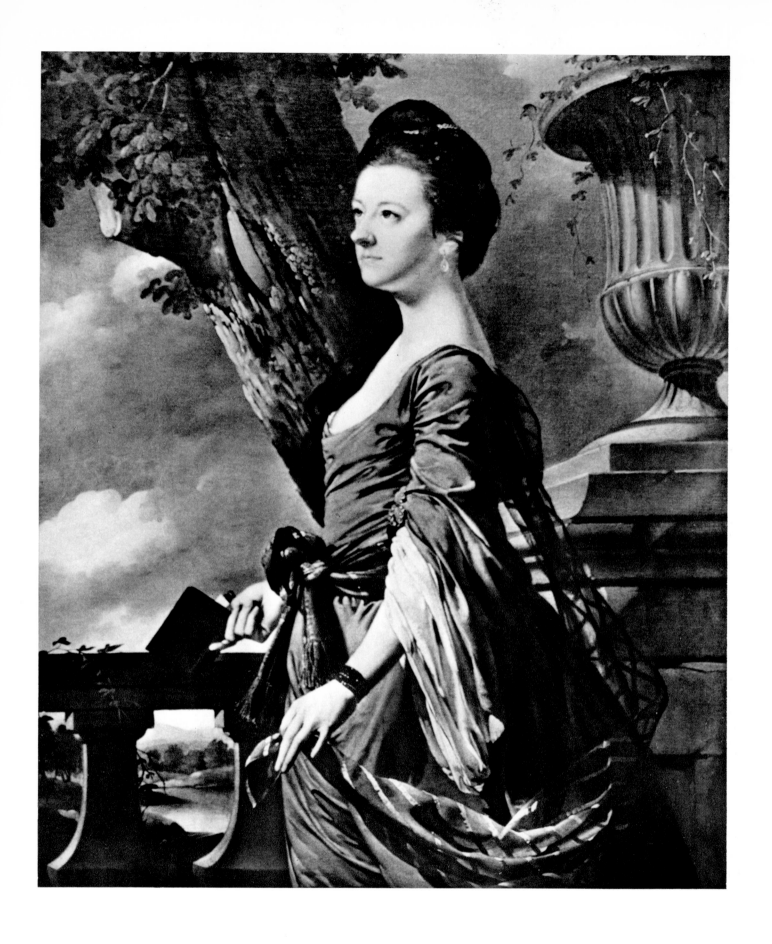

Plate 62 *Frances Hesketh* 1769
50 x 40 in / 127 x 101.6 cm
Trustees of the Hesketh Settled Estate Cat 82

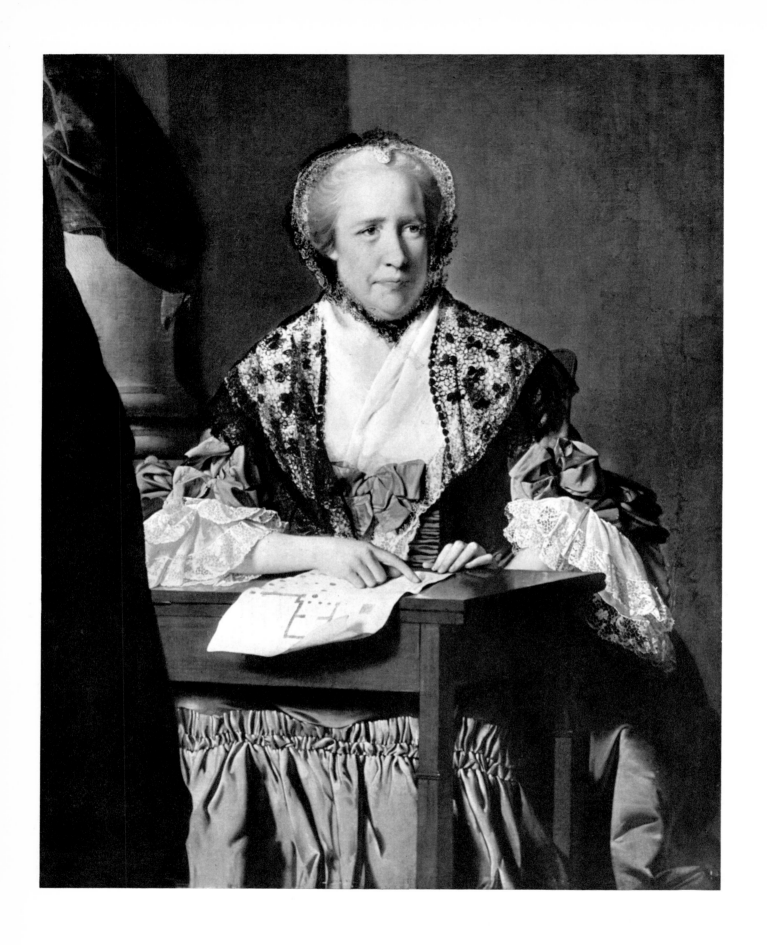

Plate 63 *Mrs Sarah Clayton* c 1769
50 x 40 in / 127 x 101.6 cm
Fitchburg Art Museum, Mass
gift of Miss Louise I. Doyle Cat 39

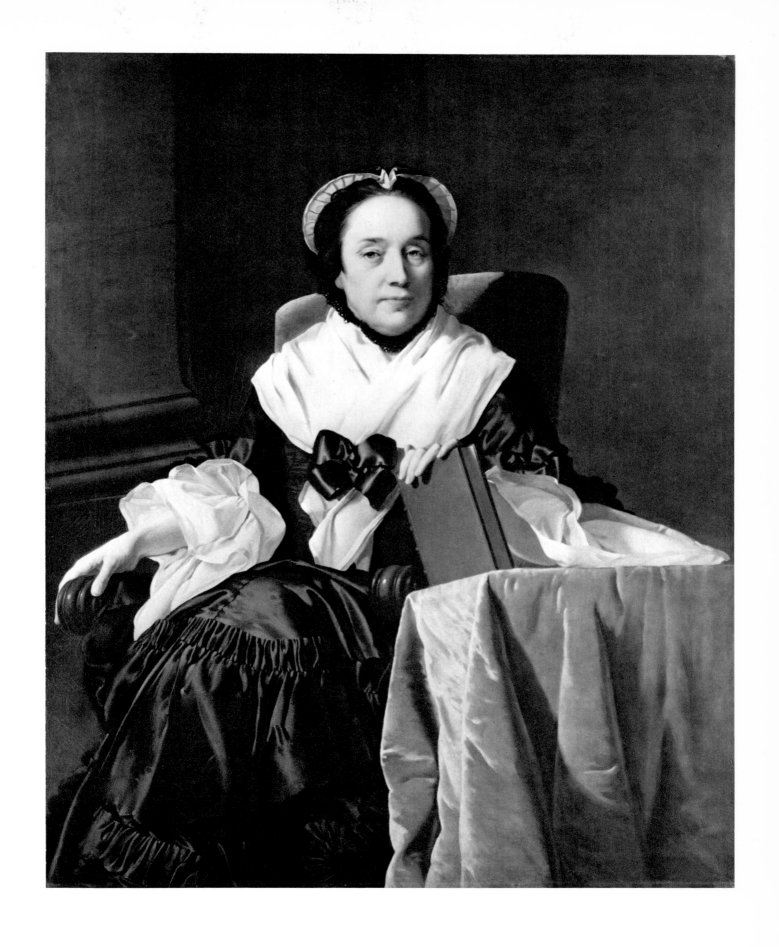

Plate 64 *Mrs John Ashton* 1769
50 x 40 in / 127 x 101.6 cm
Fitzwilliam Museum, Cambridge Cat 6

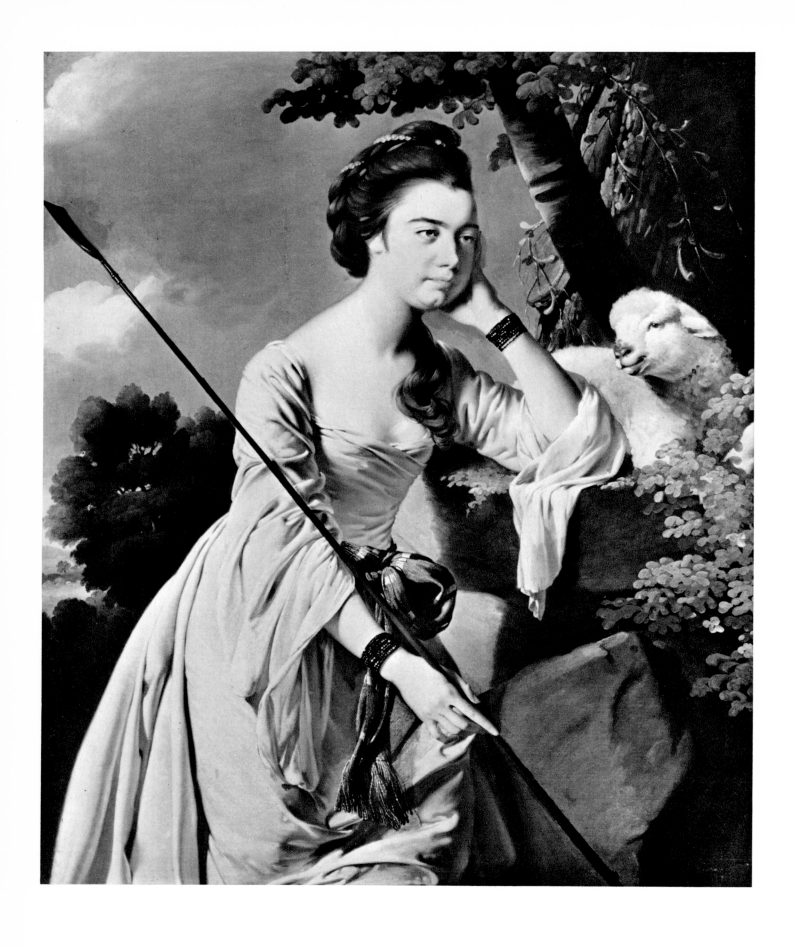

Plate 65 *Anna Ashton (Mrs Thomas Case)* 1769
c 50 x 40 in / 127 x 101.6 cm
Captain Everard Radcliffe, M. C. Cat 8

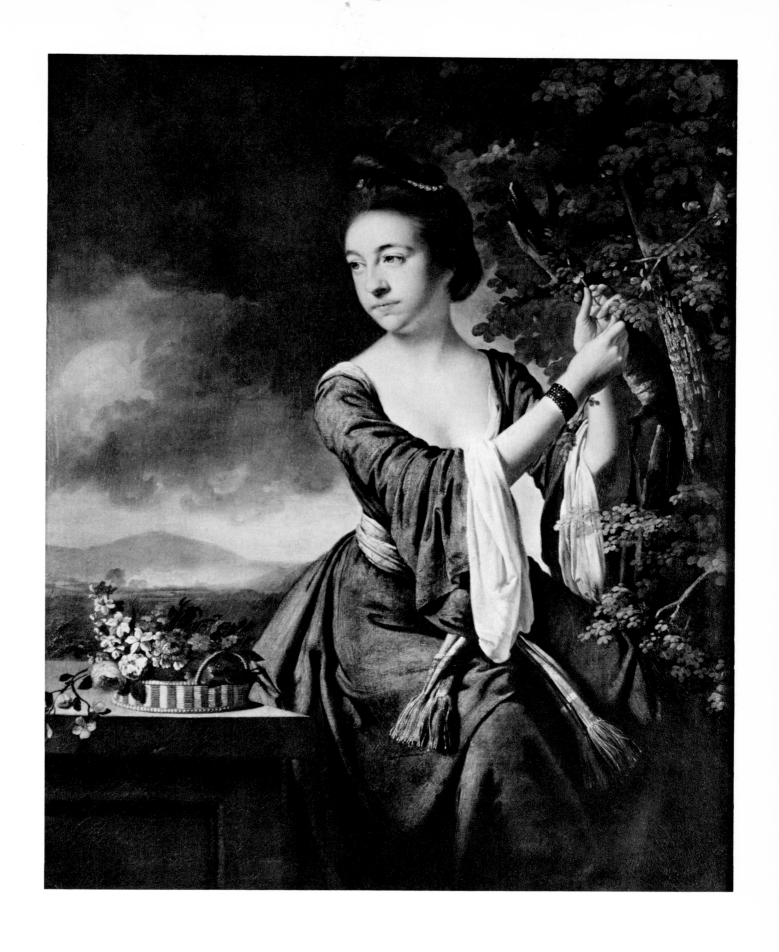

Plate 66 *Elizabeth Ashton (Mrs John Bostock)* 1769
c 50 x 40 in / 127 x 101.6 cm
David Ashton-Bostock Cat 7

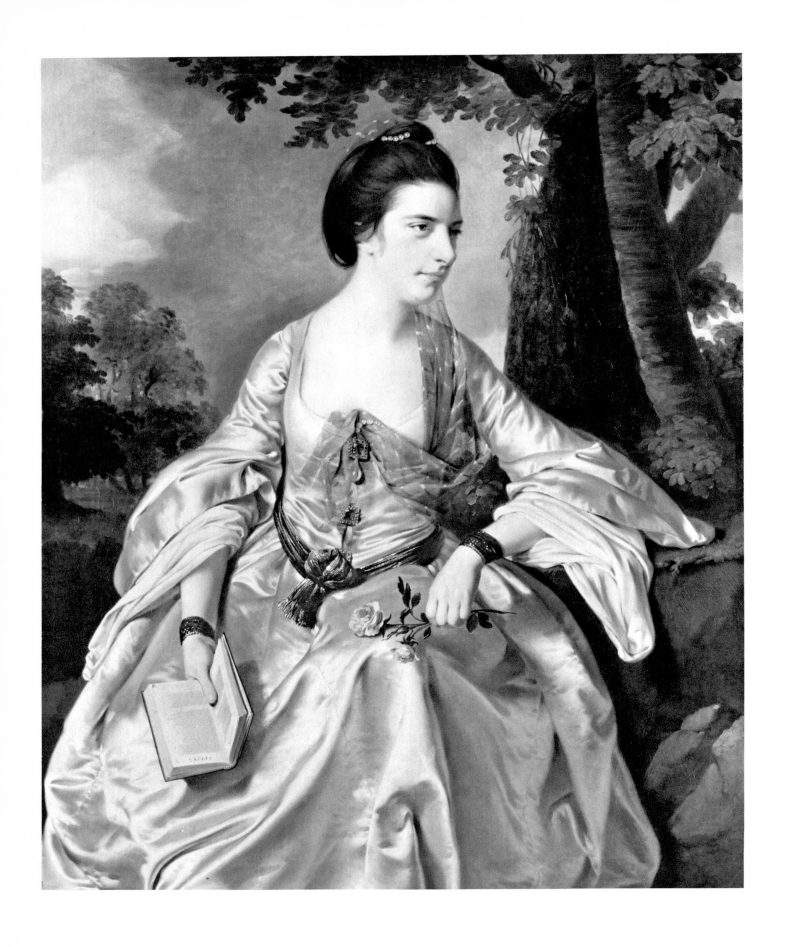

Plate 67 *Mrs Nicholas Ashton* 1769
50 x 40 in / 127 x 101.6 cm
David Ashton-Bostock Cat 9

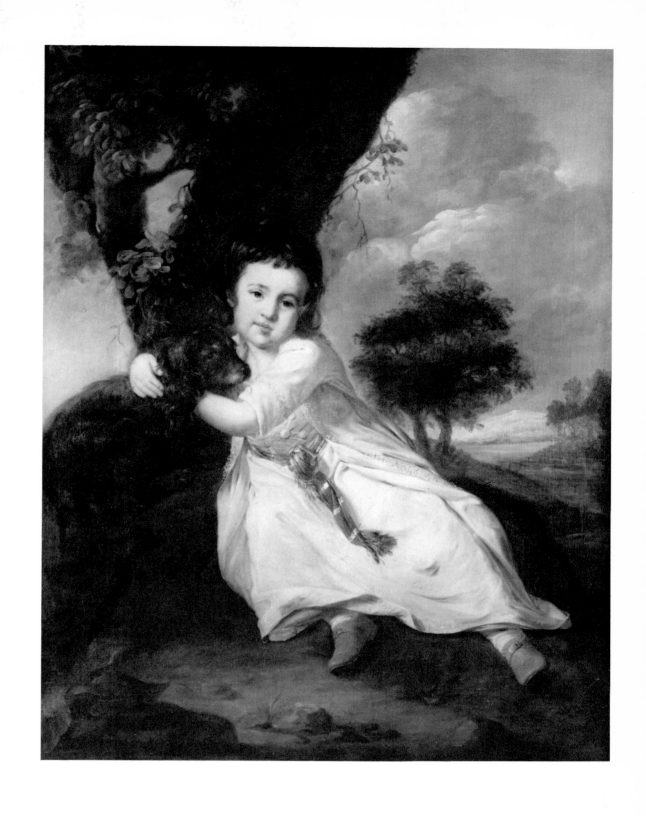

Plate 68 Copy of destroyed work by Wright *John Ashton* 1769
50 x 40 in / 127 x 101.6 cm
David Ashton-Bostock Cat 10

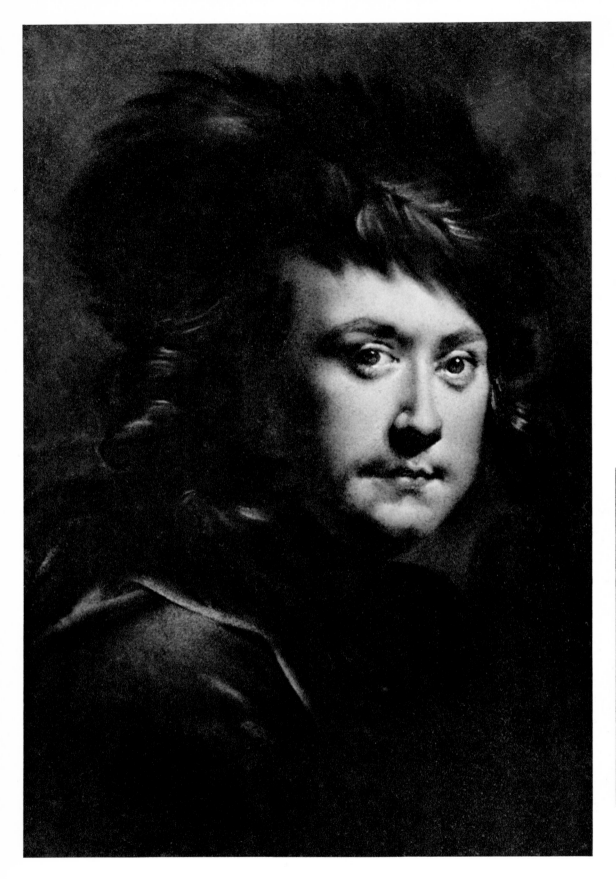

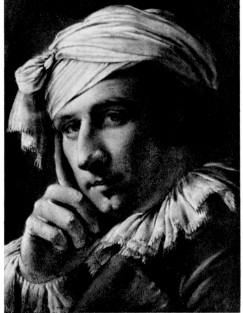

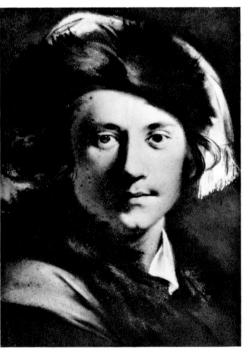

Plate 69 *Self-portrait* ? 1768
Charcoal 17 x 11⅝ in / 43.2 x 29.5 cm
Mr and Mrs Paul Mellon Cat 166

Plate 71 *Self-portrait* c 1765–68
Charcoal on bluish paper with white
heightening
16¾ x 11⅝ in / 42.5 x 29.5 cm
James Ricau Cat 165

Plate 70 *Self-portrait* c 1767–70
Charcoal 21 x 14½ in / 53.3 x 36.8 cm
Derby Museum and Art Gallery Cat 168

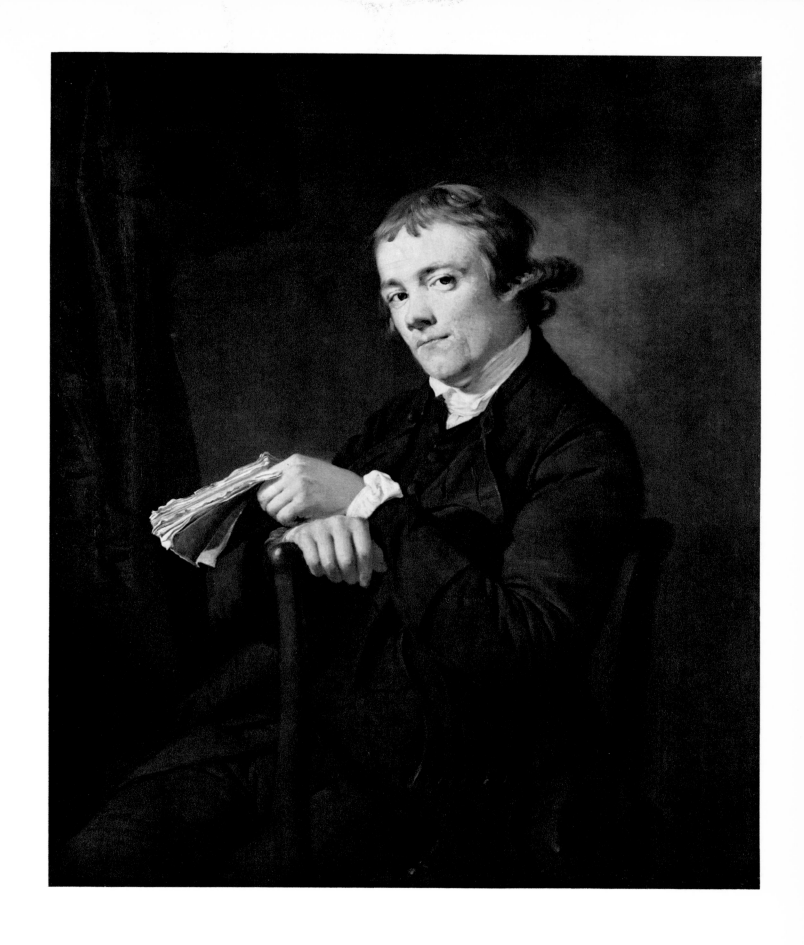

Plate 72 *Thomas Staniforth* 1769
$36\frac{1}{4}$ x 30 in / 92.1 x 76.2 cm
Tate Gallery Cat 132

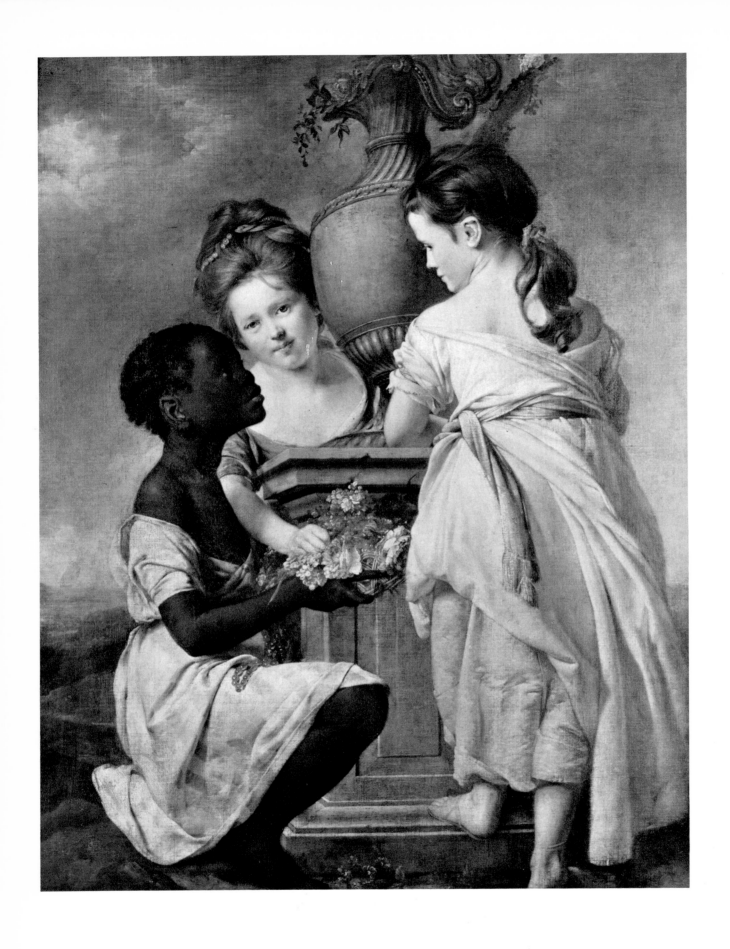

Plate 73 *Two Girls and a Negro Servant* c 1769–70
50 x 40 in / 127 x 101.6 cm
Heirs of Oliver Vernon Watney Cat 163

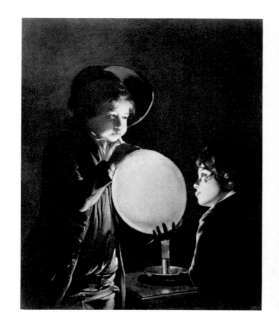

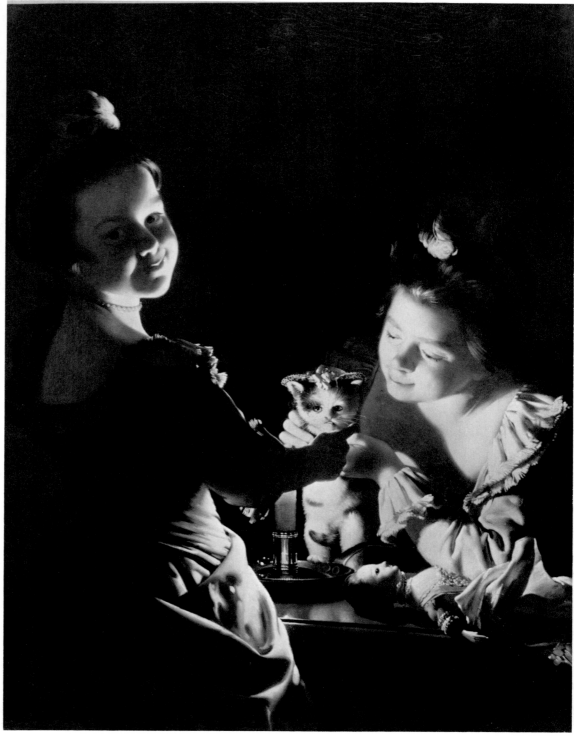

Plate 74 Copy of a lost Wright *Two Boys with a Bladder* original c 1769–70
c 36 x 28 in / 91.4 x 71.1 cm
Henry E. Huntington Library and Art Gallery Cat 208

Plate 75 *Two Girls decorating a kitten by candlelight* c 1768–70
35¾ x 28½ in / 90.8 x 72.4 cm
Mrs C. Margaret Riley Cat 212

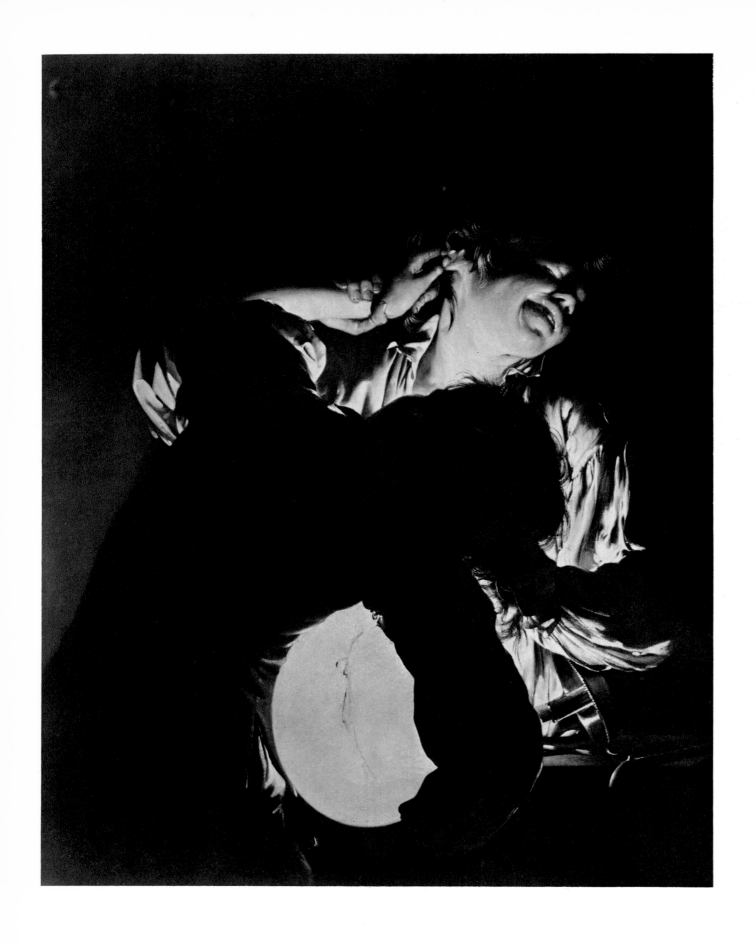

Plate 76 *Two Boys fighting over a Bladder* c 1767–70
36 x 28 in / 91.4 x 71.1 cm
Charles Rogers–Coltman Cat 206

50

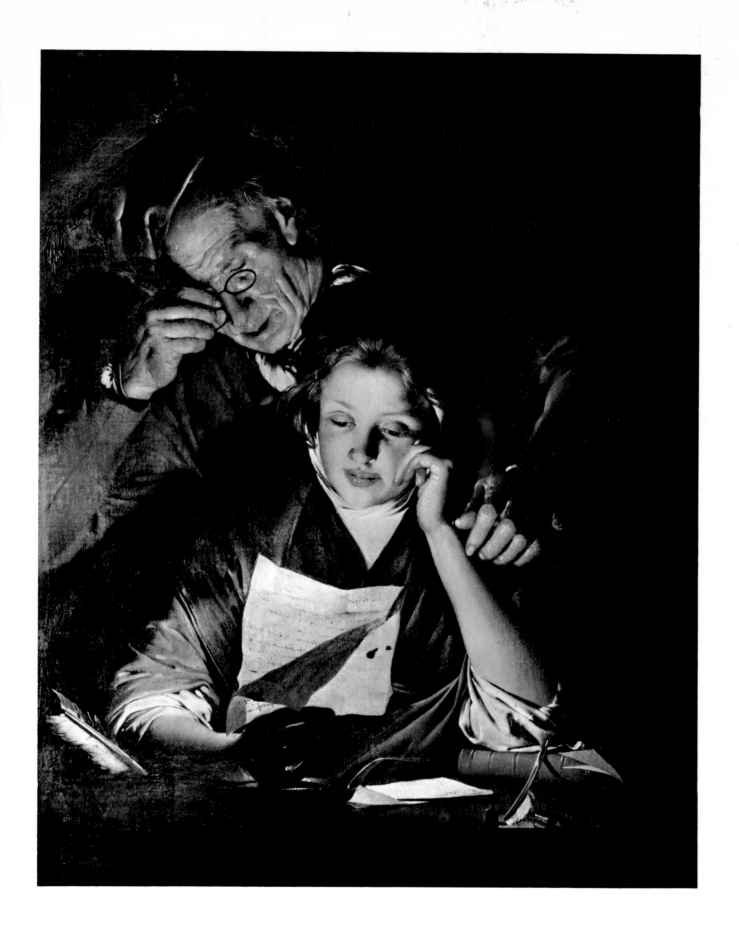

Plate 77 *A Girl reading a letter with an old man reading over her shoulder* c 1767–70
36 x 28 in / 94.4 x 71.1 cm
Charles Rogers-Coltman Cat 205

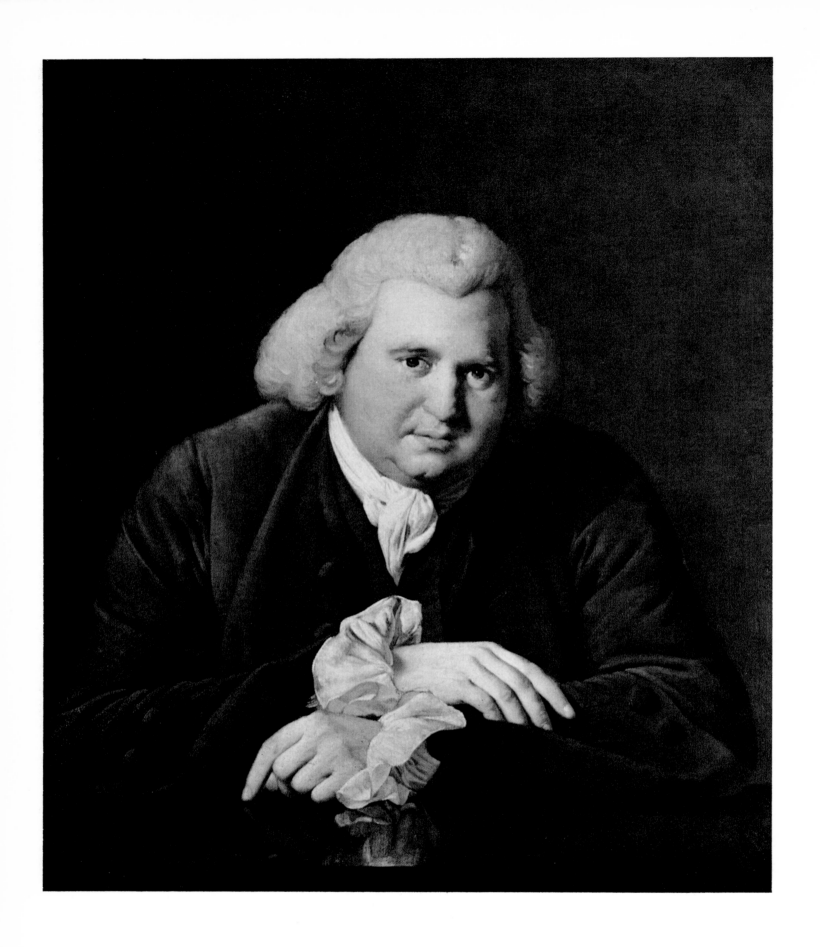

Plate 78 *Erasmus Darwin* 1770
30 x 25 in / 76.2 x 63.5 cm
G. P. Darwin; on loan to Darwin College, Cambridge Cat 50

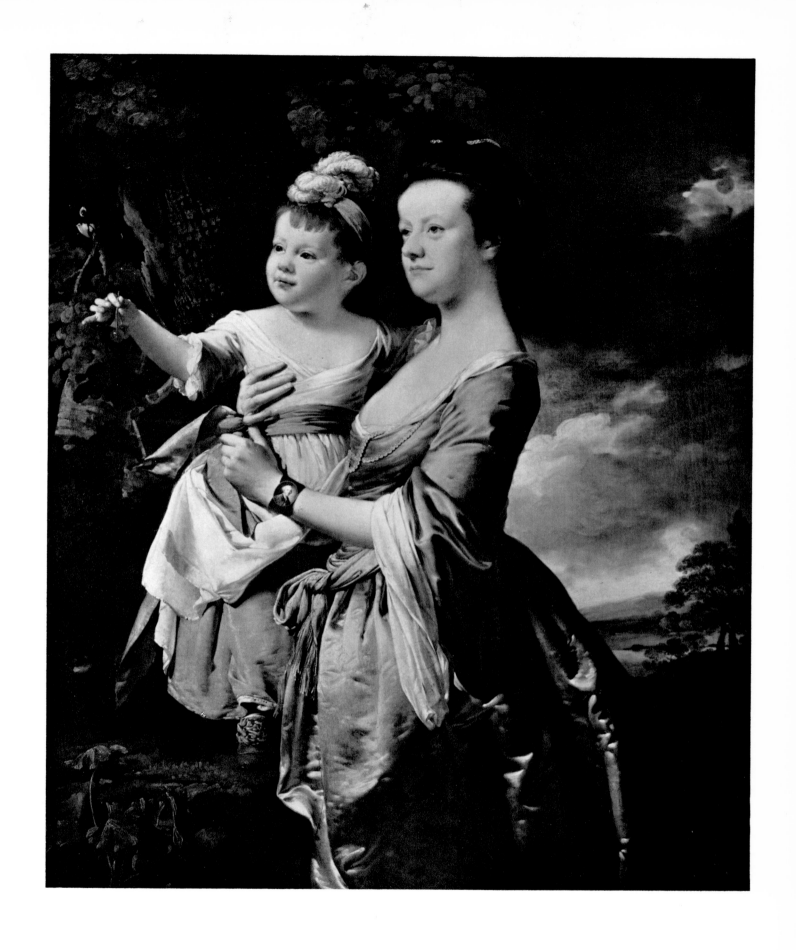

Plate 79 *Sarah Carver and her daughter Sarah* c 1769–70
50 x 40 in / 127 x 101.6 cm
Derby Museum and Art Gallery Cat 32

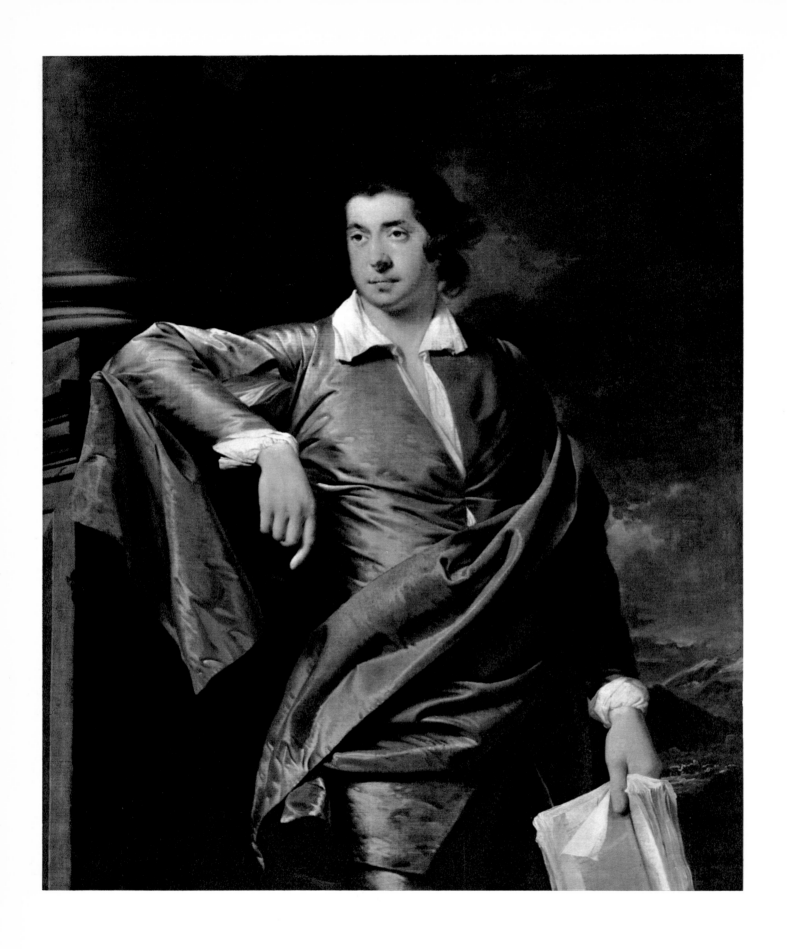

Plate 80 *Thomas Day* 1770
50 x 40 in / 127 x 101.6 cm
The Lord Belper Cat 58

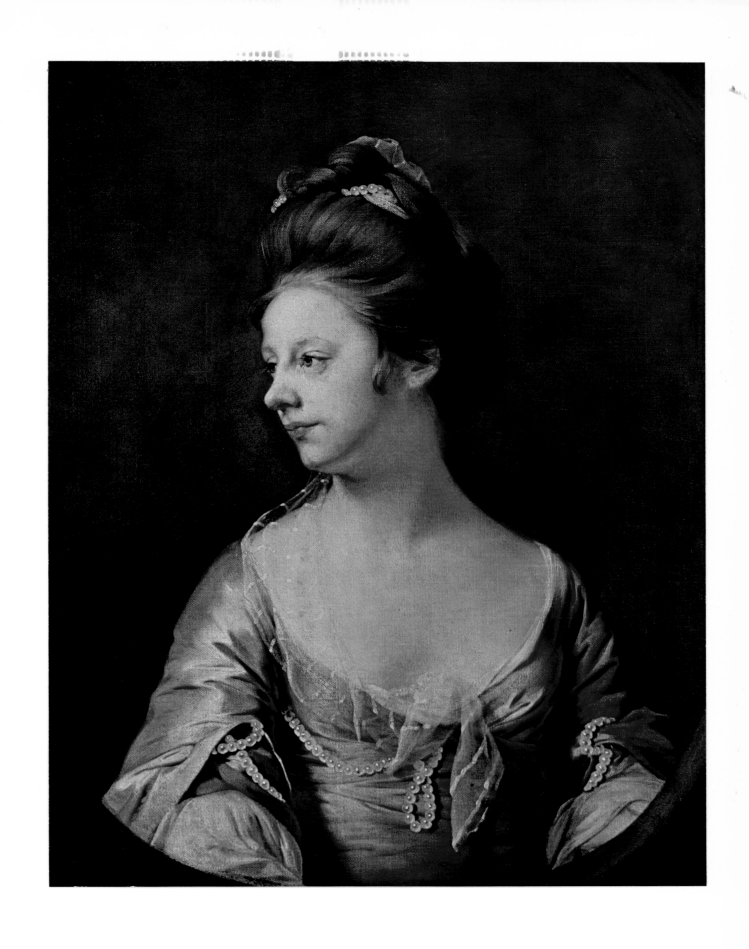

Plate 81 'Mrs Catherine Swindell' c 1769–71
28 x 22 in / 71.1 x 55.9 cm
Leicester Museum and Art Gallery Cat 134

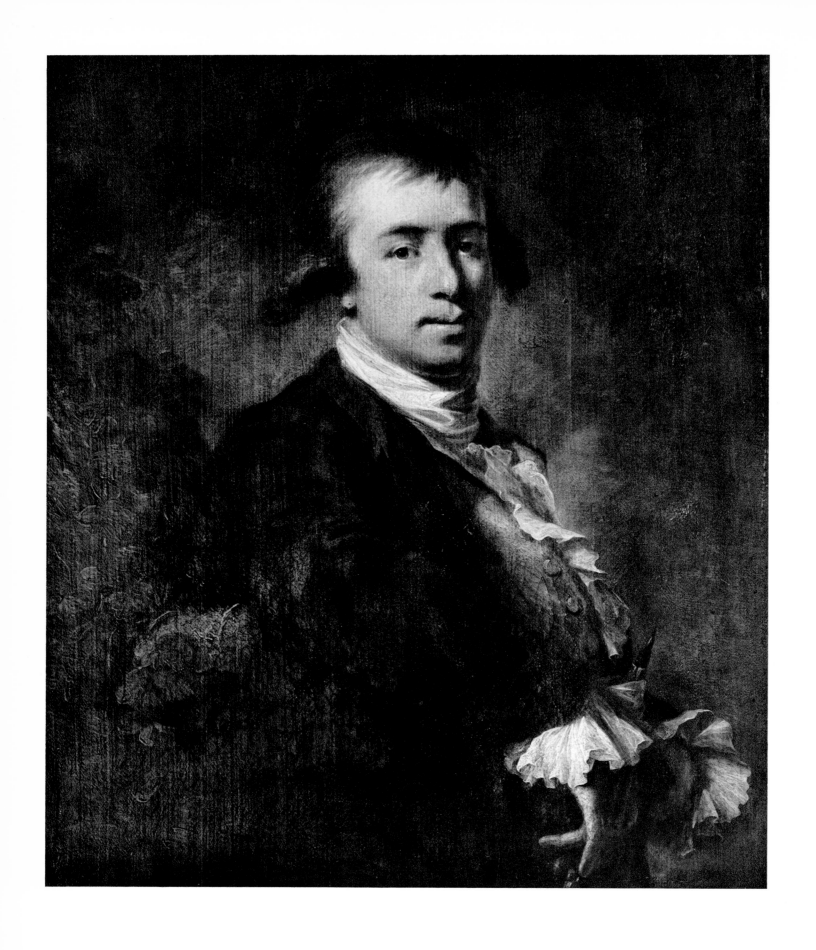

Plate 82 *Young Artist* c 1770
c 50 x 40 in / 127 x 101.6 cm
Private Collection U.K. Cat 156

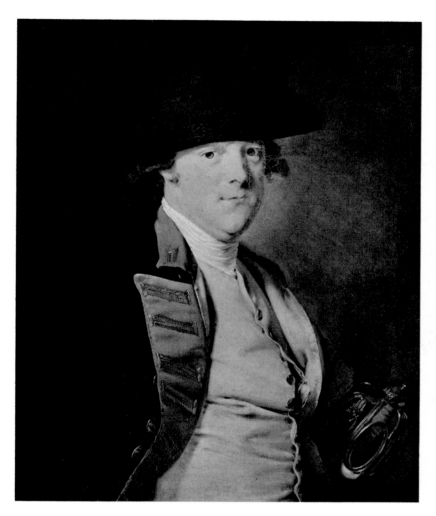

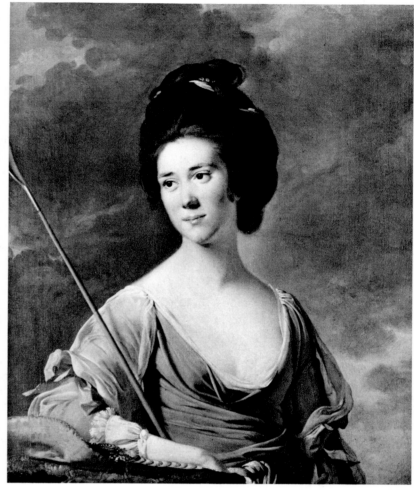

Plate 83 *Captain Henry Bathurst* c 1770–71
30 x 25 in / 76.2 x 63.5 cm
Lady Hervey-Bathurst Cat 14

Plate 84 *Mrs Henry Bathurst* c 1770–71
30 x 25 in / 76.2 x 63.5 cm
Lady Hervey-Bathurst Cat 15

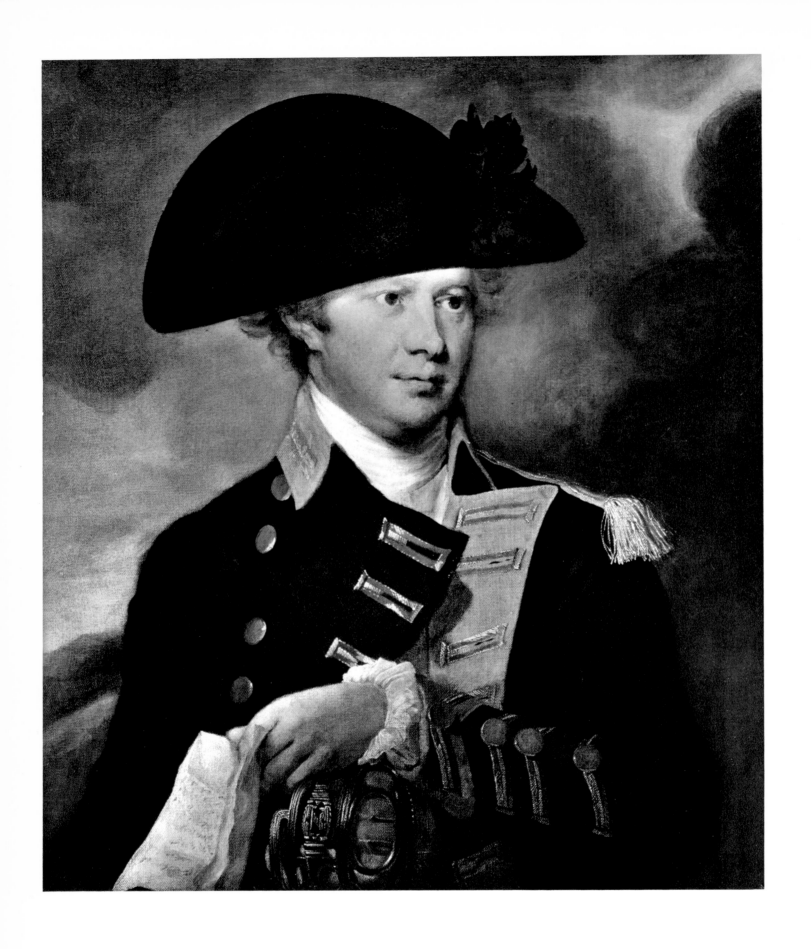

Plate 85 *Captain Richard French* c 1771–72
30 x 25 in / 76.2 x 63.5 cm
L. B. Sanderson Cat 64

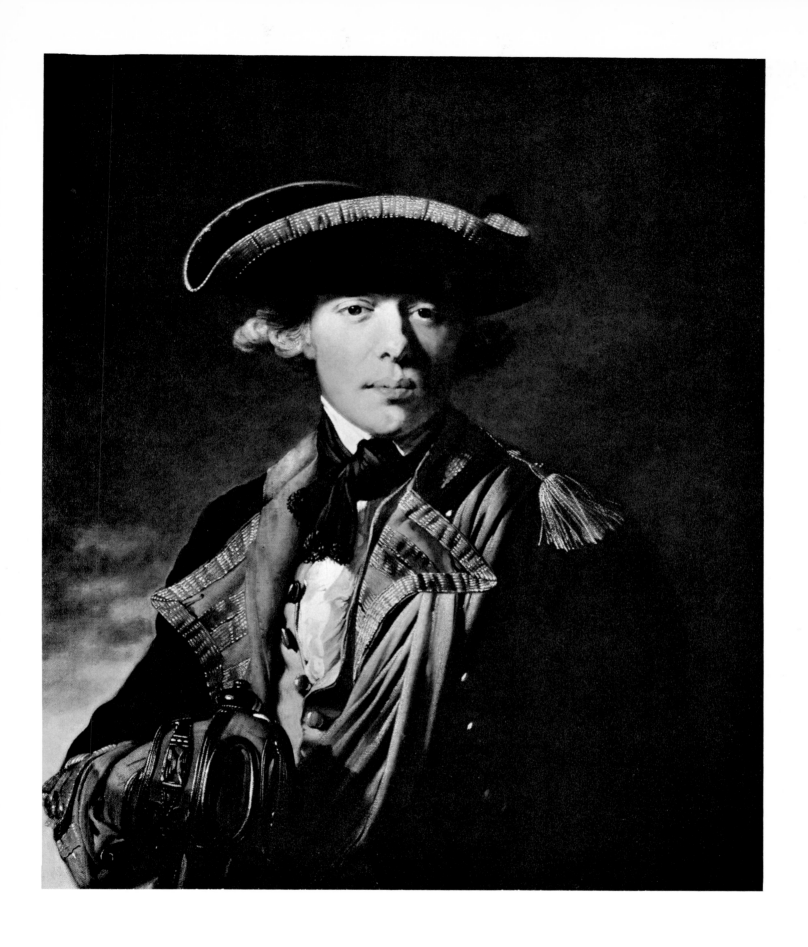

Plate 86 *Sir George Cooke, Bart* c 1770–71
30 x 25 in / 76.2 x 63.5 cm
Nelson Gallery–Atkins Museum (Nelson Fund),
Kansas City Cat 44

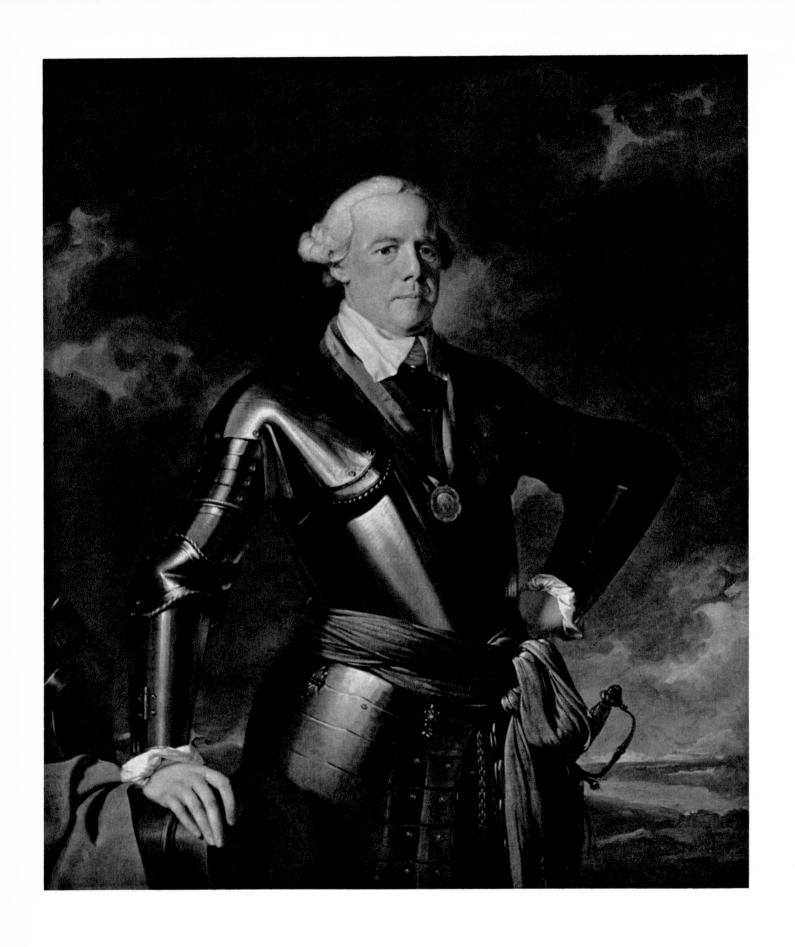

Plate 87 *Colonel Edward Sacheverell Pole* 1772
36 x 30 in / 91.4 x 76.2 cm
Major J. W. Chandos-Pole Cat 122

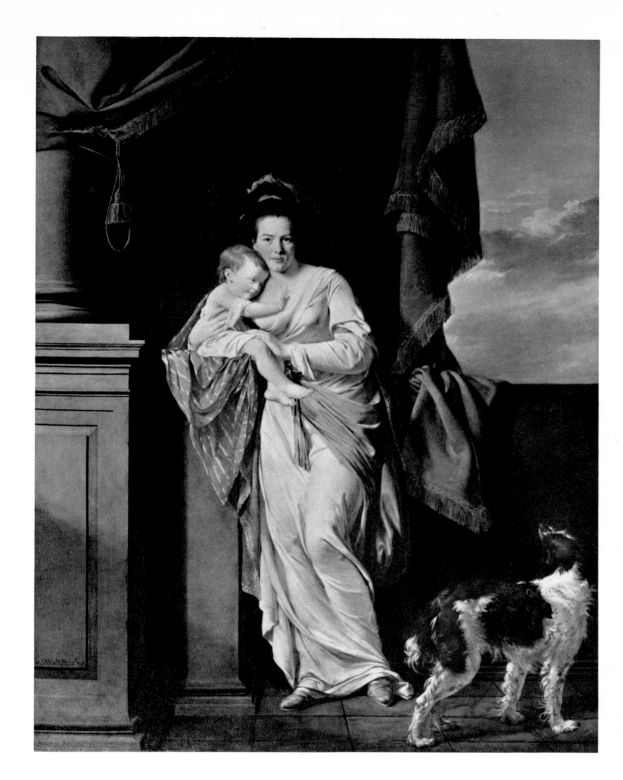

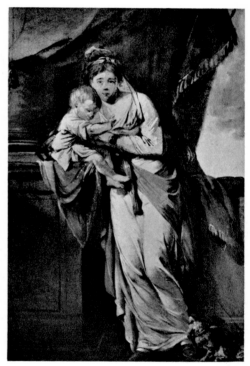

Plate 88 *Elizabeth, wife of Edward Sacheverell Pole, and her son
Sacheverell* 1771
91¾ x 68¼ in / 233 x 173.3 cm
Major J. W. Chandos-Pole Cat 123

Plate 89 *Study for portrait of Mrs
Sacheverell Pole and her son* c 1771
Gouache on paper with some brown
wash
18¼ x 11¾ in / 45.3 x 29.8 cm
Derby Museum and Art Gallery

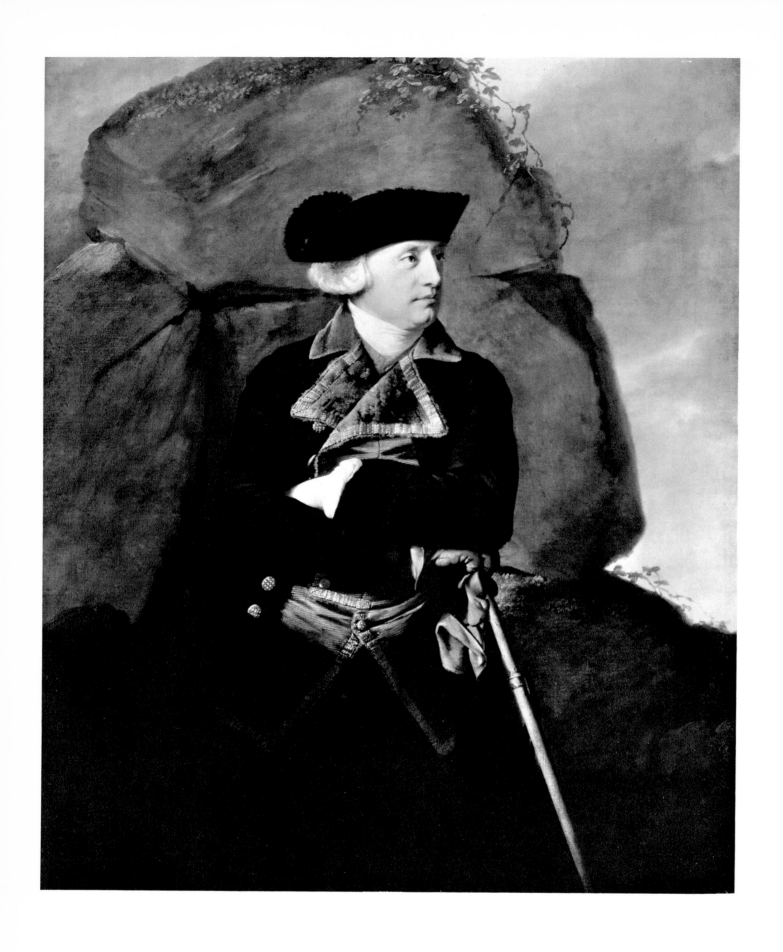

Plate 90 'Richard, Earl Howe' early '70's
50 x 40 in / 127 x 101.6 cm
National Gallery of Art, Washington D.C. Cat 91

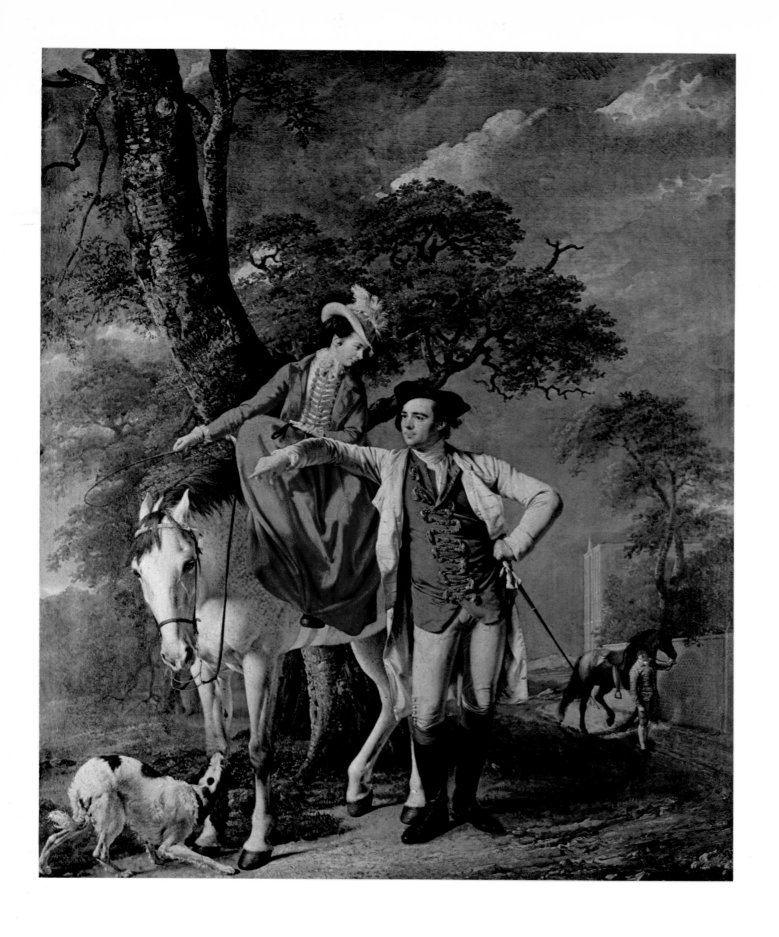

Plate 91 *Mr and Mrs Thomas Coltman* c 1771–72
50 x 40 in / 127 x 101.6 cm
Charles Rogers–Coltman Cat 41

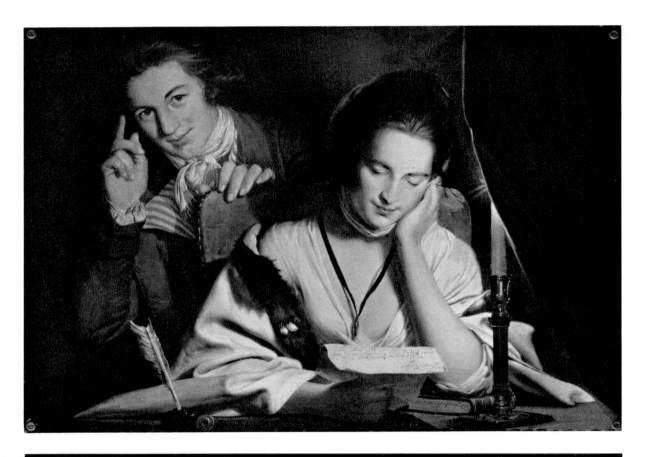

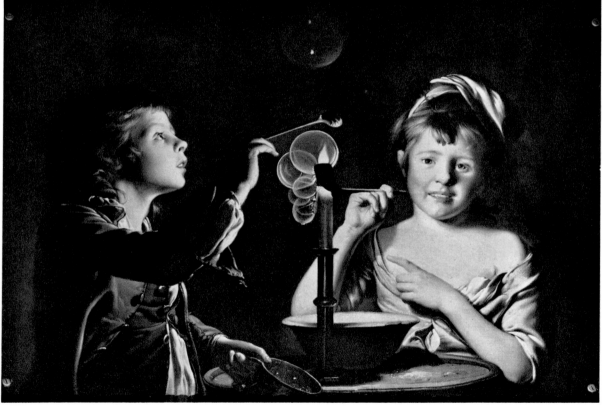

Plate 92 *Girl reading a letter* 1772
Major J. W. Chandos-Pole Cat 201

Plate 93 *Boy and Girl blowing bubbles* 1772
Major J. W. Chandos-Pole Cat 202

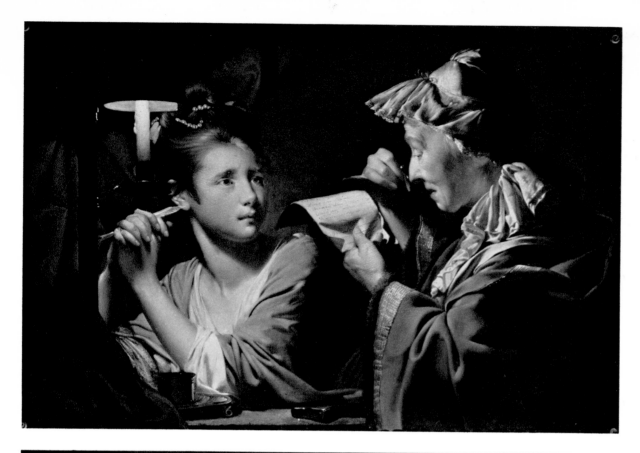

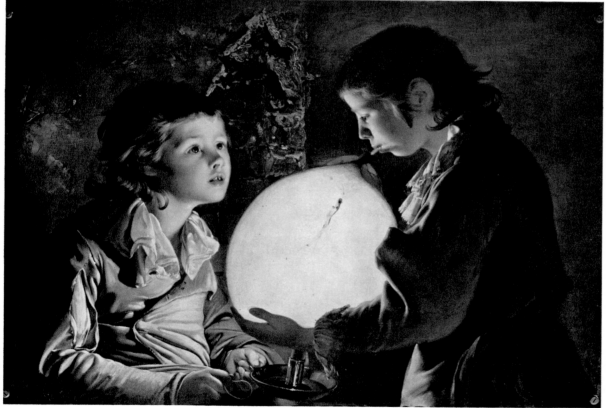

Plate 94 *Old Woman reading a letter in company of a young girl*
1772
Major J. W. Chandos-Pole Cat 203

Plate 95 *Two Boys blowing on a Bladder* 1772
Major J. W. Chandos-Pole Cat 204

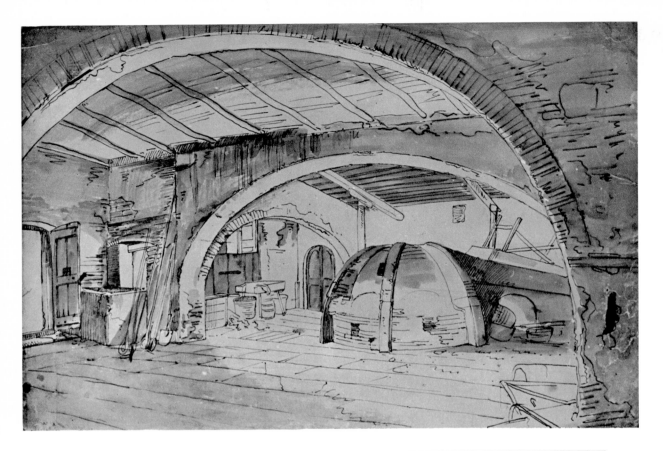

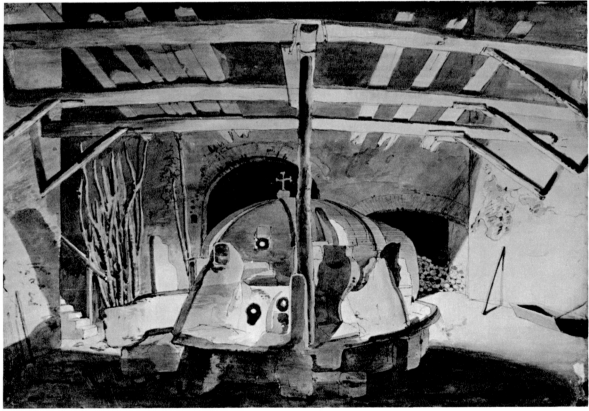

Plate 96 *Glass-blowing Factory* c 1770–72
Brown ink and grey wash, sight size $14\frac{3}{8}$ x $20\frac{7}{8}$ in / 36.5 x 53 cm
Derby Museum and Art Gallery

Plate 97 *Glass-blowing Factory* c 1770–72
Pen and wash $14\frac{1}{4}$ x $20\frac{1}{2}$ in / 36 x 52 cm
Derby Museum and Art Gallery

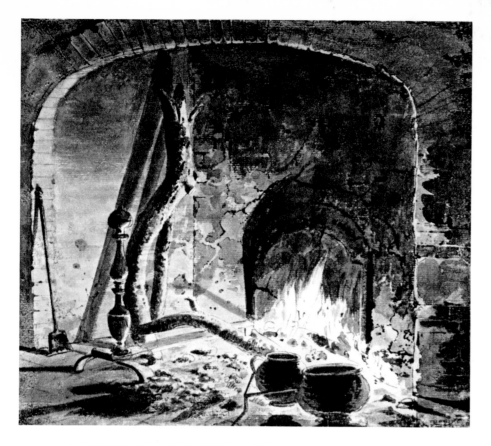

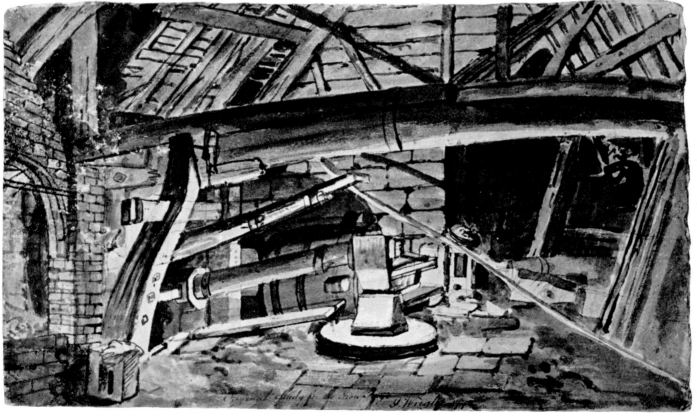

Plate 98 *Study of open hearth with fire ?* c 1770–72
Sepia wash with touches of brown ink
sight size 11 x 12 in / 27.9 x 30.4 cm
Derby Museum and Art Gallery

Plate 99 *Study for an Iron Forge* 1772
Pen and wash heightened with white 12⅝ x 20½ in / 31.1 x 50.5 cm
Derby Museum and Art Gallery

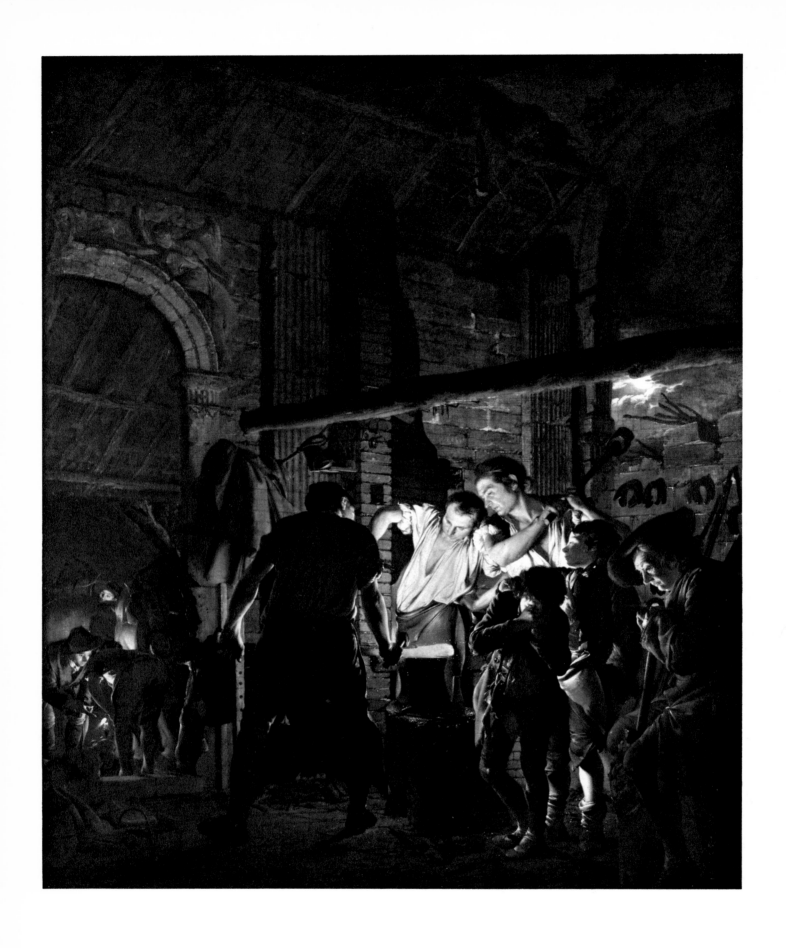

Plate 100 *The Blacksmith's Shop* 1771
$50\frac{1}{2}$ x 41 in / 128.2 x 104.1 cm
Mr and Mrs Paul Mellon Cat 199

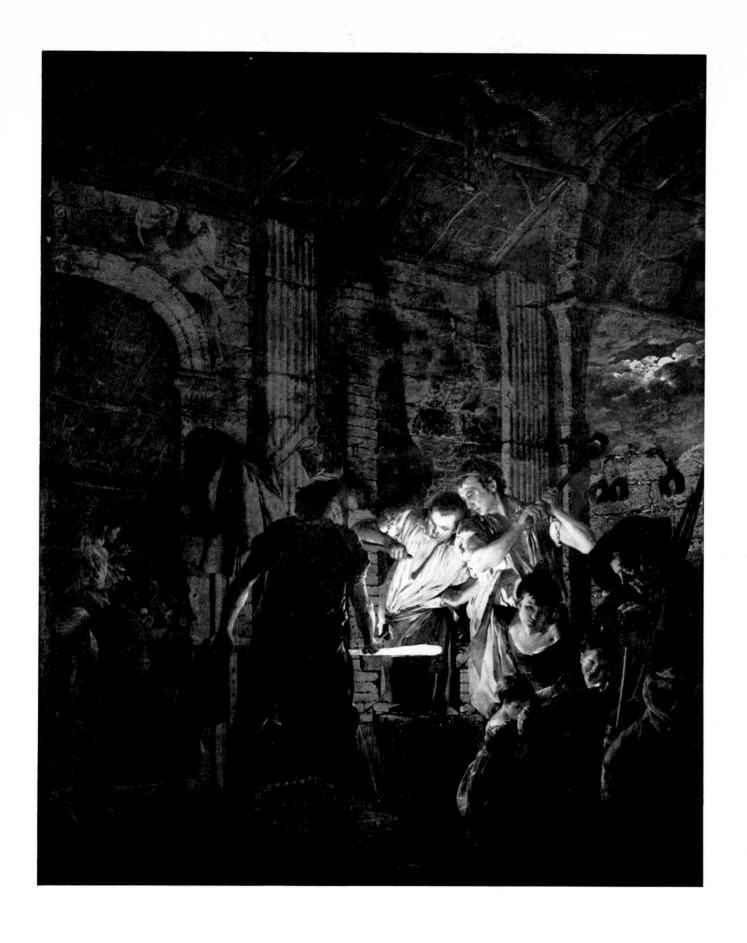

Plate 101 *The Blacksmith's Shop* 1771
49½ x 39 in / 125.7 x 99 cm
Private Collection U.K. Cat 200

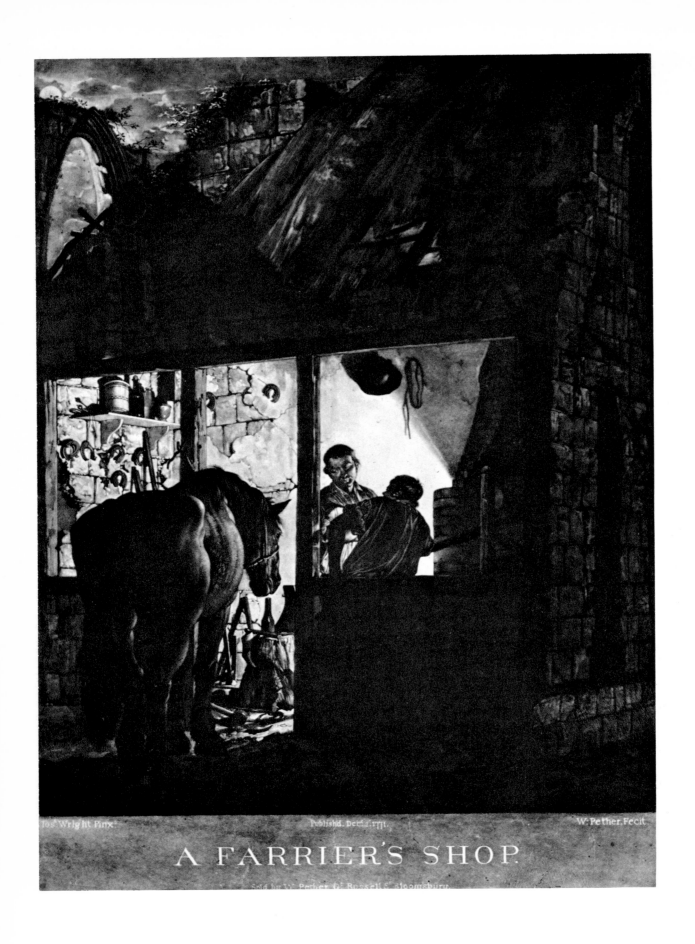

Plate 102 Engraving by W. Pether after Wright
A Farrier's Shop 1771

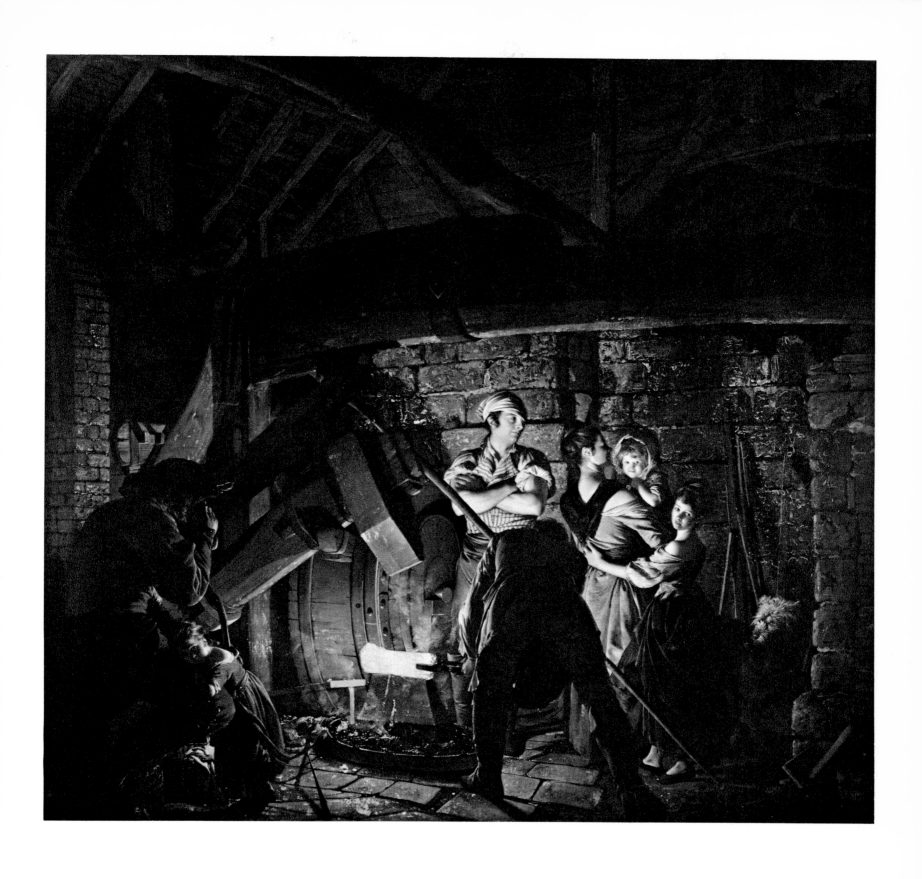

Plate 103 *An Iron Forge* 1772
48 x 52 in / 121.9 x 132.1 cm
Admiral of the Fleet The Earl Mountbatten of Burma Cat 197

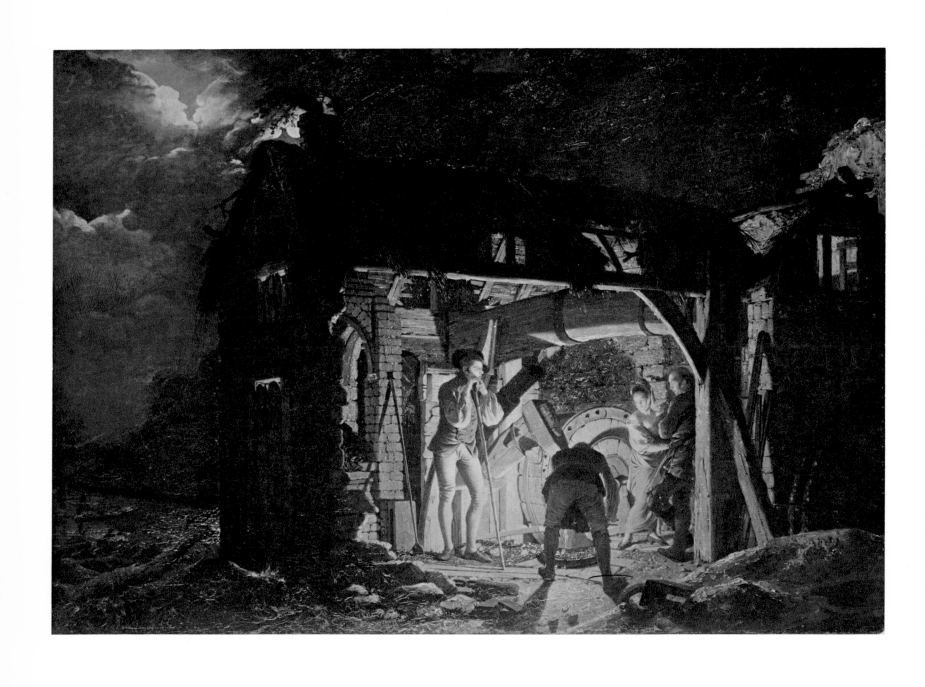

Plate 104 *An Iron Forge viewed from without* 1773
41 x 55 in / 104.1 x 139.7 cm
Hermitage Museum, Leningrad Cat 198

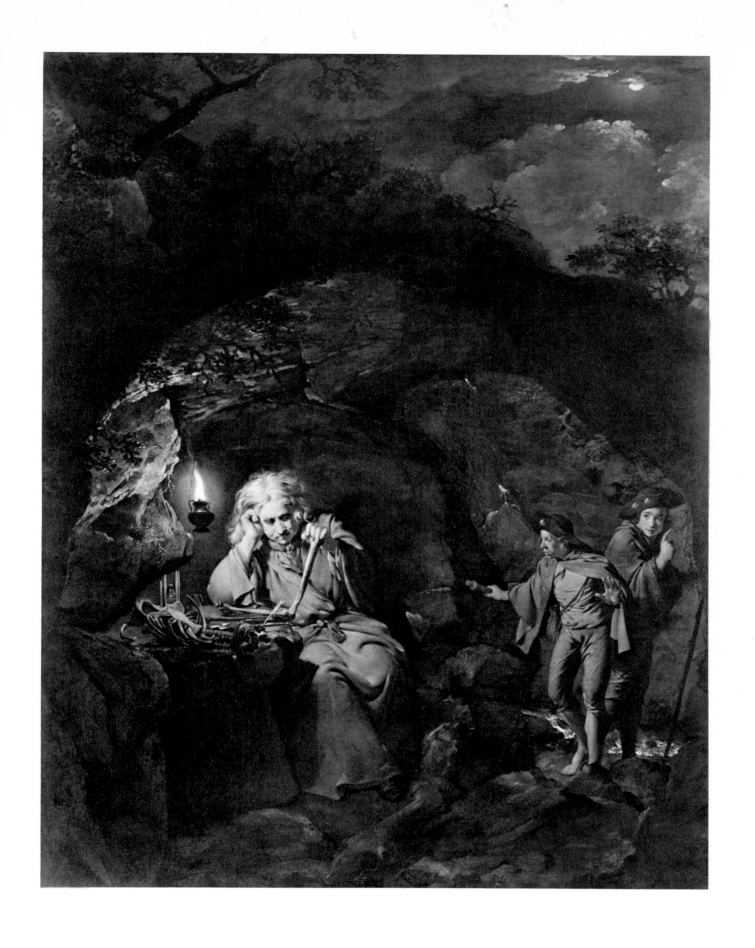

Plate 105 *Hermit studying Anatomy* c 1771–73
50½ x 40½ in / 128.2 x 102.9 cm
Derby Museum and Art Gallery Cat 196

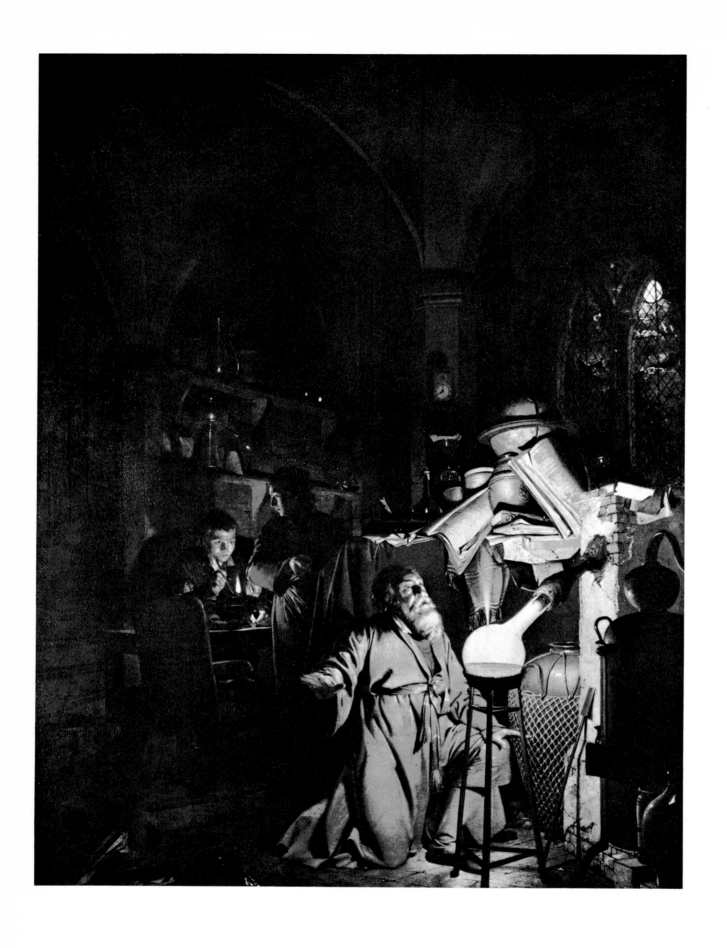

Plate 106 *The Alchemist in search of the Philosopher's Stone
discovers Phosphorus* 1771/1795
50 x 40 in / 127 x 101.6 cm
Derby Museum and Art Gallery Cat 195

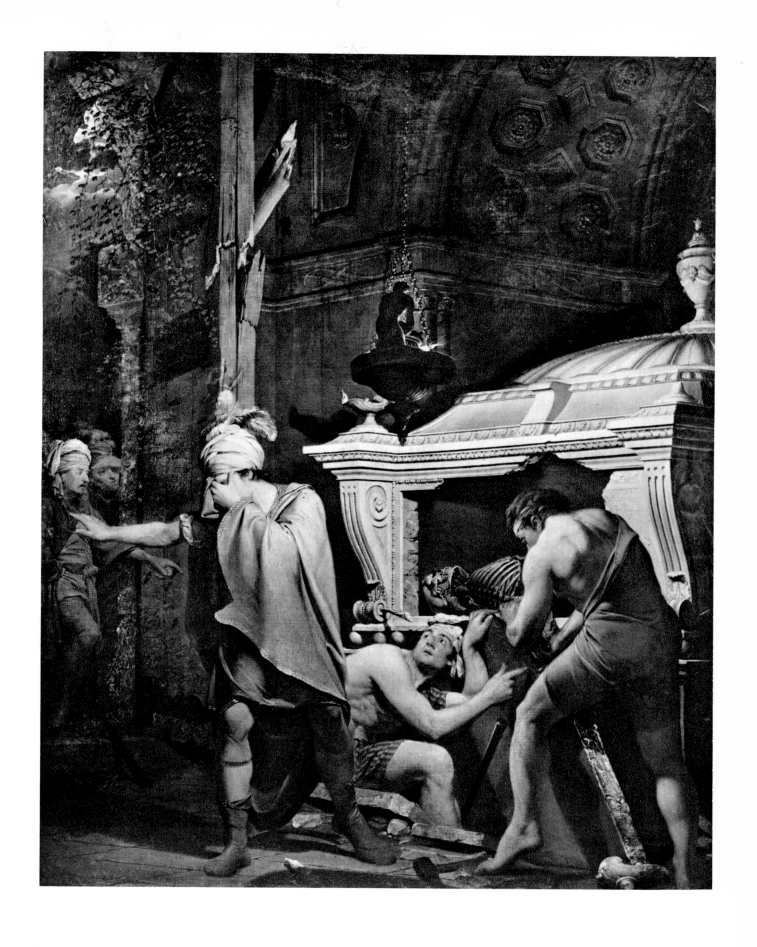

Plate 107 *Miravan opening the Tomb of his Ancestors* 1772
50 x 40 in / 127 x 101.6 cm
Derby Museum and Art Gallery Cat 222

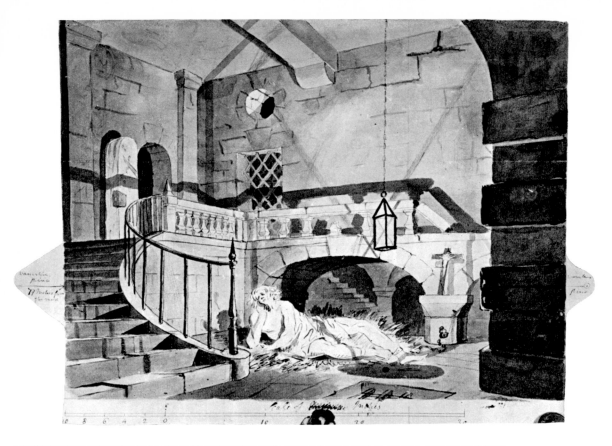

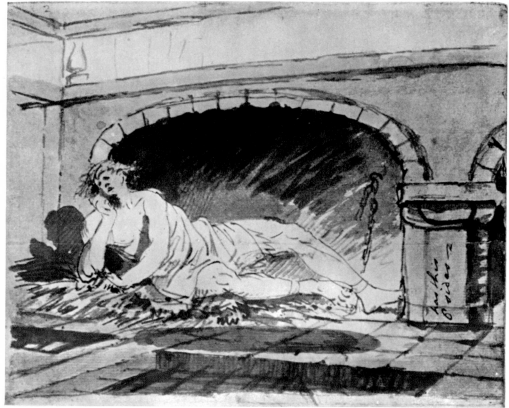

Plate 108 Study for the *Captive King* c 1772–73
Pen and wash 13¼ x 15⅝ in / 33.6 x 39.6 cm
Derby Museum and Art Gallery

Plate 109 *Study for the Captive King* 1772
Pen and wash
Untraced

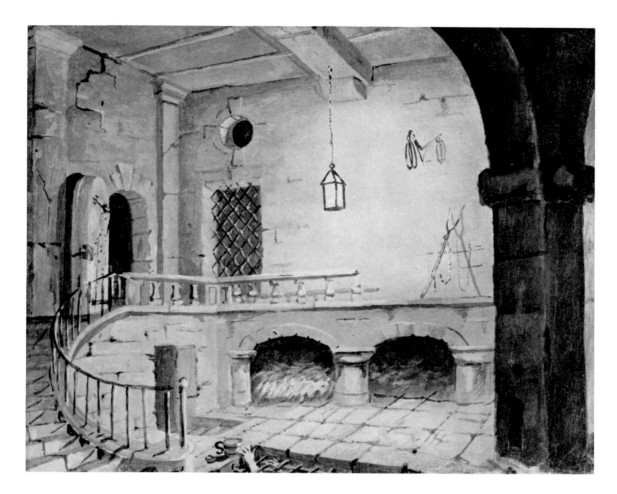

Plate 110 *The Captive King* c 1772
12 x 14¼ in / 30.4 x 36.2 cm
Basil Taylor Cat 215

Plate 111 Sketch for the *Captive King*
from a letter to P. P. Burdett
Pen and ink
Herman W. Liebert

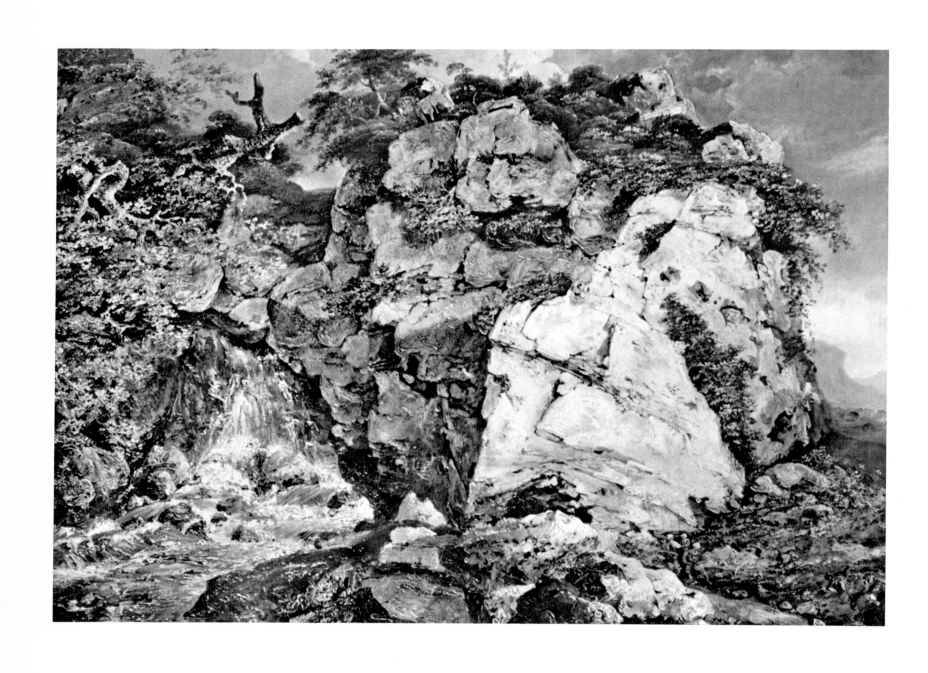

Plate 112 *Rocks with Waterfall* c 1771–72
Size unknown
Major J. W. Chandos–Pole Cat 328

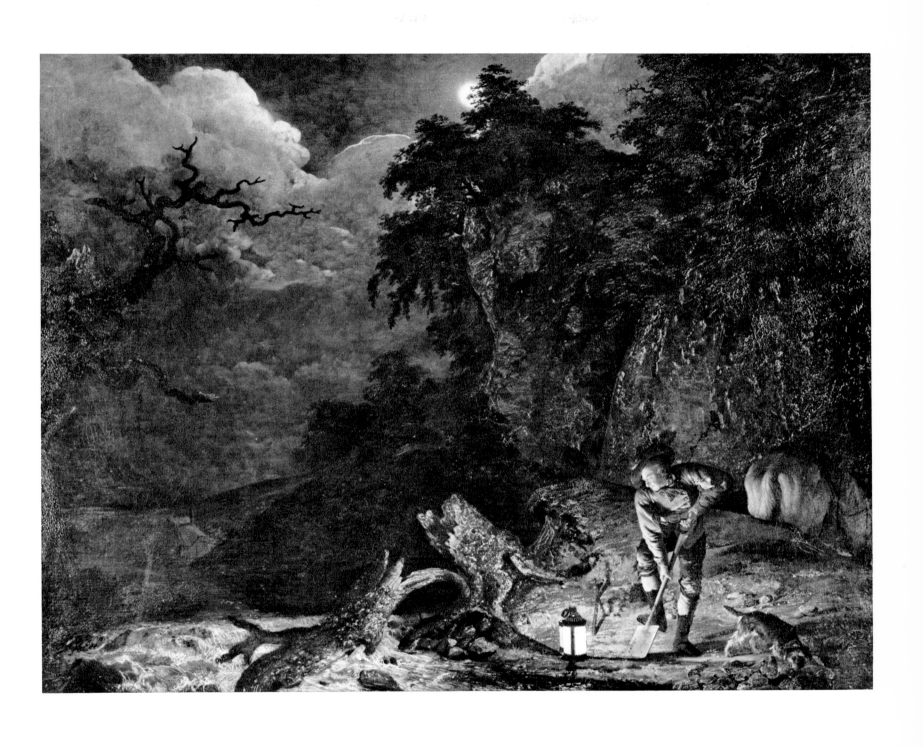

Plate 113 *The Earthstopper on the Banks of the Derwent* 1773
38 x 47½ in / 96.5 x 120.6 cm
Derby Museum and Art Gallery Cat 242

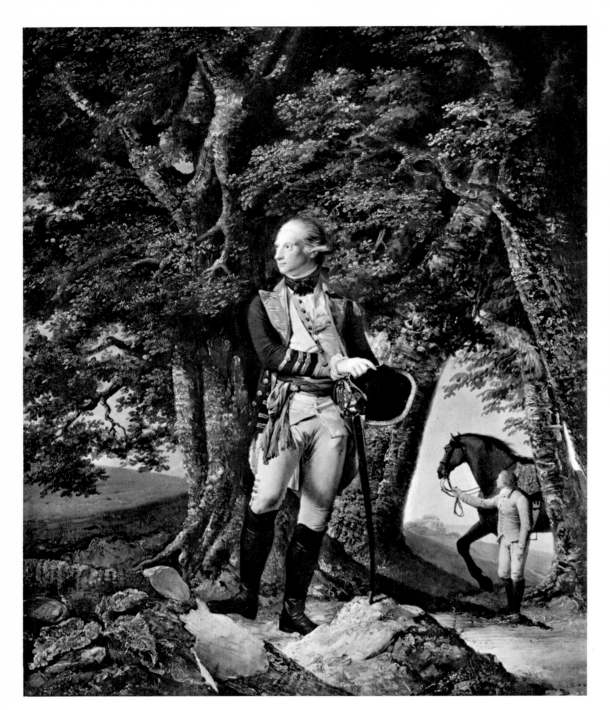

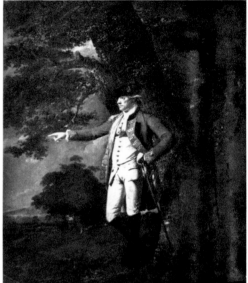

Plate 114 '*Captain*' *Robert Shore Milnes* c 1771–72
50 x 40 in / 127 x 101.6 cm
Mrs Lawrence Copley Thaw Cat 107

Plate 115 *Colonel Charles Heathcote*
c 1771–72
50 x 40 in / 127 x 101.6 cm
Untraced Cat 79

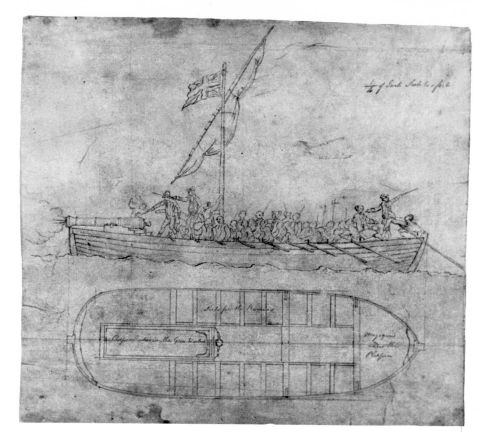

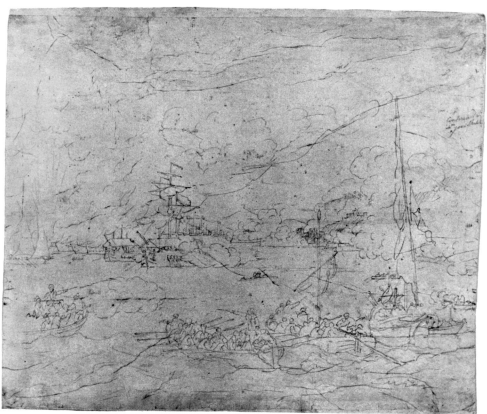

Plate 116 *British Gun-boat in action, with plan of the boat*
? early '70's
Pencil, $12\frac{1}{4}$ x $13\frac{1}{8}$ in / 31.1 x 33.3 cm
Derby Museum and Art Gallery

Plate 117 *Sea Battle* ? early '70's
Pencil, $11\frac{1}{2}$ x $13\frac{1}{8}$ in / 29.2 x 33.3 cm
Derby Museum and Art Gallery

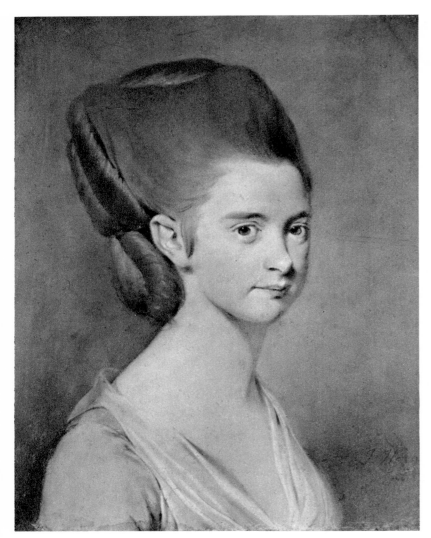

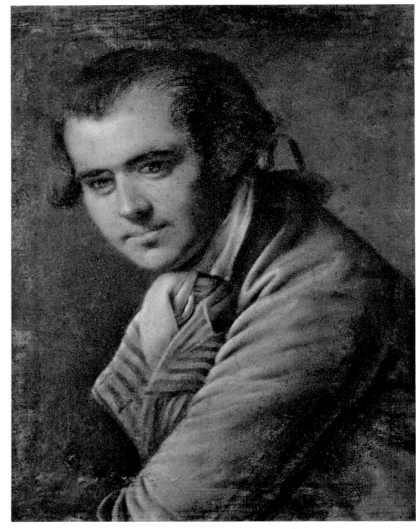

Plate 118 *Mrs Coltman* c 1772–73
Charcoal with white heightening on canvas
21⅜ x 17½ in / 54.3 x 43.8 cm
Charles Rogers–Coltman Cat 43

Plate 119 *Thomas Coltman* c 1772–73
Charcoal with white heightening on canvas
21⅜ x 17½ in / 54.3 x 43.8 cm
Charles Rogers–Coltman Cat 42

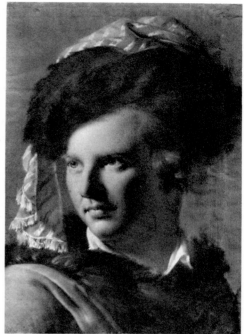

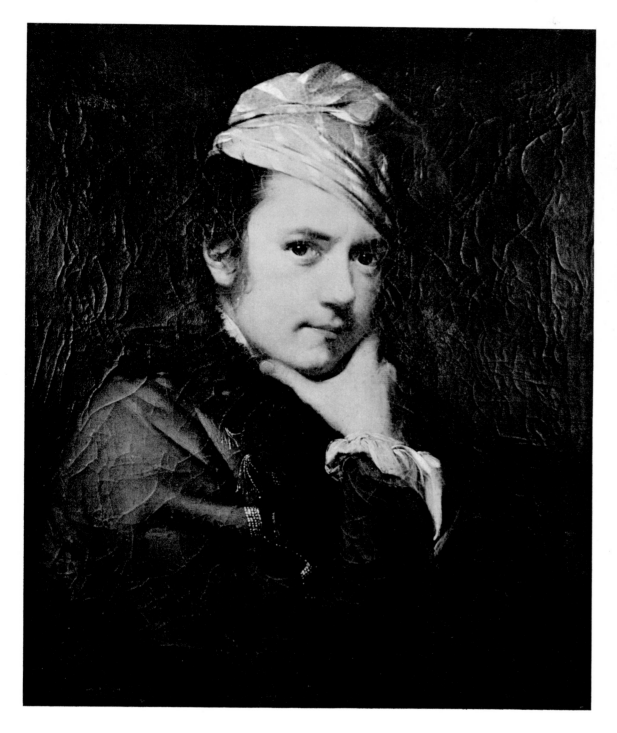

Plate 120 *Self-portrait* c 1773
c 28 x 24 in / 71.1 x 60.9 cm
Mrs Beryl E. Cade Cat 169

Plate 121 *Young Man in fur cap*
c 1772–73
Chalk c 16 x 12 in / 40.6 x 30.5 cm
J. B. Speed Art Museum, Louisville
Cat 155

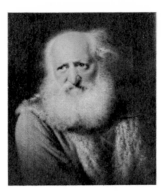

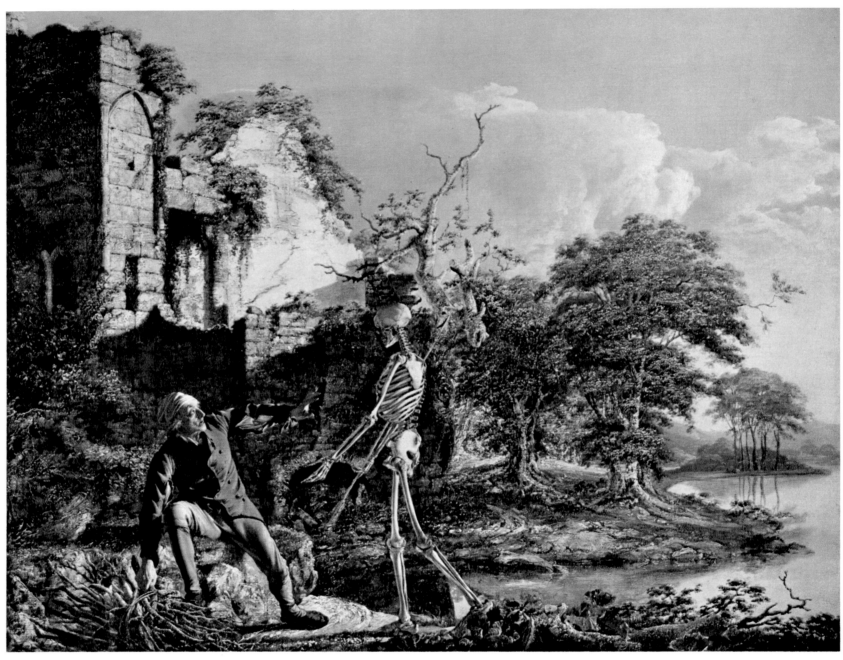

Plate 122 *Head of Old Man* c 1770–73
10⅜ x 8⅝ in / 26.3 x 21.9 cm
Sir Gilbert Inglefield Cat 187

Plate 123 *The Old Man and Death* 1773
40 x 50 in / 101.7 x 127 cm
Wadsworth Atheneum, Hartford, Conn Cat 220

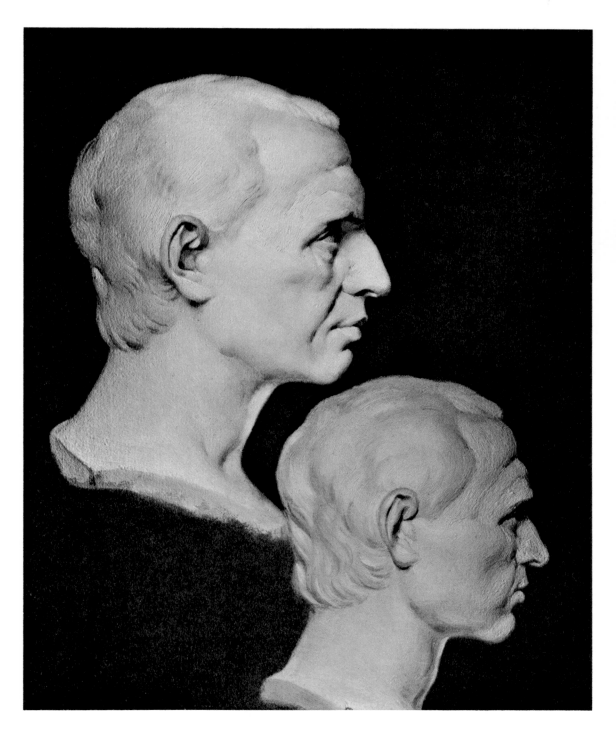

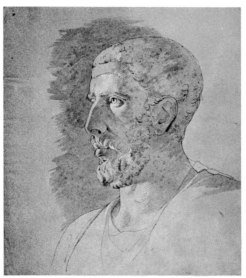

Plate 124 *Study of an antique bust, in two positions* c 1774–75
Oil on paper on canvas 20 x 16½ in / 50.8 x 41.9 cm
Charles E. Buckley Cat 180

Plate 125 *Study after a Roman portrait bust* c 1774–75
Brown ink and wash on light blue paper
14 x 11¾ in / 35.5 x 29.8 cm
Derby Museum and Art Gallery

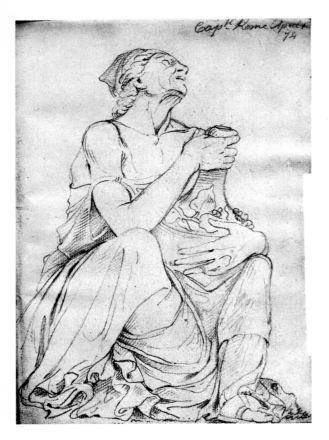

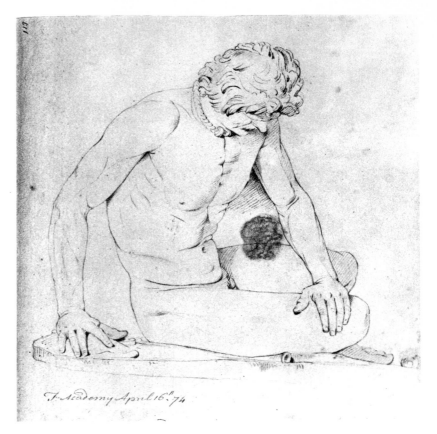

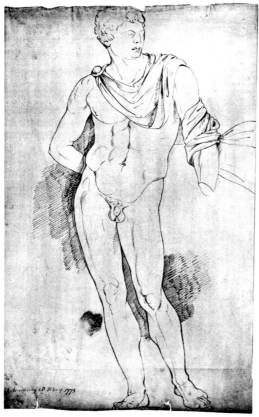

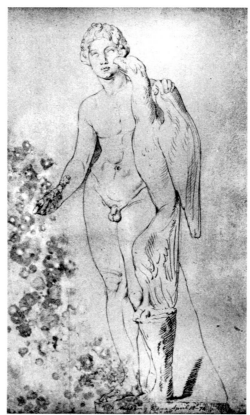

Plate 126 Drawing after *The Drunken Old Woman*
From Wright's sketchbook 1774
British Museum

Plate 128 Drawing after the *Huntsman and Dog* 1775
Pen on light green paper
22⅜ x 13⅜ in / 56.8 x 33.9 cm
Derby Museum and Art Gallery

Plate 127 Drawing after *The Dying Gaul* 1774
Pencil 13¼ x 12⅝ in / 33.6 x 32 cm
Derby Museum and Art Gallery

Plate 129 Drawing after *Ganymede with
the Eagle* 1774
Pencil 21 x 11¾ in / 53.3 x 29.8 cm
Derby Museum and Art Gallery

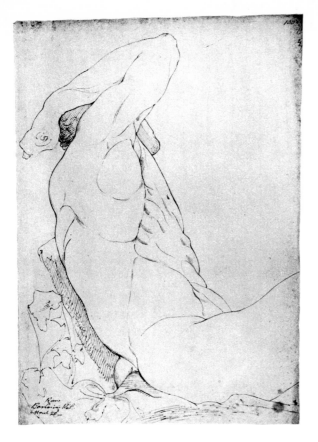

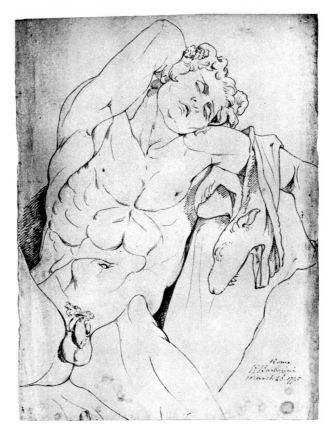

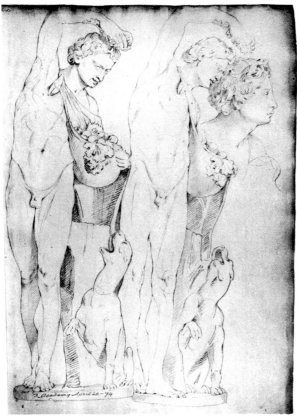

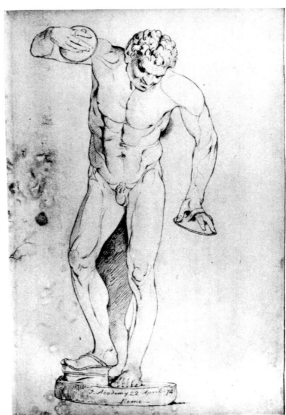

Plate 130 Drawing after the *Barberini Fawn* 1775
Pen 20½ x 13⅞ in / 52 x 35.2 cm
Derby Museum and Art Gallery

Plate 132 Drawing after the *Panther* and
Ganymede 1774
Pencil 21½ x 14½ in / 54.6 x 36.8 cm
Derby Museum and Art Gallery

Plate 131 Drawing after the *Barberini Fawn* 1775
Pen 20 x 14¼ in / 50.8 x 36.1 cm
Derby Museum and Art Gallery

Plate 133 Drawing after *Satyr* 1774
Pencil 20⅝ x 12¾ in / 52.4 x 32.4 cm
Derby Museum and Art Gallery

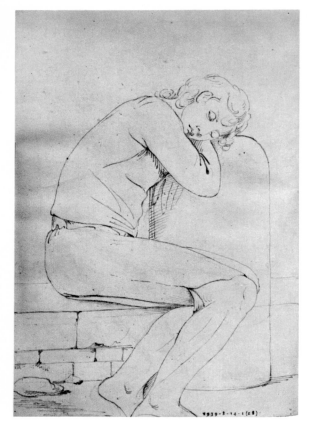

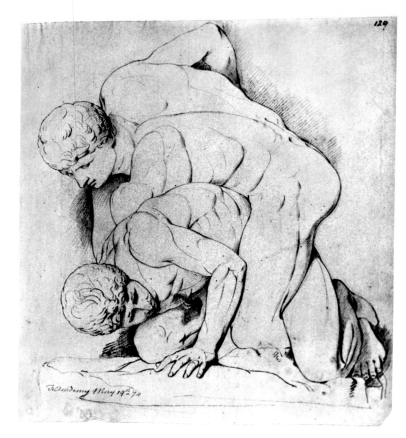

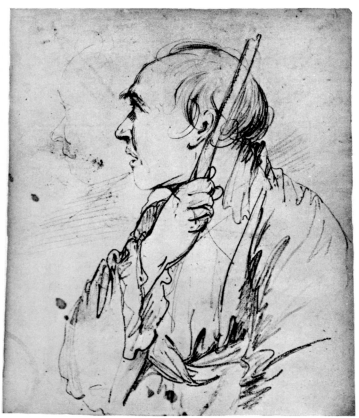

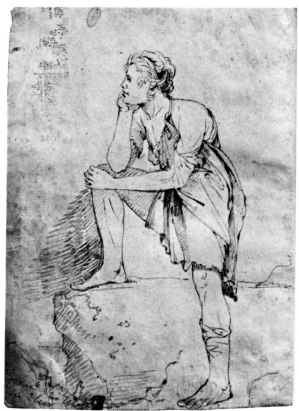

Plate 134 *Boy asleep*
From Wright's sketchbook 1774
British Museum

Plate 135 Drawing after *The Wrestlers* 1774
Pencil 15½ x 14 in / 39.3 x 35.5 cm
Derby Museum and Art Gallery

Plate 136 *Man in profile* sketched twice c 1774
Pencil 9 x 7⅜ in / 22.8 x 18.7 cm
Derby Museum and Art Gallery

Plate 137 *Boy with leg up*
From Wright's sketchbook 1774
British Museum

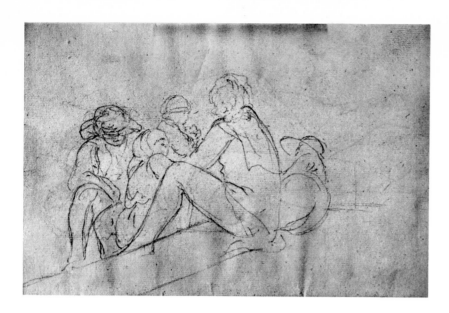

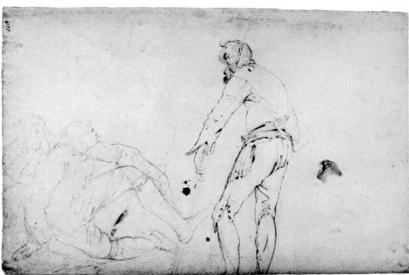

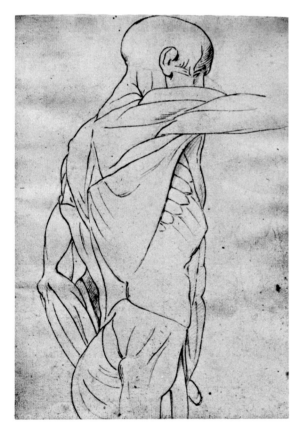

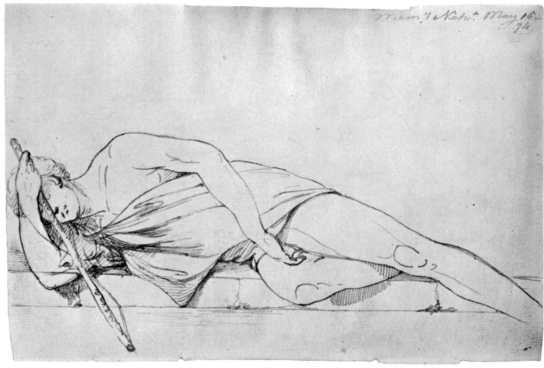

Plate 138 *Boys reclining* 1774
Pencil and brown ink
14¼ x 21⅛ in / 36.2 x 53.6 cm
Derby Museum and Art Gallery

Plate 140 Drawing after *Ecorché* figure
From Wright's sketchbook 1774
British Museum

Plate 139 *Boys reclining*
From Wright's sketchbook 1774
British Museum

Plate 141 *Youth asleep with stick*
From Wright's sketchbook 1774
British Museum

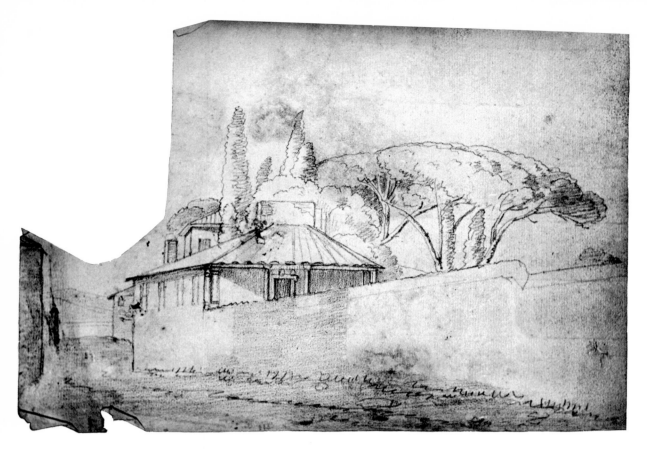

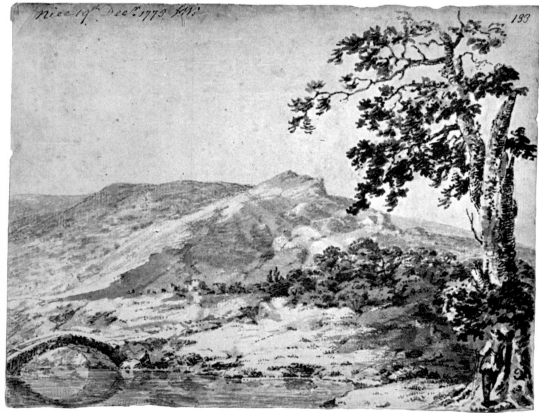

Plate 142 *Villa behind wall* c 1774
Pencil 7 x 7¾ (10¼) / 17.7 x 19.6 (26) cm
Derby Museum and Art Gallery

Plate 143 *Nice landscape* 1773
Grey wash 9¾ x 12¼ in / 24.7 x 31.1 cm
Derby Museum and Art Gallery

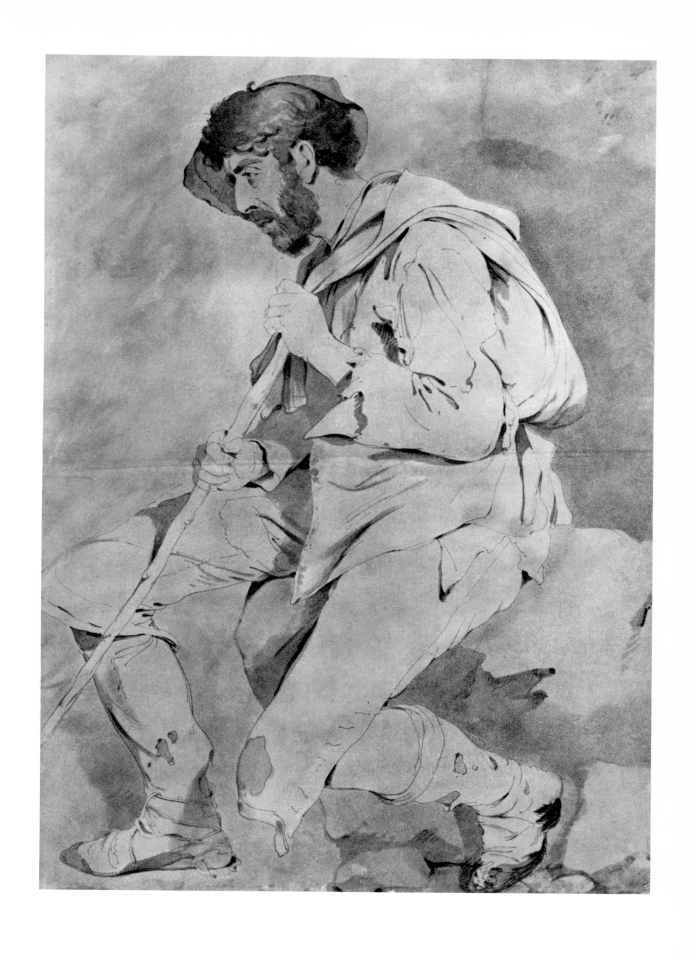

Plate 144 Study of a *Man seated* c 1774
Pen and sepia wash 27 x 19 in / 68.6 x 48.3 cm
Derby Museum and Art Gallery

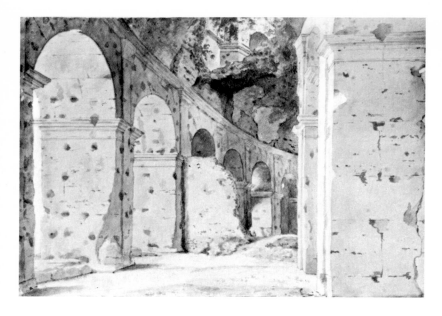

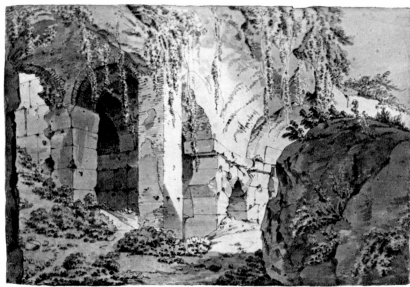

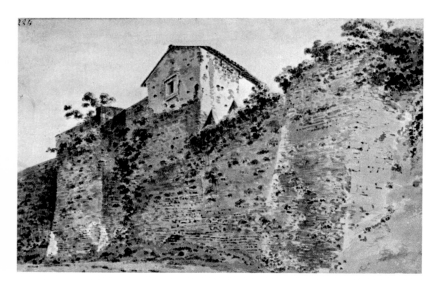

Plate 145 *Part of the Colosseum* c 1774–75
Grey wash 15 x 21½ in / 38.1 x 54.6 cm
Henry E. Huntington Library and Art Gallery

Plate 147 *House built on top of wall* c 1774–75
Watercolour 10⅝ x 16⅜ in / 26.9 x 41.6 cm
Derby Museum and Art Gallery

Plate 146 *Part of the Colosseum* c 1774–75
Brown ink and wash
15 x 21⅜ in / 38.1 x 54.3 cm
Derby Museum and Art Gallery

Plate 148 *Tree study, Rome* 1774
Pencil on green prepared paper (reverse white)
14¼ x 21⅛ in / 36.2 x 53.6 cm
Derby Museum and Art Gallery

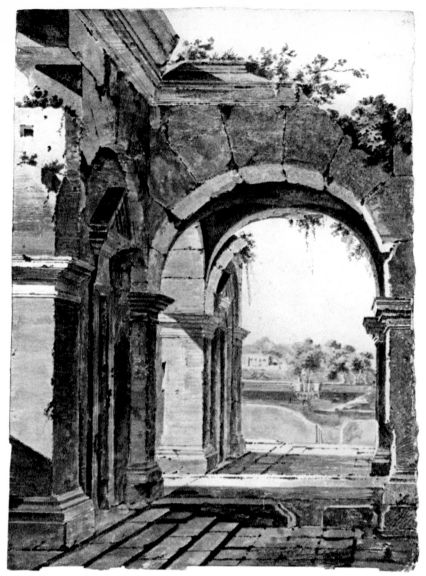

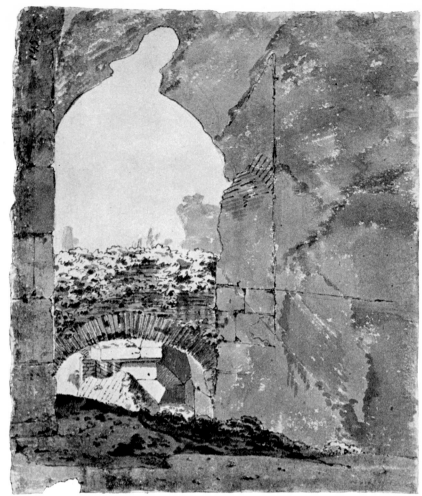

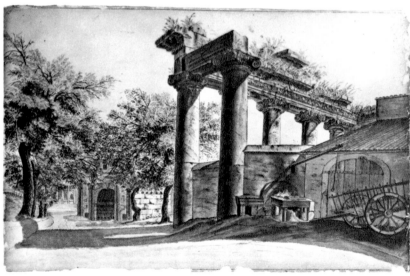

Plate 149 *Roman Ruins* c 1774–75
Grey wash
sight size 18½ x 12½ in / 46.9 x 31.7 cm
Derby Museum and Art Gallery

Plate 151 *Ionic Temple, Rome* c 1774–75
Pencil and sepia wash
18¾ x 12⅝ in / 47.6 x 32 cm
Derby Museum and Art Gallery

Plate 150 *Roman Ruins* c 1774–75
Brown ink and wash
11¼ x 9 in / 28.5 x 22.8 cm
Derby Museum and Art Gallery

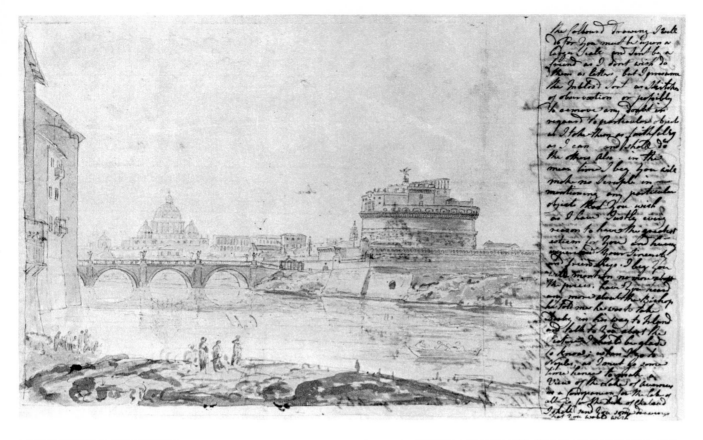

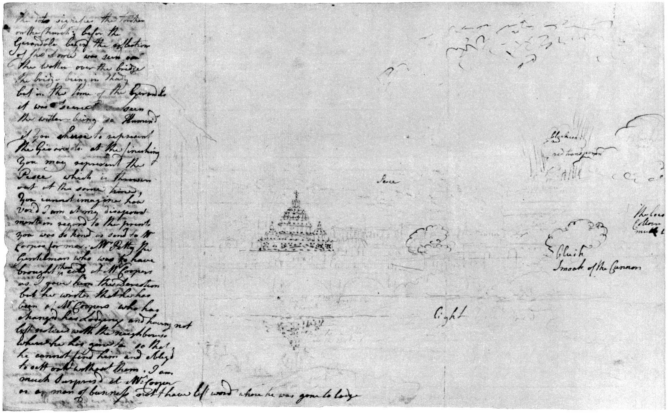

Plate 152 A letter from the Artist, with a view of Castel
Sant'Angelo and St. Peter's
Pen & wash 9 x 12 in / 22.9 x 30.5 cm
Derby Museum and Art Gallery

Plate 153 Reverse of letter in Plate 152
Derby Museum and Art Gallery

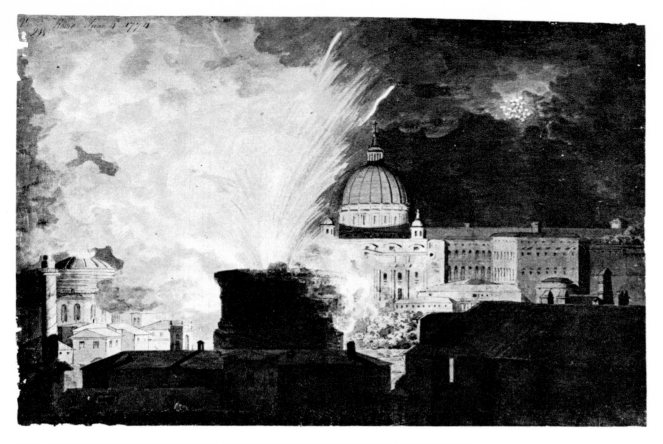

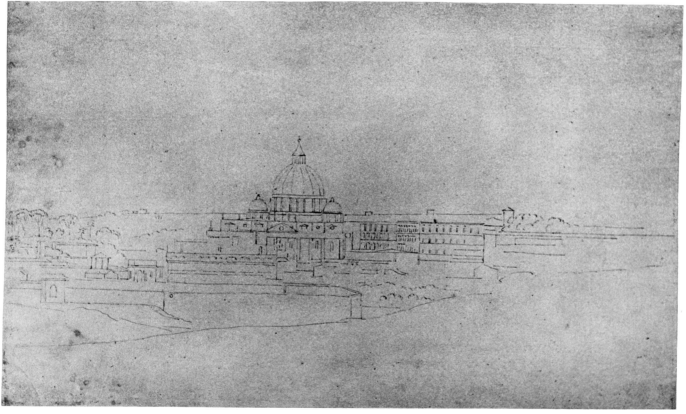

Plate 154 *Girandola from the Castel Sant' Angelo* 1774
Sepia wash with brown ink
Sight size 13¼ x 19¾ in / 33.6 x 50.1 cm
Derby Museum and Art Gallery

Plate 155 Schematic drawing of *St. Peter's* c 1774–75
Brown ink 10⅝ x 17½ in / 29.5 x 44.4 cm
Derby Museum and Art Gallery

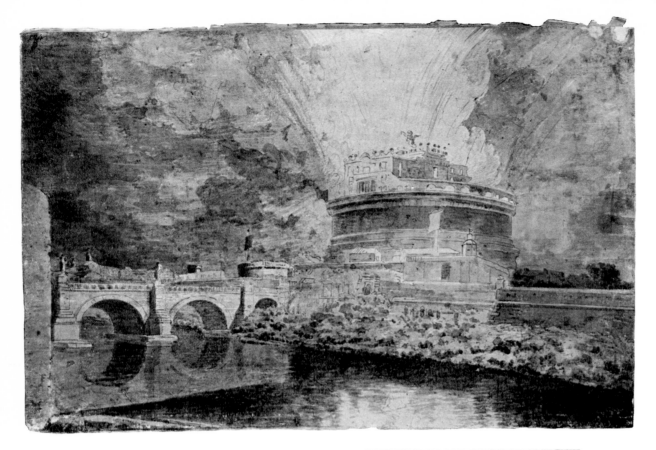

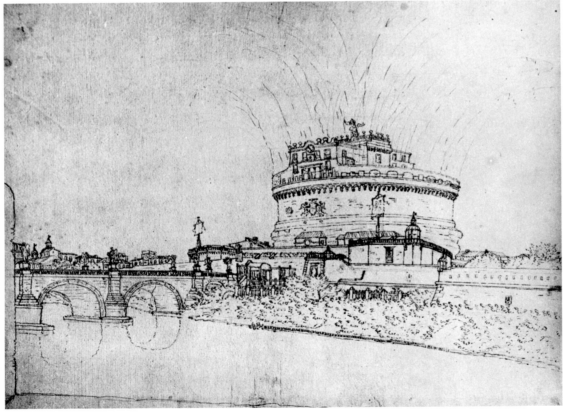

Plate 156 *Girandola from the Castel Sant'Angelo* c 1774–75
Watercolour 19 x 12½ in / 48.2 x 31.7 cm
Derby Museum and Art Gallery

Plate 157 *Girandola from the Castel Sant'Angelo* c 1774–75
Pen 14⅝ x 18⅞ in / 37.1 x 47.9 cm
Derby Museum and Art Gallery

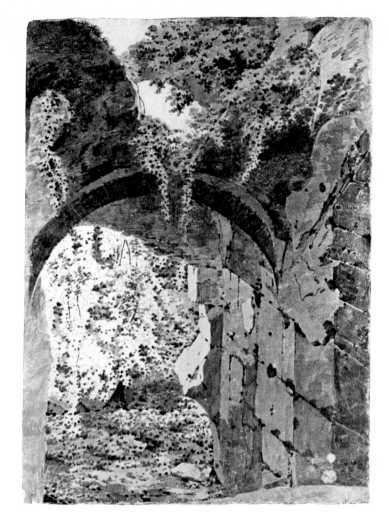

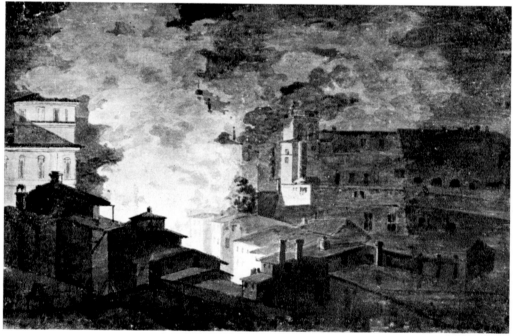

Plate 158 *View through archway, Rome* c 1774–75
Grey wash sight size 20½ x 13⅝ in / 52 x 34.6 cm
Derby Museum and Art Gallery

Plate 159 *Fire in Rome* 1774
Pen and bistre wash on toned yellow paper
sight size 11 x 16½ in / 27.9 x 41.9 cm
Derby Museum and Art Gallery

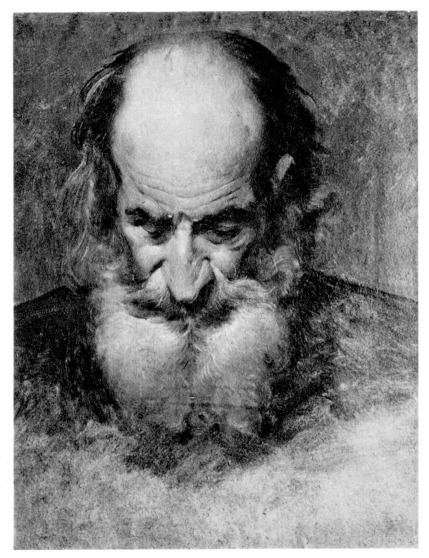

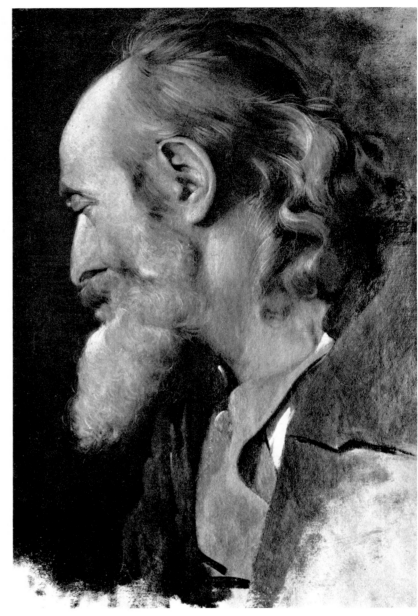

Plate 160 *Old man, full face* c 1774–75
Oil on paper pasted on board
c 19 x 14 in / 48.2 x 35.5 cm
Private Collection U.K. Cat 185

Plate 161 *Old man, profile* c 1774–75
Oil on paper pasted on board
19 x 12 in / 48.2 x 35.5 cm
Private collection U.K. Cat 186

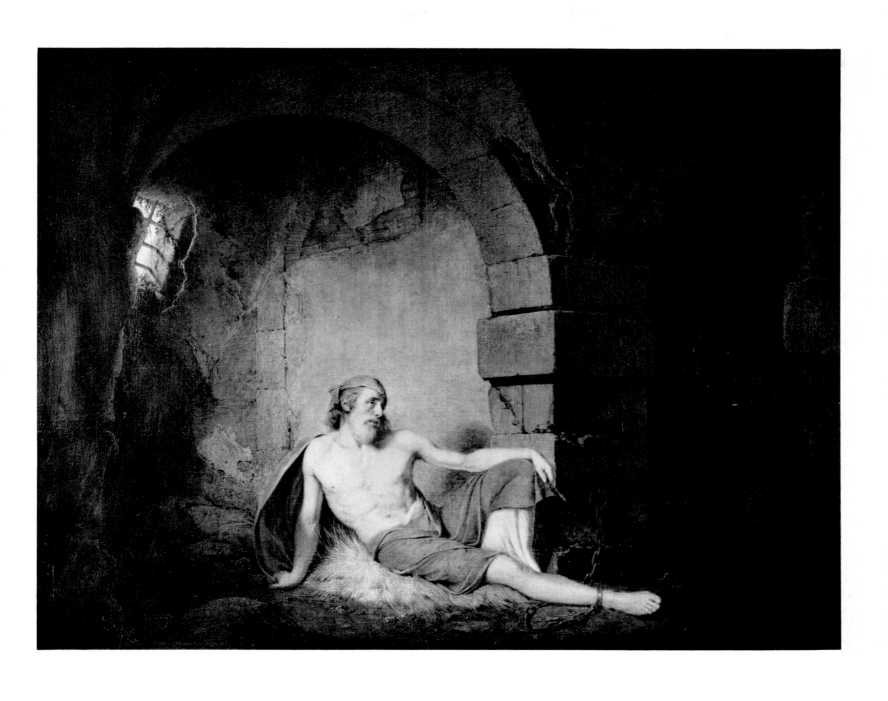

Plate 162 *The Captive, from Sterne* c 1775–77
40 x 50 in / 101.6 x 127 cm
Derby Museum and Art Gallery Cat 217

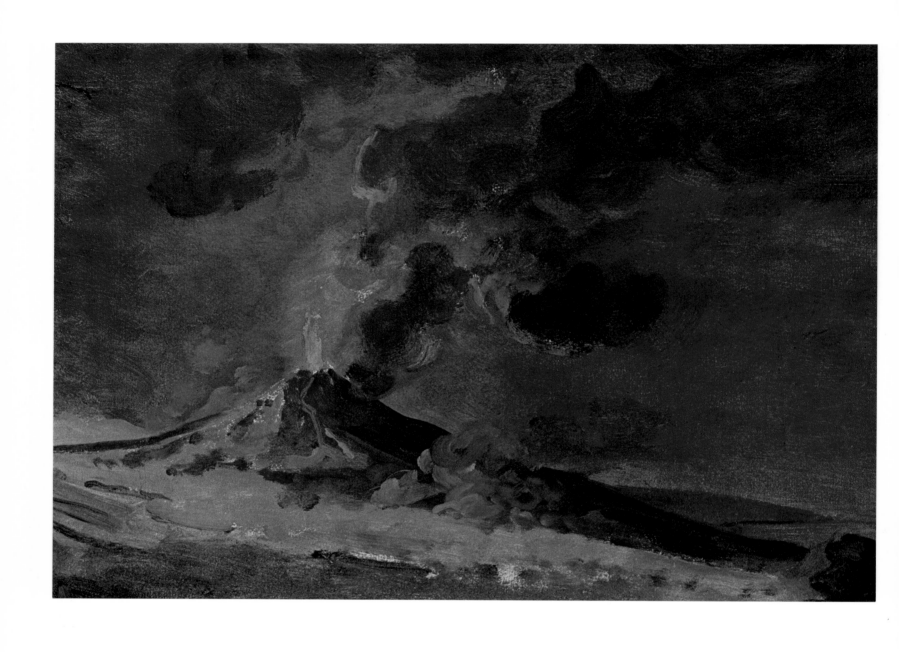

Plate 163 *Eruption of Vesuvius* 1774
Gouache $12\frac{3}{4}$ x $18\frac{3}{8}$ in / 32.4 x 46.7 cm
Derby Museum and Art Gallery

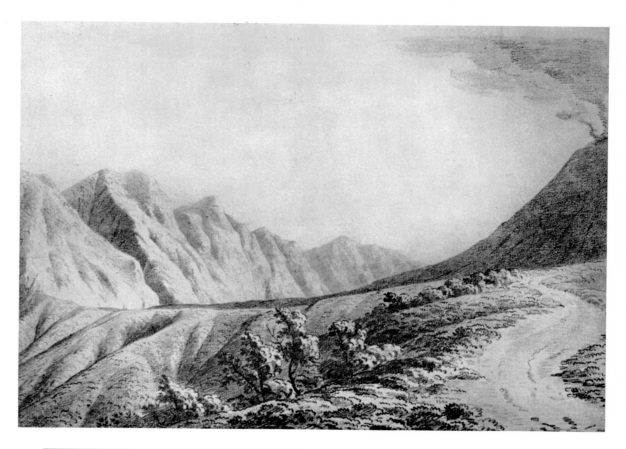

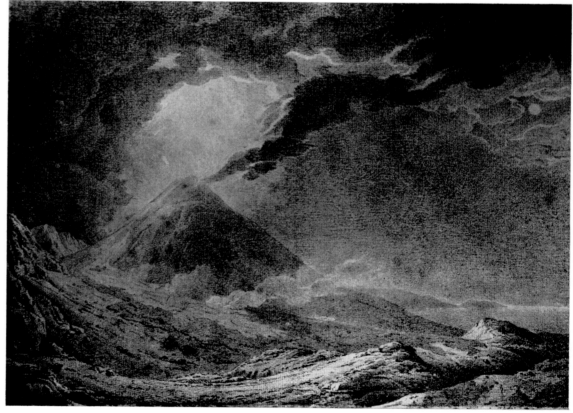

Plate 164 *Vesuvius* 1774
Pencil $12\frac{1}{4}$ x $17\frac{3}{4}$ in / 31.1 x 45 cm
Derby Museum and Art Gallery

Plate 165 *Vesuvius* 1774
Pencil $12\frac{1}{2}$ x $16\frac{1}{2}$ in / 31.1 x 41.9 cm
Sir Gilbert Inglefield

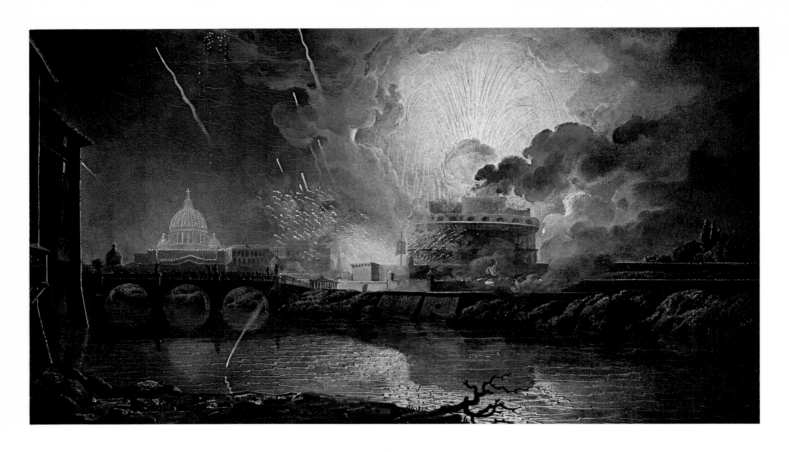

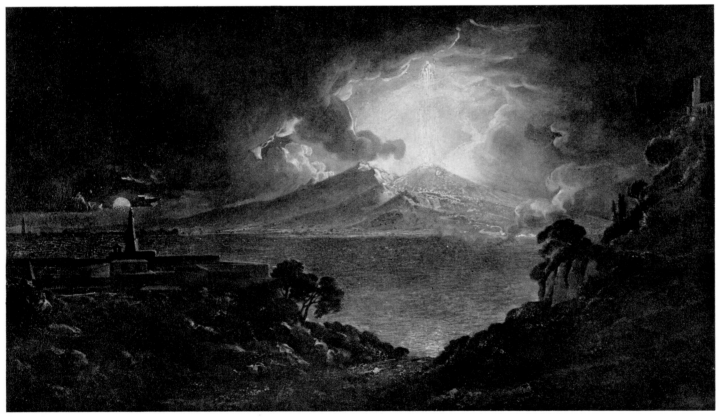

Plate 166 *Firework Display at the Castel Sant' Angelo* c 1774–75
16¾ x 28 in / 42.5 x 71.1 cm
Birmingham Art Gallery Cat 249

Plate 167 *Vesuvius* c 1774–75
16¾ x 28 in / 42.5 x 71.1 cm
L. B. Sanderson Cat 273

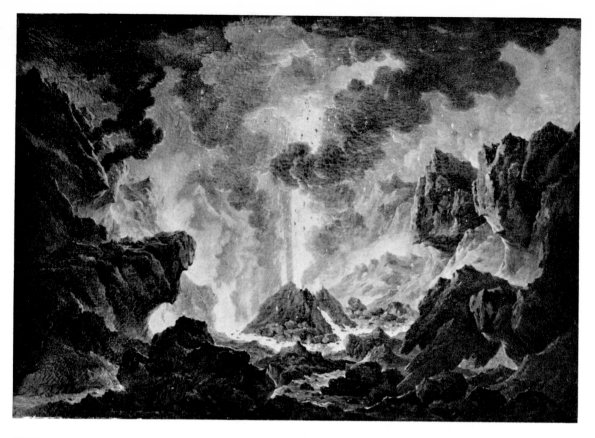

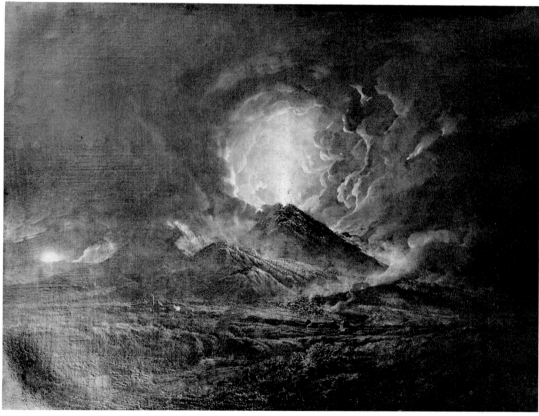

Plate 168 *Vesuvius* c 1774–75
47½ x 67 in / 120.6 x 170.2 cm
Derby Museum and Art Gallery Cat 275

Plate 169 *Vesuvius in Eruption* ? c 1775–77
40 x 50 in / 101.6 x 127 cm
University College of Wales, Aberystwyth Cat 274

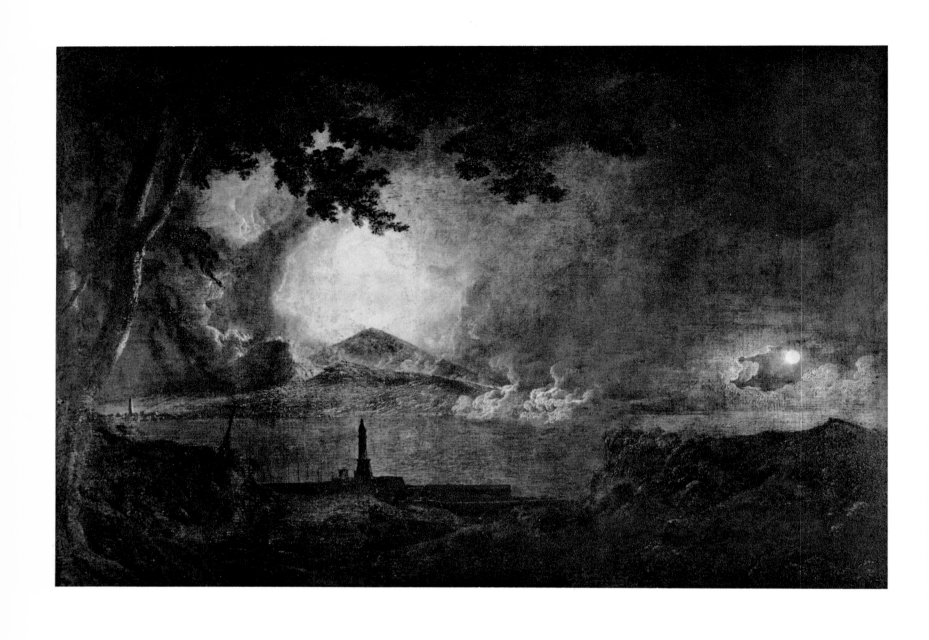

Plate 170 *Vesuvius in Eruption* mid to late '70's
49 x 71 in / 124.4 x 180.3 cm
Miss D. M. R. Cade Cat 266

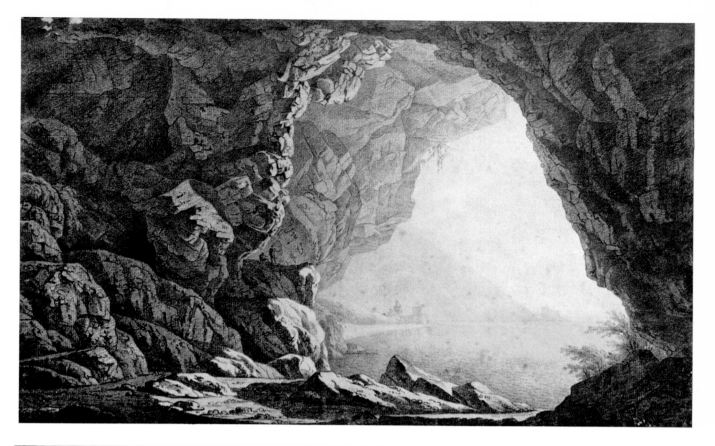

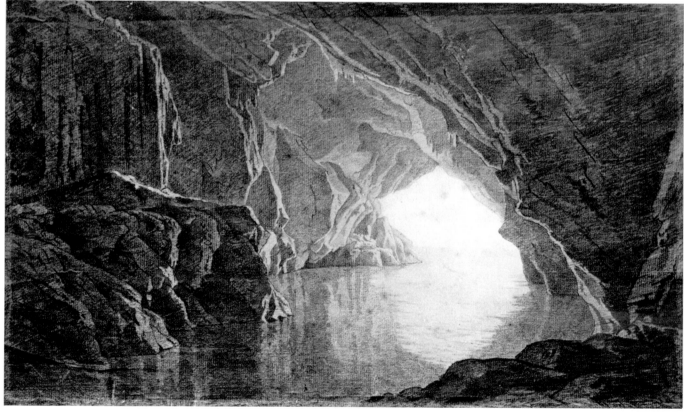

Plate 171 *Grotto in the Gulf of Salerno* 1774
Black chalk 11¼ x 18½ in / 28.5 x 46.9 cm
Private collection U.K. see Cat 279

Plate 172 *Grotto in the Gulf of Salerno* 1774
Black chalk 11¼ x 18½ in / 28.5 x 46.9 cm
Private collection U.K. see Cat 280

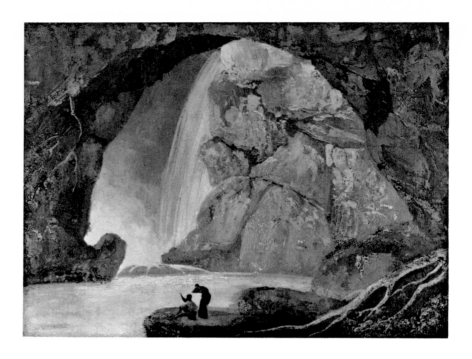

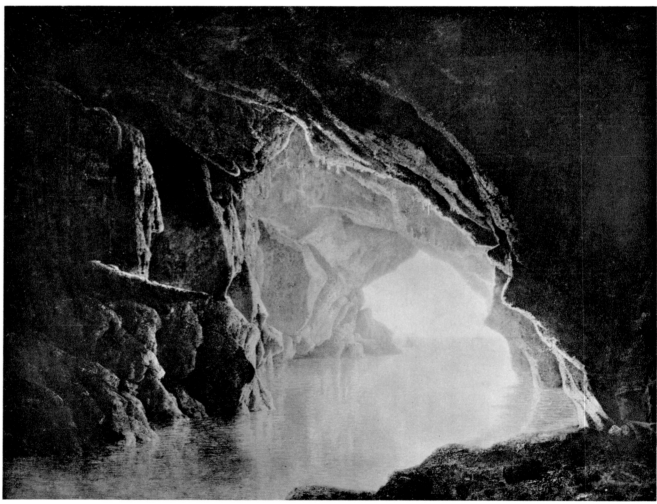

Plate 173 *Grotto with Waterfall* c 1775–79
$15\frac{1}{4}$ x $19\frac{1}{2}$ in / 38.7 x 49.5 cm
Ian Appleby Cat 293

Plate 174 *A Cavern, Evening* 1774
40 x 50 in / 101.6 x 127 cm
Smith College Museum of Art Cat 282

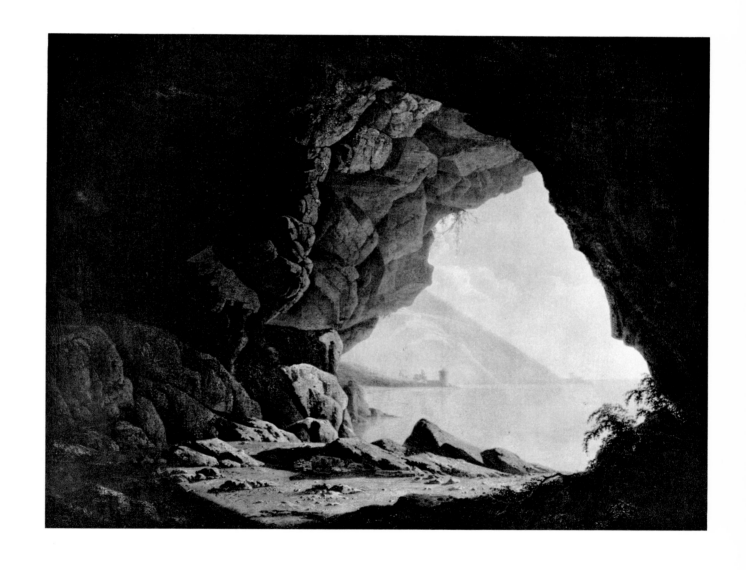

Plate 175 *A Cavern, Morning* 1774
40 x 50 in / 101.6 x 127 cm
Mr and Mrs R. Kirk Askew Jr Cat 281

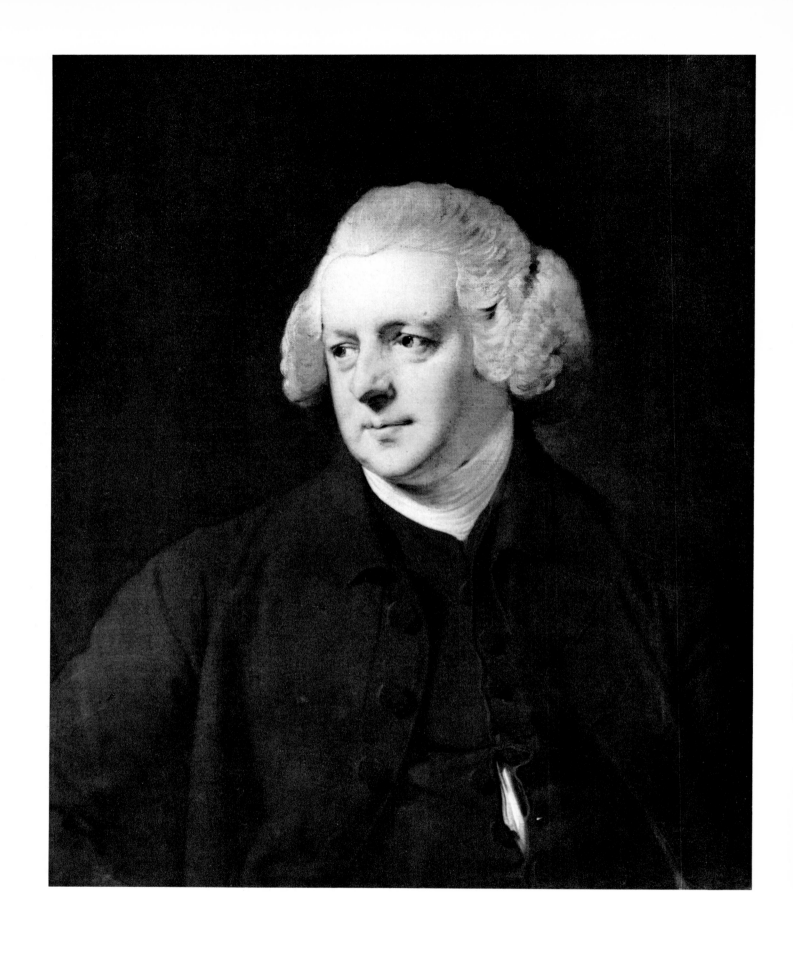

Plate 176 *William Alvey Darwin* 1776
30 x 25 in / 76.2 x 63.5 cm
Mrs Richard Kindersley Cat 55

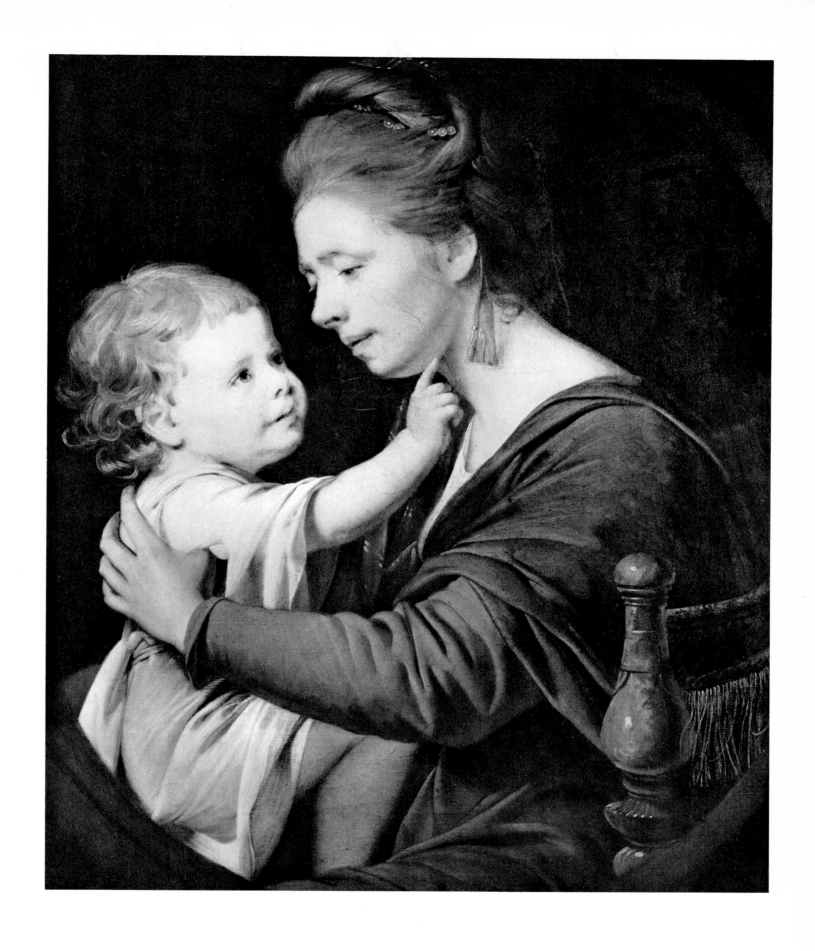

Plate 177 *Jane Darwin and her son William Brown Darwin* 1776
30 x 25 in / 76.2 x 63.5 cm
Mrs Richard Kindersley Cat 56

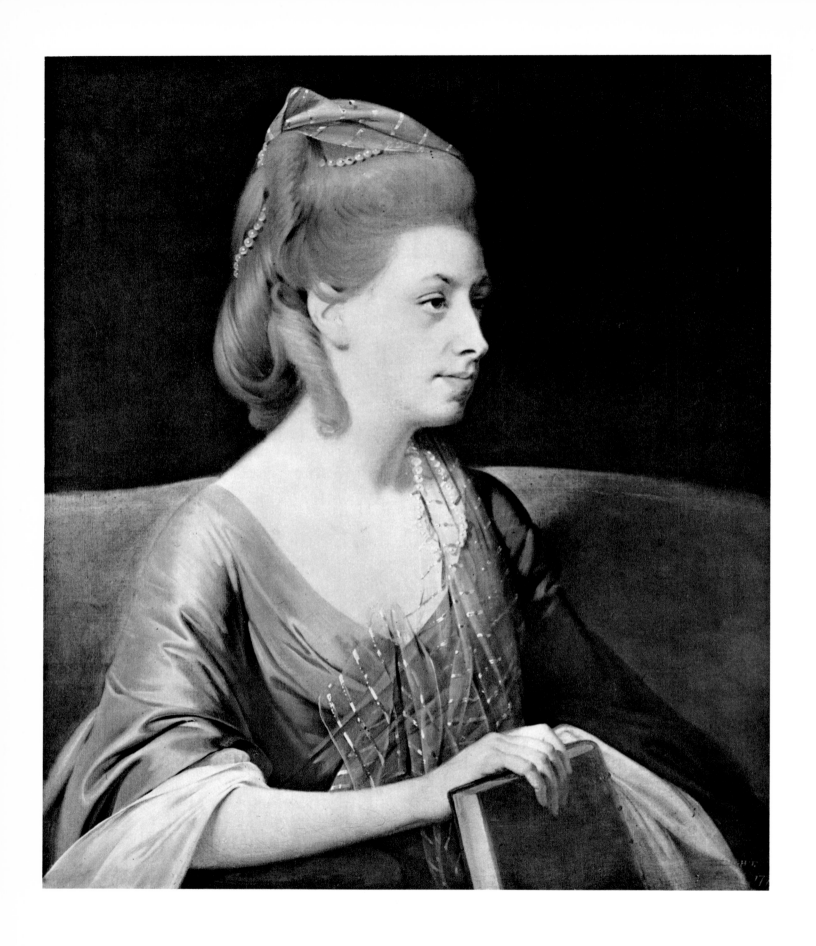

Plate 178 *Mrs Edward Witts* 1776
30 x 25 in / 76.2 x 63.5 cm
Major General F. V. B. Witts Cat 150

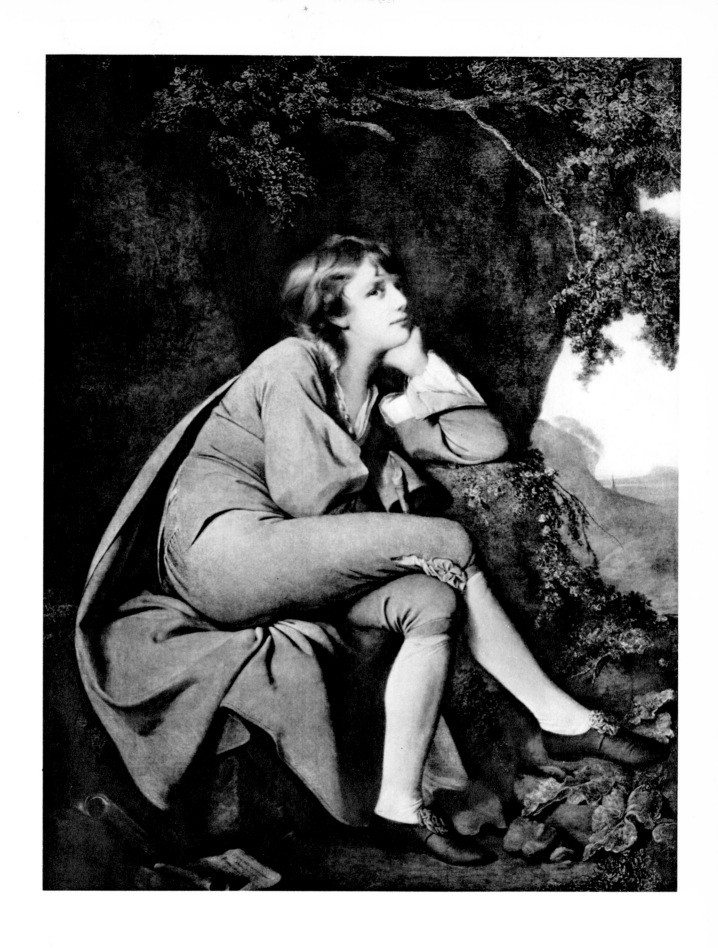

Plate 179 *Edwin, from Dr Beattie's Minstrel* c 1777–78
63 x 46 in / 160 x 116.8 cm
Lady Cynthia Colville Cat 235

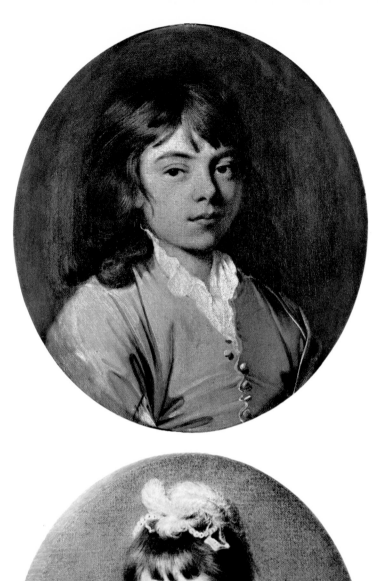

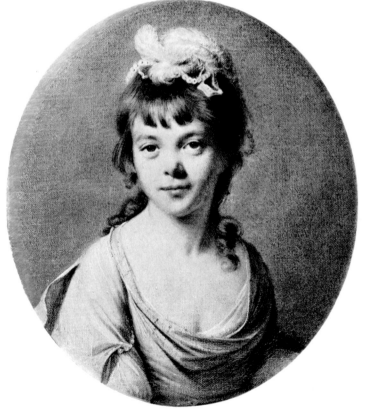

Plate 180 *Charles Stead Hope as a boy* c 1776–77
Oval $13\frac{1}{2}$ x $11\frac{1}{2}$ in / 34.3 x 29.2 cm
Private collection U.K. Cat 89

Plate 181 *Miss Harriet Hope* c 1776–77
Oval 14 x 12 in / 35.5 x 30.5 cm
H. R. Edwards Cat 90

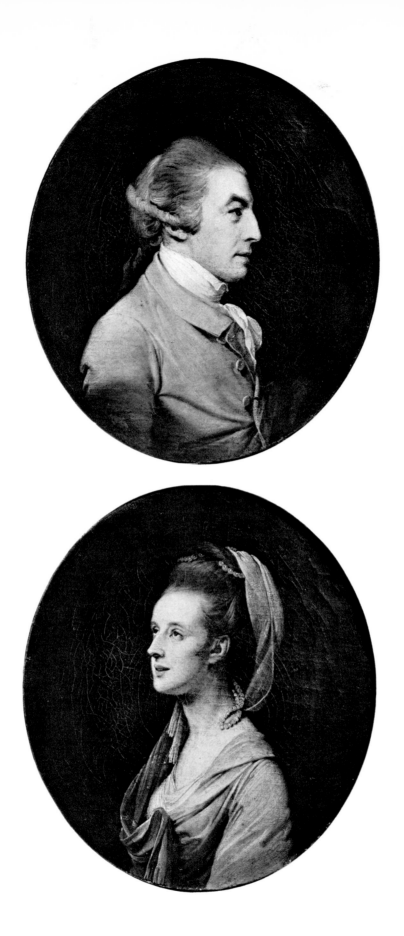

Plate 182 *William Hayley* 1776
Grisaille oval 13¼ x 11½ in / 34.3 x 29.2 cm
Private collection U.K. Cat 75

Plate 183 *Mrs William Hayley* 1776
Grisaille oval 13¼ x 11½ in / 34.3 x 29.2 cm
Private collection U.K. Cat 76

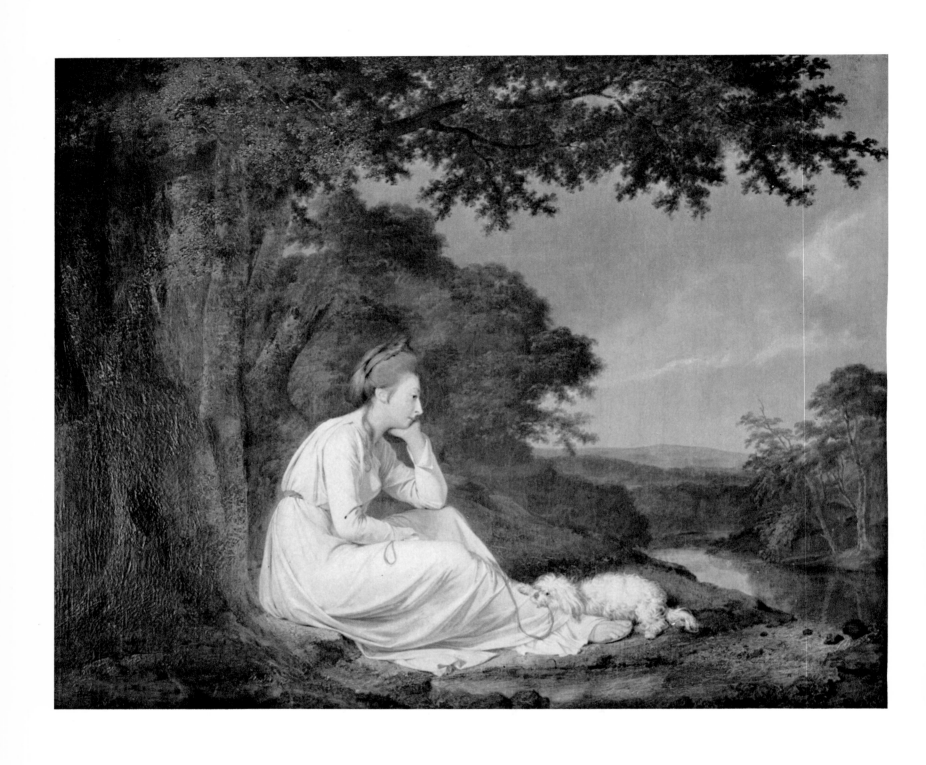

Plate 184 *Maria and her dog Sylvio* 1777
$32\frac{1}{2}$ x $49\frac{1}{2}$ in / 82.5 x 125.7 cm
Private collection U.K. Cat 236

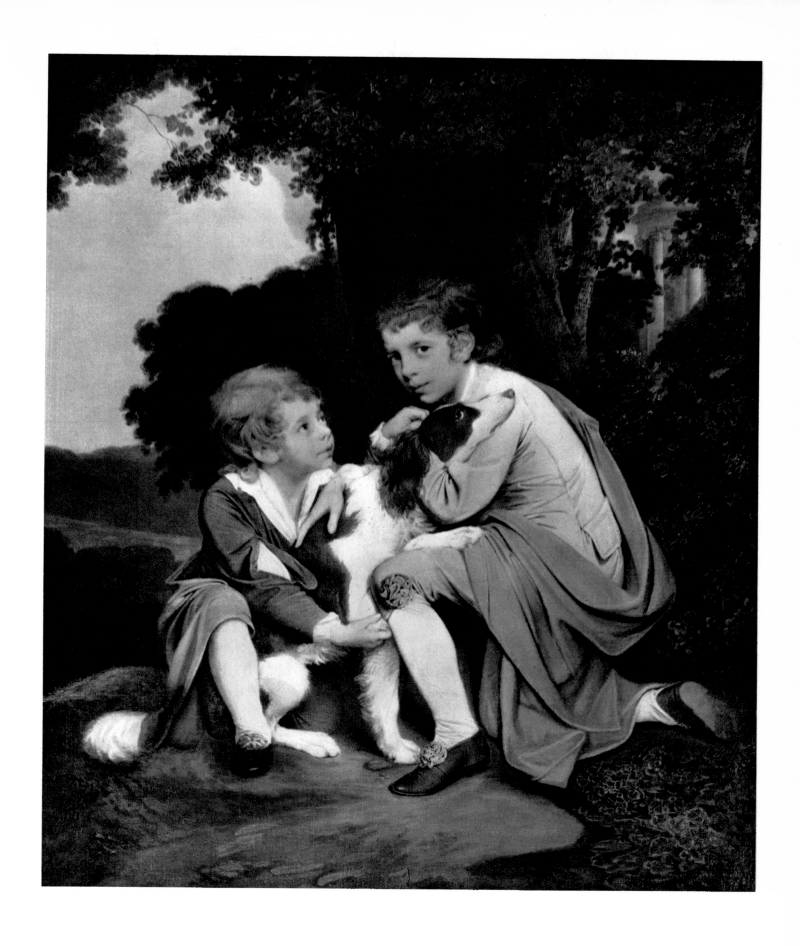

Plate 185 *Pickford Children* c 1777
58 x 48 in / 147.3 x 121.9 cm
Private collection U.K. Cat 119

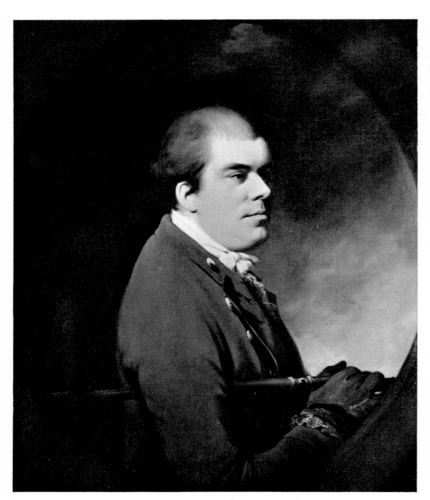 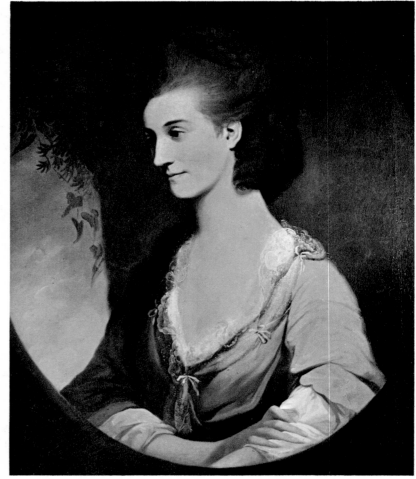

Plate 186 'H. B.' Hall c 1776–78
30 x 25 in / 76.2 x 63.5 cm
Hugh Wontner M. V. O., J. P. Cat 72

Plate 187 Mrs Hall c 1776–78
30 x 25 in / 76.2 x 63.5 cm
Mrs Nancie C. MacGilp Cat 73

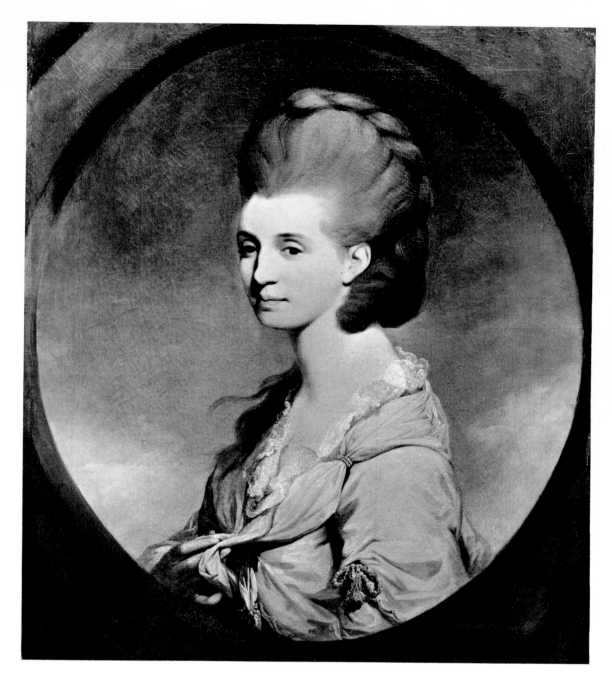

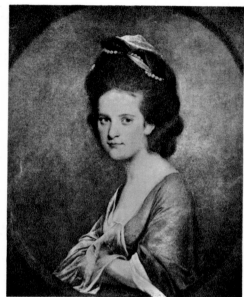

Plate 188 'Elizabeth Kennion, Mrs Smyth' c 1776–78
30 x 25 in / 76.2 x 63.5 cm
W. R. Kennion Cat 131

Plate 189 Mrs Hodges c 1775–76
30 x 25 in / 76.2 x 63.5 cm
Formerly Humphrey Roberts collection
Cat 83

117

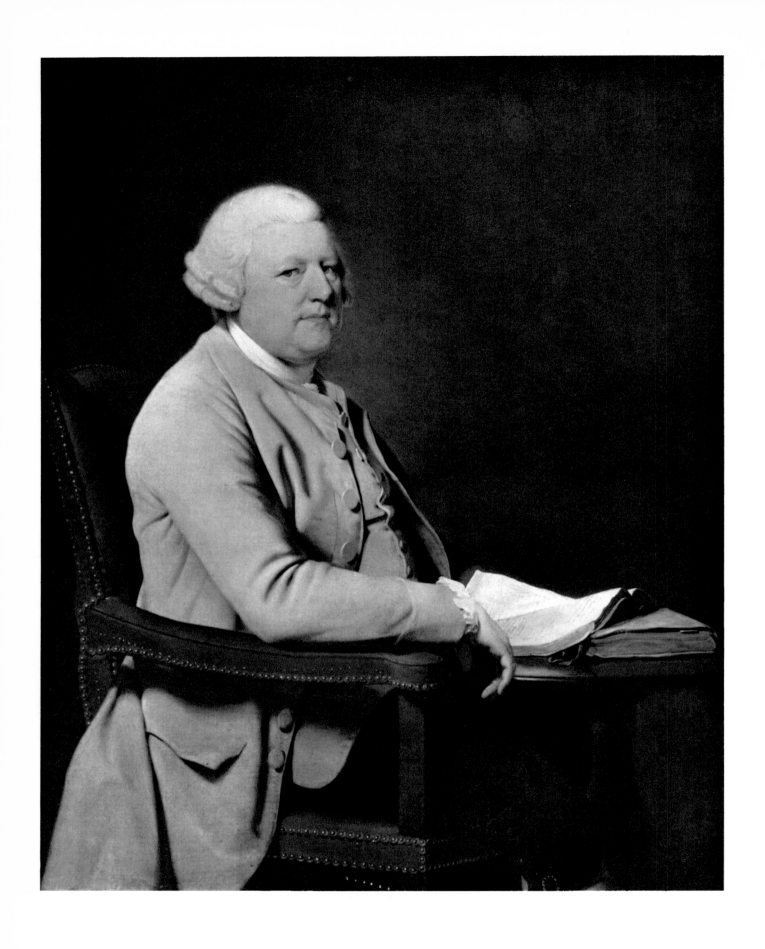

Plate 190 *Richard Cheslyn* 1777
50 x 40 in / 127 x 101.6 cm
Private collection U.K. Cat 38

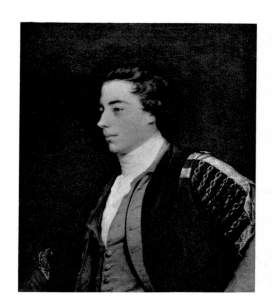

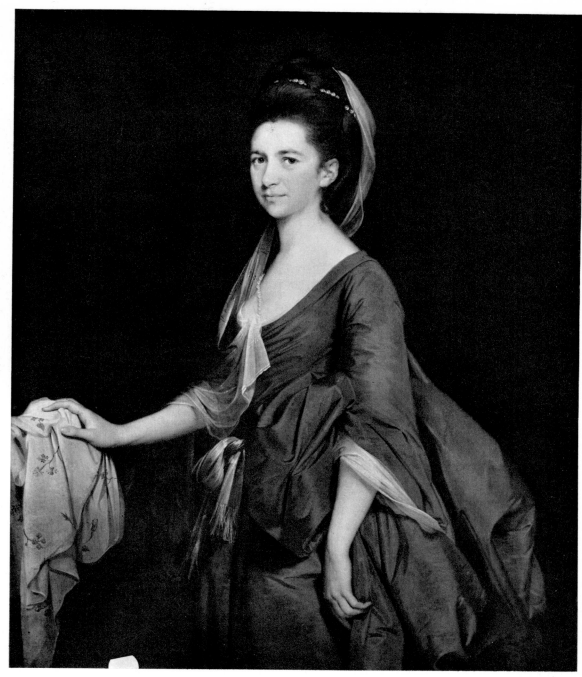

Plate 191 *Thomas Gisborne* 1777
30 x 25 in / 76.2 x 63.5 cm
Mr and Mrs Patrick Gibson Cat 66

Plate 192 *Mrs Beridge* 1777
50 x 40 in / 127 x 101.6 cm
Minneapolis Institute of Arts Cat 18

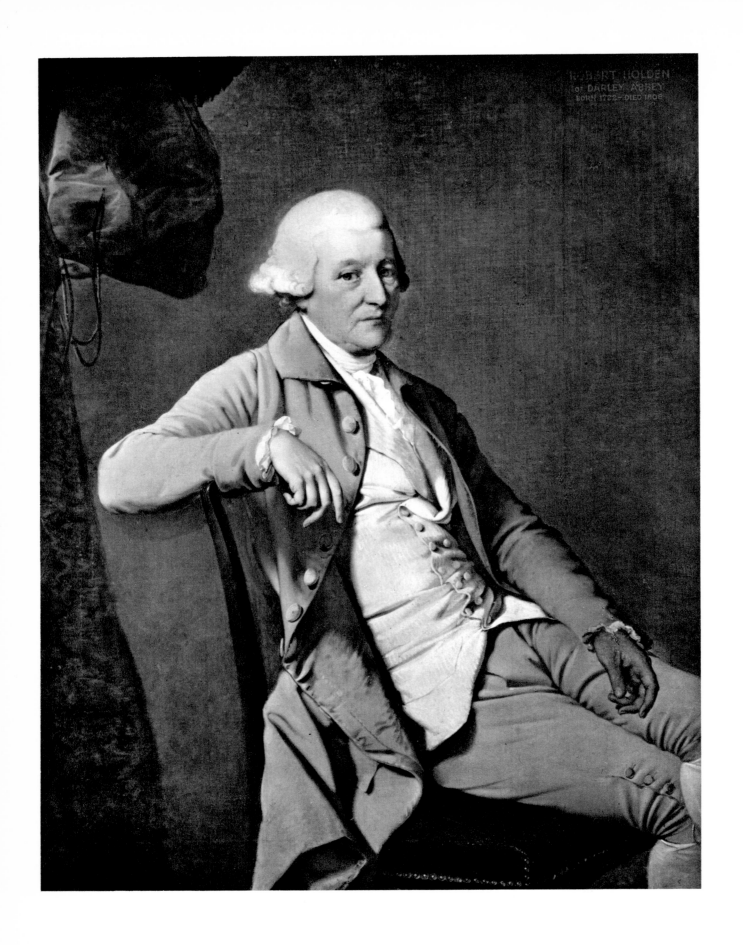

Plate 193 *Robert Holden* c 1778–79
50 x 40 in / 127 x 101.6 cm
Major H. R. Holden Cat 84

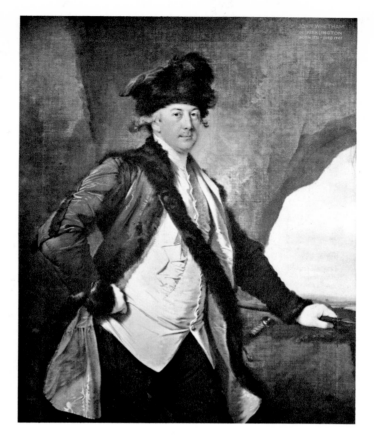

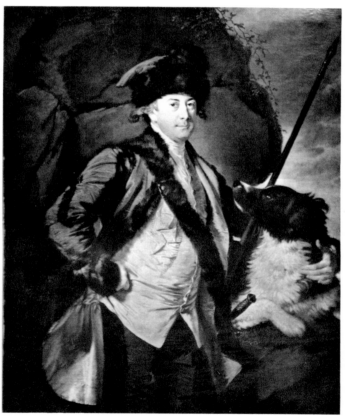

Plate 194 *John Whetham of Kirklington* c 1778–79
50 x 40 in / 127 x 101.6 cm
Major H. R. Holden Cat 140

Plate 195 *John Whetham of Kirklington* c 1778–79
50 x 40 in / 127 x 101.6 cm
Mrs Daphne M. Smith Cat 139

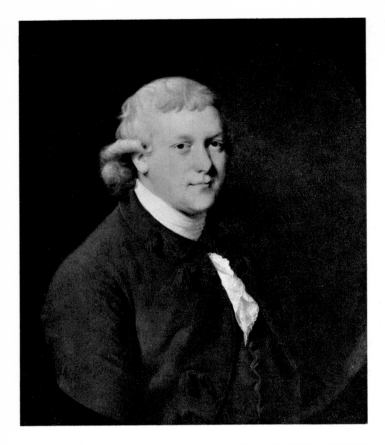

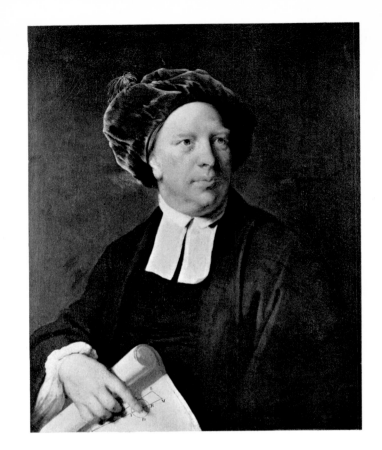

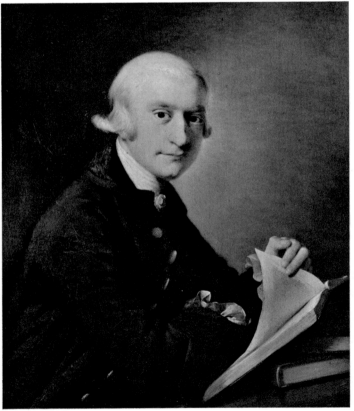

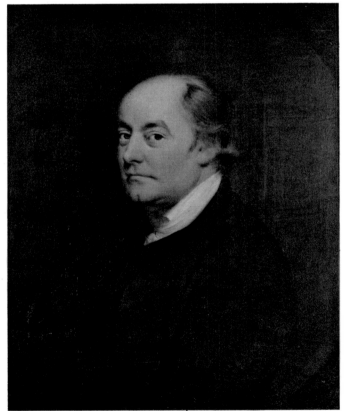

Plate 196 *'Henry Flint'* c 1778–80
30 x 25 in / 76.2 x 63.5 cm
D. R. Sherborn Cat 61

Plate 197 *Rev William (?) Pickering* c 1777–80
30 x 25 in / 76.2 x 63.5 cm
Sir Gilbert Inglefield Cat 118

Plate 198 *Henry Richmond* c 1777–80
30 x 25 in / 76.2 x 63.5 cm
Professor Oliffe Richmond Cat 125

Plate 199 *'John Harrison'* 1779–80
30 x 25 in / 76.2 x 63.5 cm
Private collection U.K. Cat 74

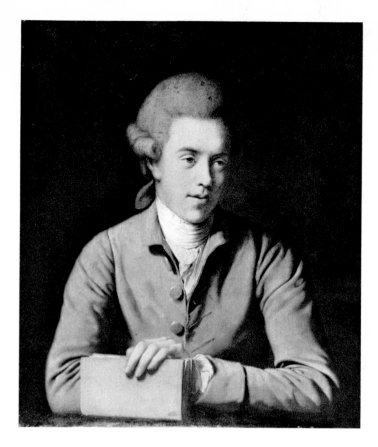

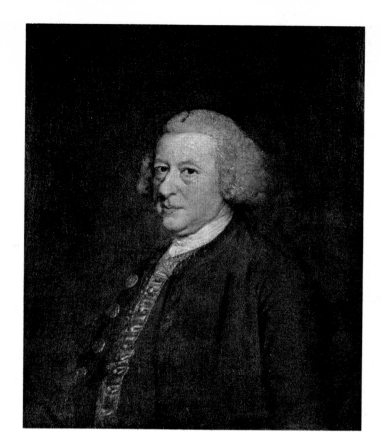

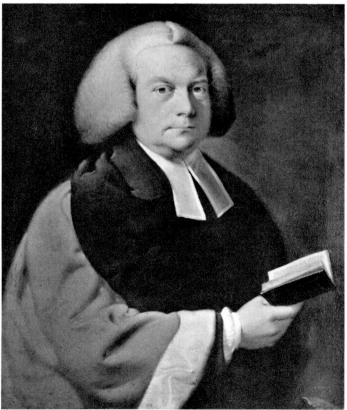

Plate 200 'Hon Thomas Bligh' c 1777–80
30 x 25 in / 76.2 x 63.5 cm
Manchester City Art Galleries Cat 19

Plate 201 Charles Roe c 1777–80
30 x 25 in / 76.2 x 63.5 cm
Parish of Christ Church, Macclesfield Cat 126

Plate 202 Lynford Caryl c 1780
30 x 25 in / 76.2 x 63.5 cm
Jesus College, Cambridge Cat 33

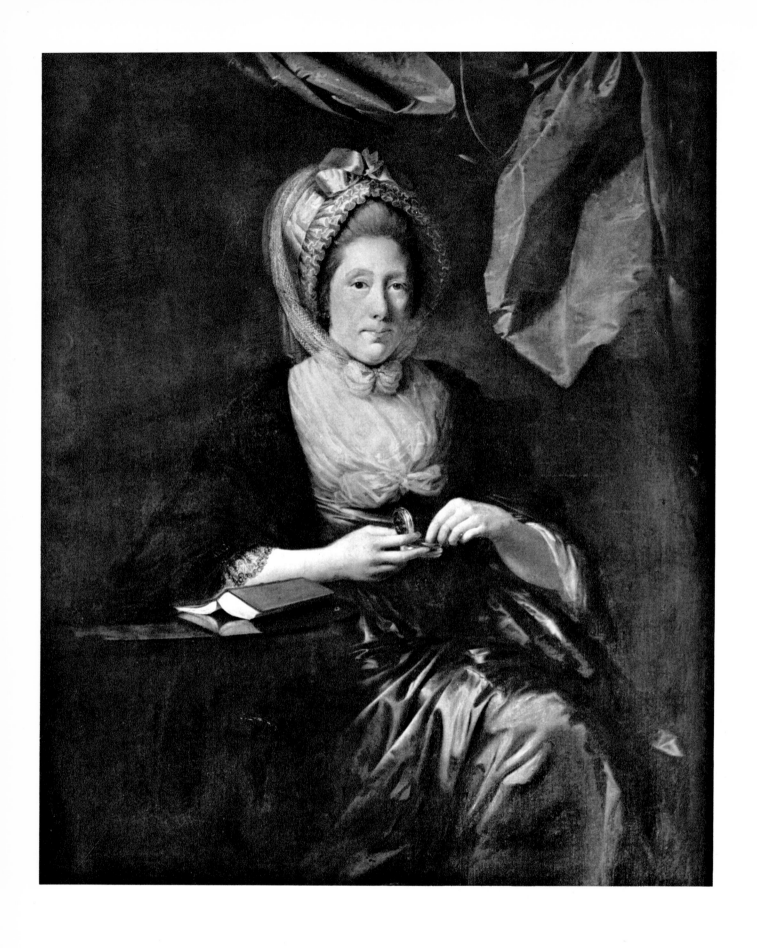

Plate 203 *Mrs Francis Hurt* c 1780
50 x 40 in / 127 x 101.6 cm
Michael Hurt Cat 93

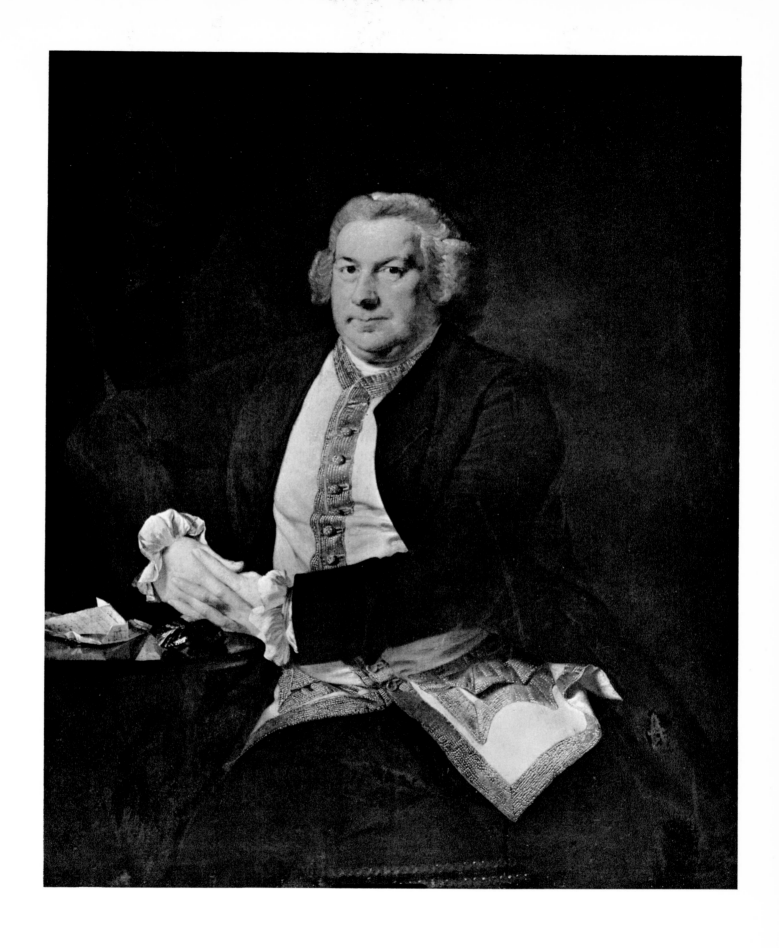

Plate 204 *Francis Hurt of Alderwasley* c 1780
50 x 40 in / 127 x 101.6 cm
Michael Hurt Cat 92

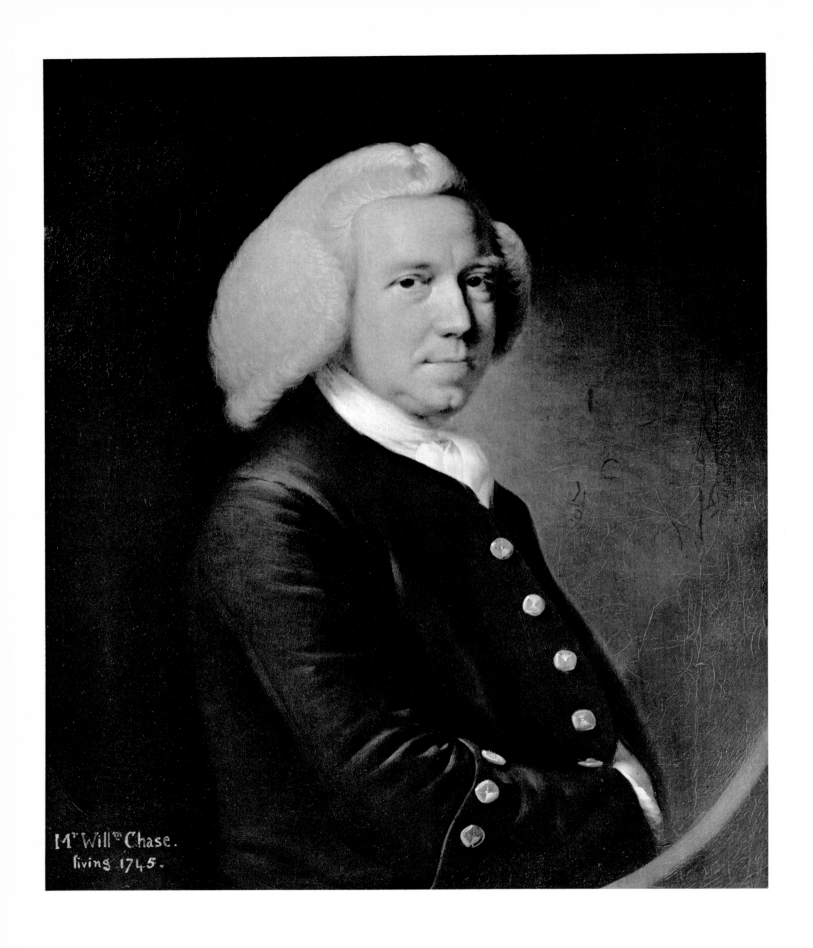

Plate 205 *William Chase* c 1779–81
30 x 25 in / 76.2 x 63.5 cm
Yale University Art Gallery (gift of Junius S. & Henry S. Morgan)
Cat 35

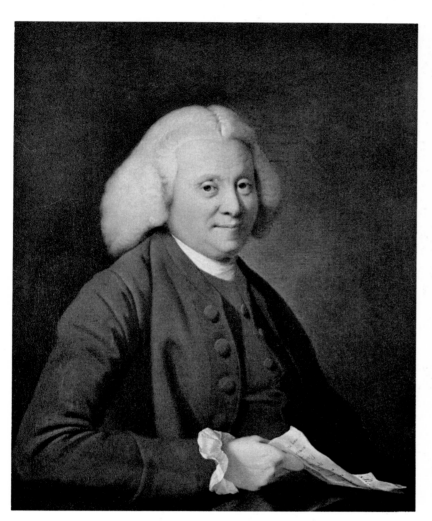

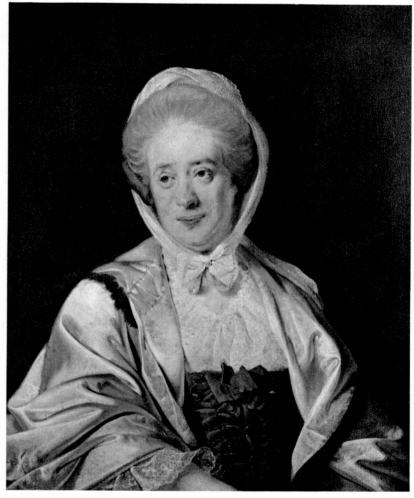

Plate 206 *Samuel Crompton* c 1780
30 x 25 in / 76.2 x 63.5 cm
Colonel Sir John Crompton-Inglefield Cat 46

Plate 207 *Mrs Samuel Crompton* c 1780
30 x 25 in / 76.2 x 63.5 cm
Colonel Sir John Crompton-Inglefield Cat 47

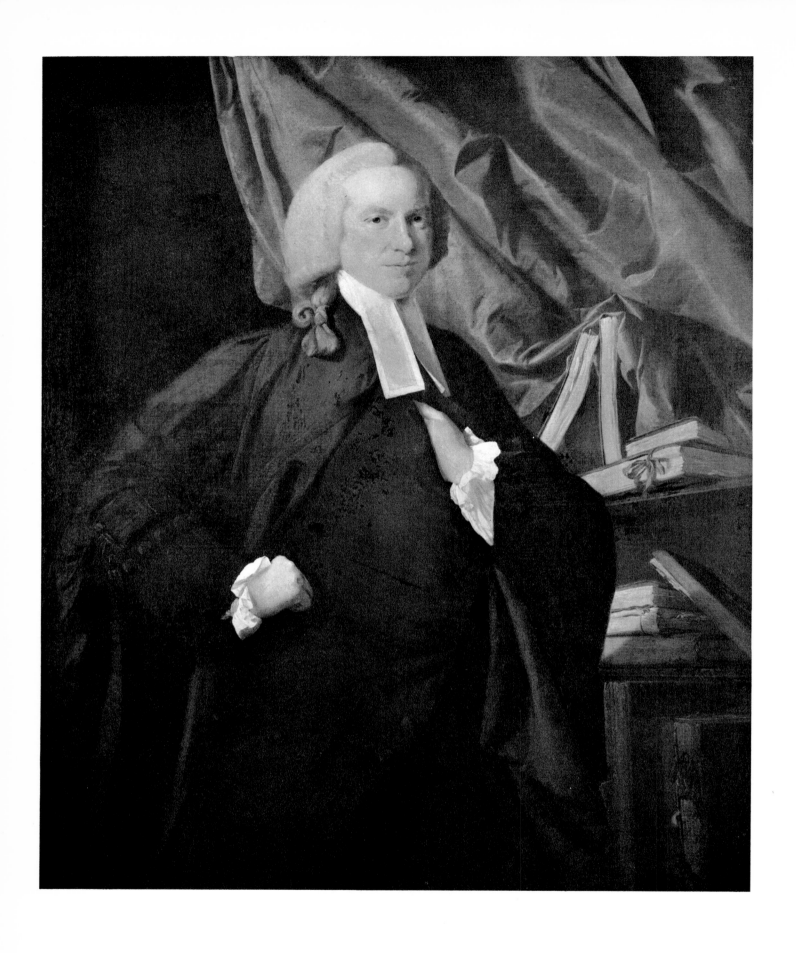

Plate 208 *Robert Bakewell* c 1780
50 x 40 in / 127 x 101.6 cm
Richard Dyott Cat 11

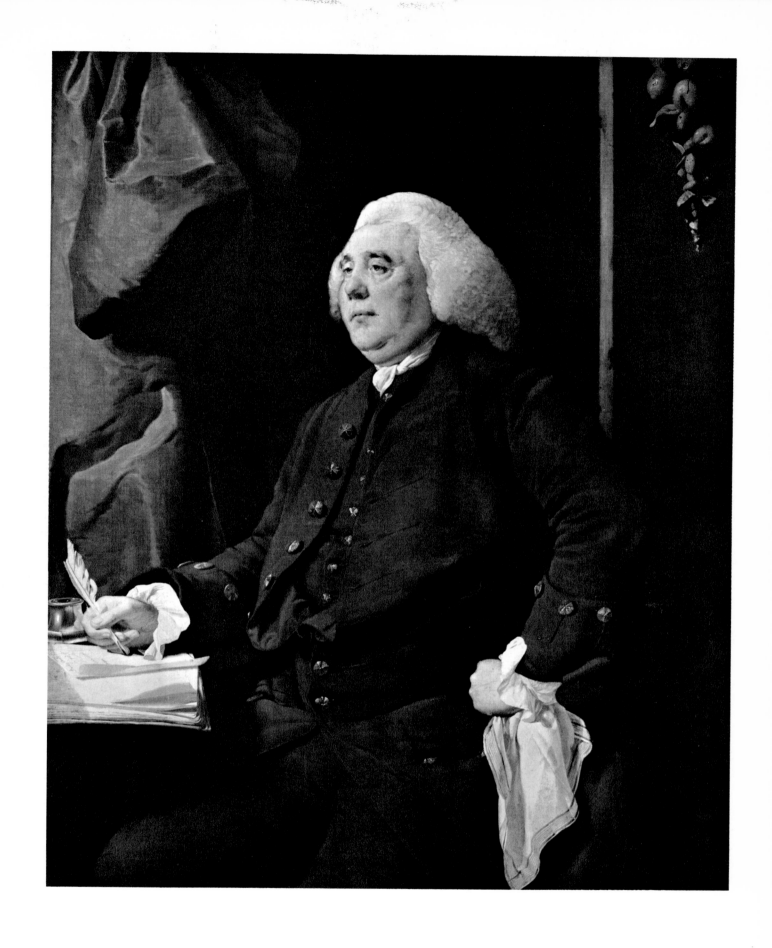

Plate 209 '*Christopher Heath*' c 1781
50 x 40 in / 127 x 101.6 cm
Private collection U.K. Cat 78

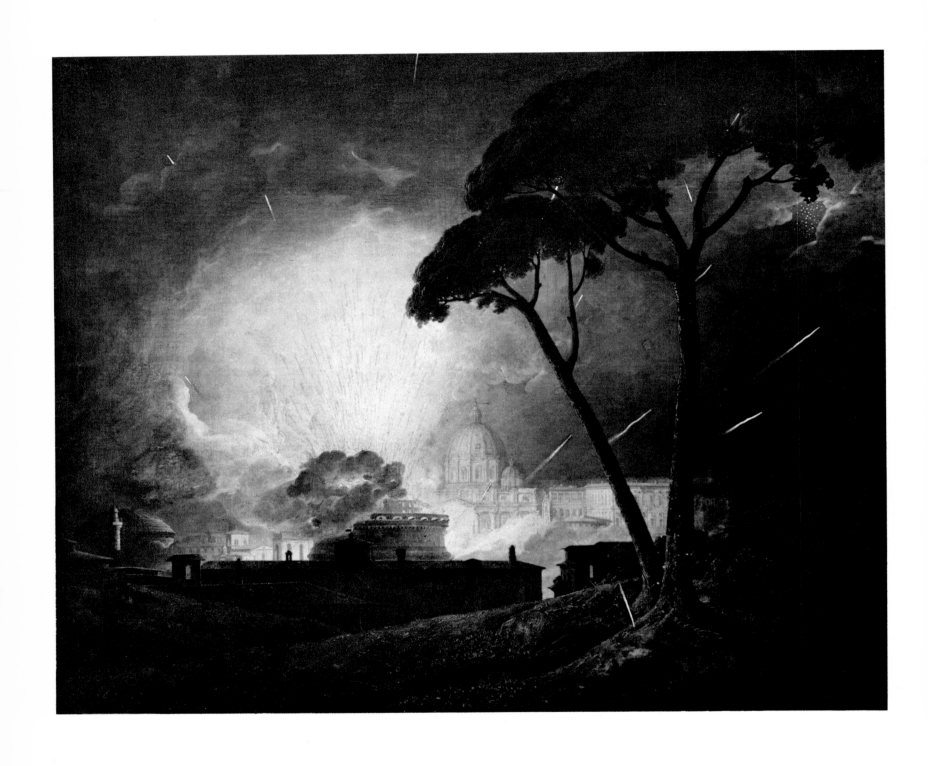

Plate 210 *Firework Display at the Castel Sant'Angelo* c 1775–78
$55\frac{1}{4}$ x $68\frac{1}{8}$ in / 140.3 x 173 cm
Walker Art Gallery, Liverpool Cat 250

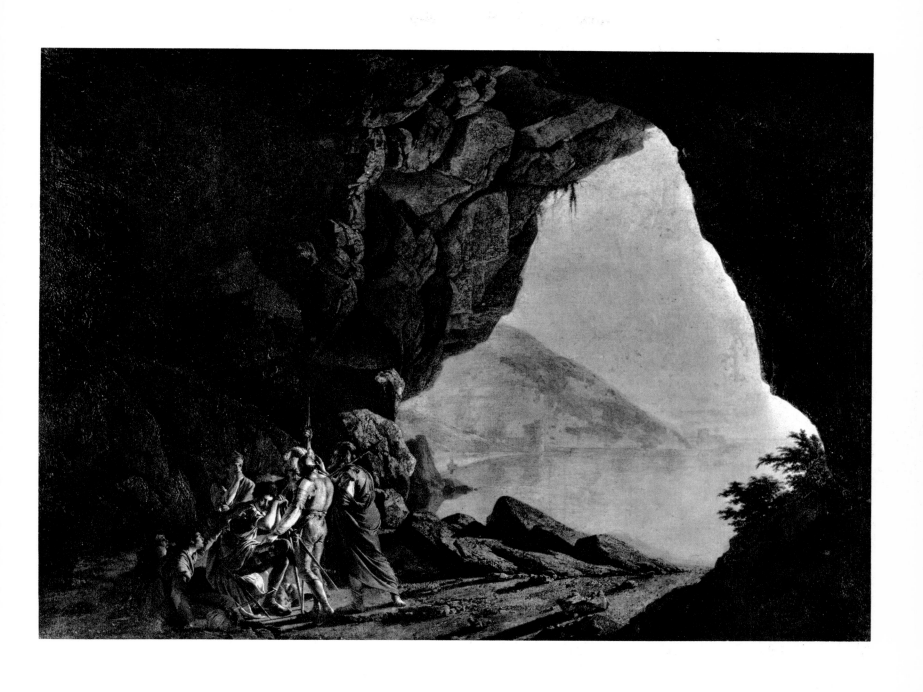

Plate 211 *A Grotto in the Kingdom of Naples with Banditti:
A Sunset* c 1777–78
48 x 68 in / 121.9 x 172.7 cm
G. Meynell M.B.E. Cat 277

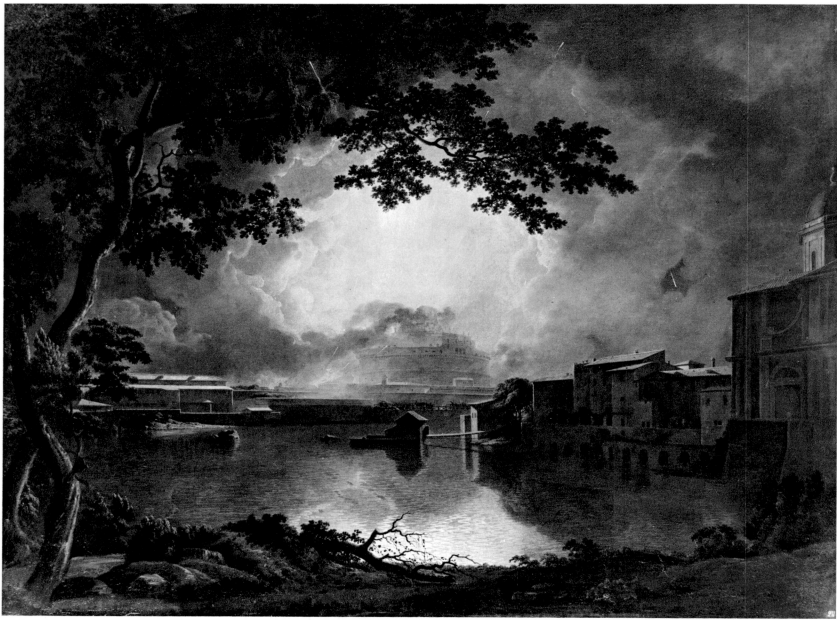

Plate 212 *Matlock High Tor, moonlight* c 1777–79
24 x 29 in / 60.9 x 73.6 cm
Leicester Museum and Art Gallery Cat 307

Plate 213 *Firework Display at the Castel Sant'Angelo* 1778–79
63¾ x 84 in / 161.9 x 213.3 cm
Hermitage Museum, Leningrad Cat 251

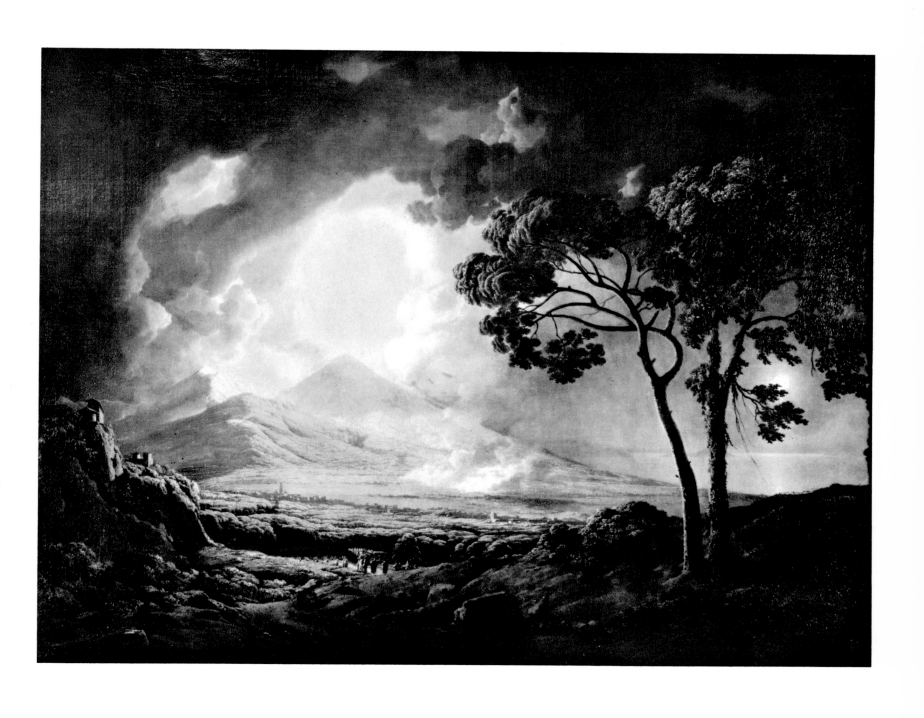

Plate 214 *Vesuvius with the procession of St Januerius' Head* 1778
63¾ x 84 in / 161.9 x 213.3 cm
Pushkin Museum, Moscow Cat 268

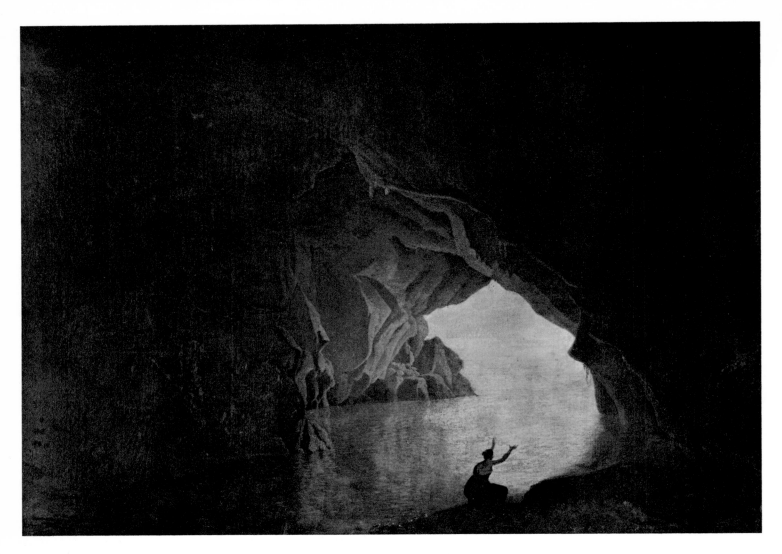

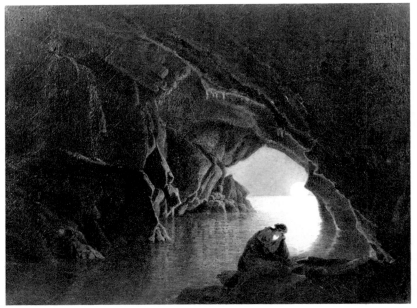

Plate 215 *Grotto with the figure of Julia* 1780
c 48 x 67 in / 121.9 x 172.7 cm
G. Meynell M.B.E. Cat 278

Plate 216 *Grotto with the figure of Julia* 1780
15½ x 20 in / 39.4 x 50.8 cm
R. D. Plant Cat 283

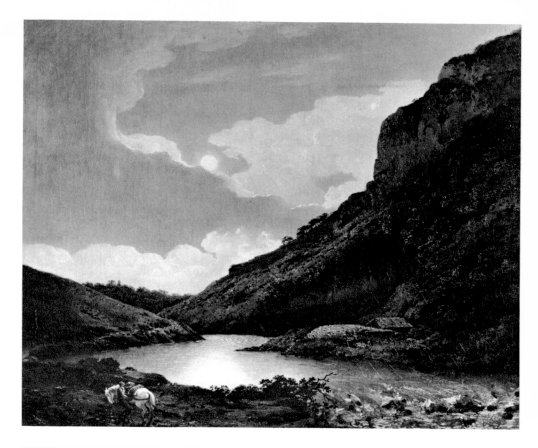

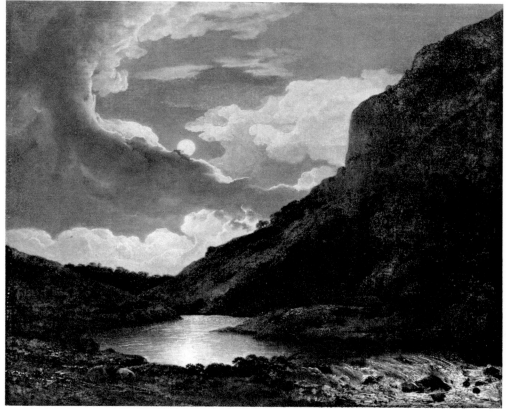

Plate 217 *Matlock Tor, Moonlight* ? c 1778–80
25 x 30 in / 63.5 x 76.2 cm
Mr and Mrs Paul Mellon Cat 308

Plate 218 *Matlock Tor, Moonlight* c 1778–80
25 x 30 in / 63.5 x 76.2 cm
Detroit Institute of Arts Cat 309

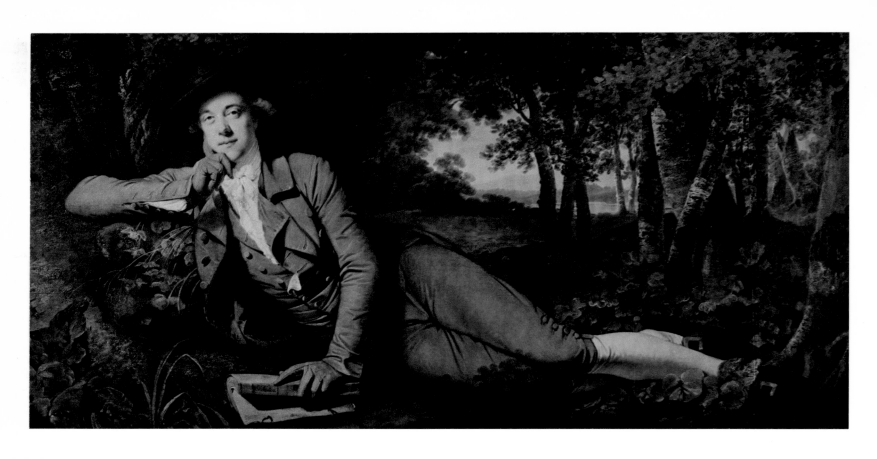

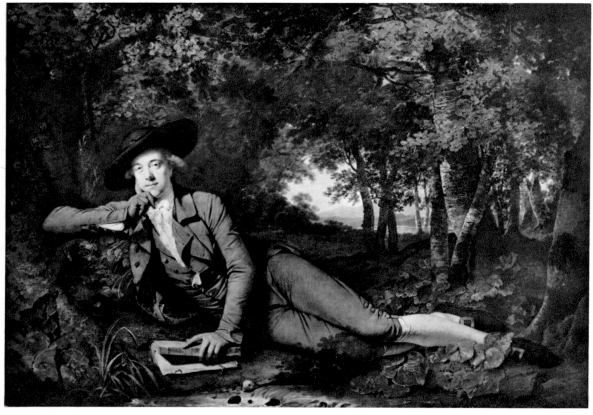

Plates 219, 219a *Brooke Boothby* 1780–81
58¼ x 81¼ in / 148 x 206.4 cm
Tate Gallery Cat 20

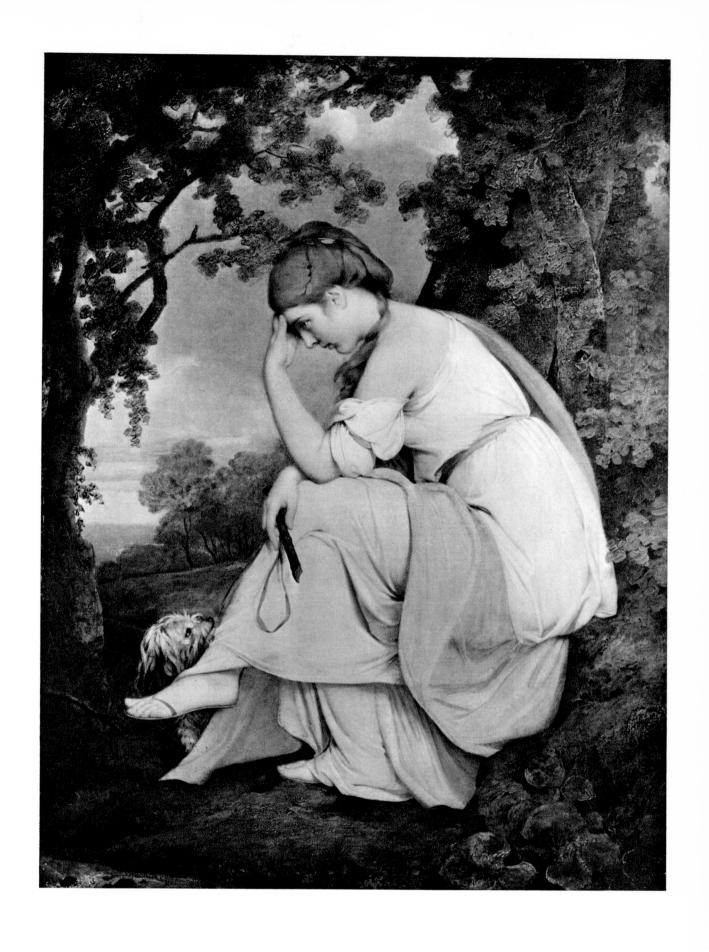

Plate 220 *Maria, from Sterne* 1781
63 x 45½ in / 160 x 115.6 cm
Derby Museum and Art Gallery Cat 237

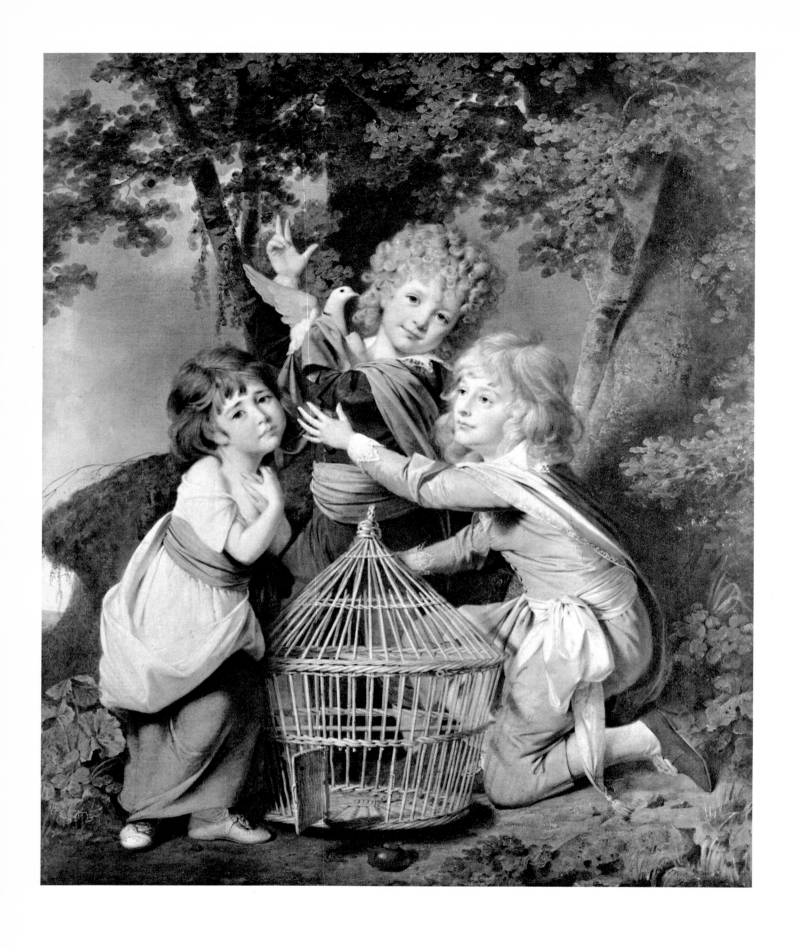

Plate 221 *Synnot Children* c 1780–81
60 x 49½ in / 152.4 x 125.8 cm
Mrs Michael Hawker, S. Australia Cat 135

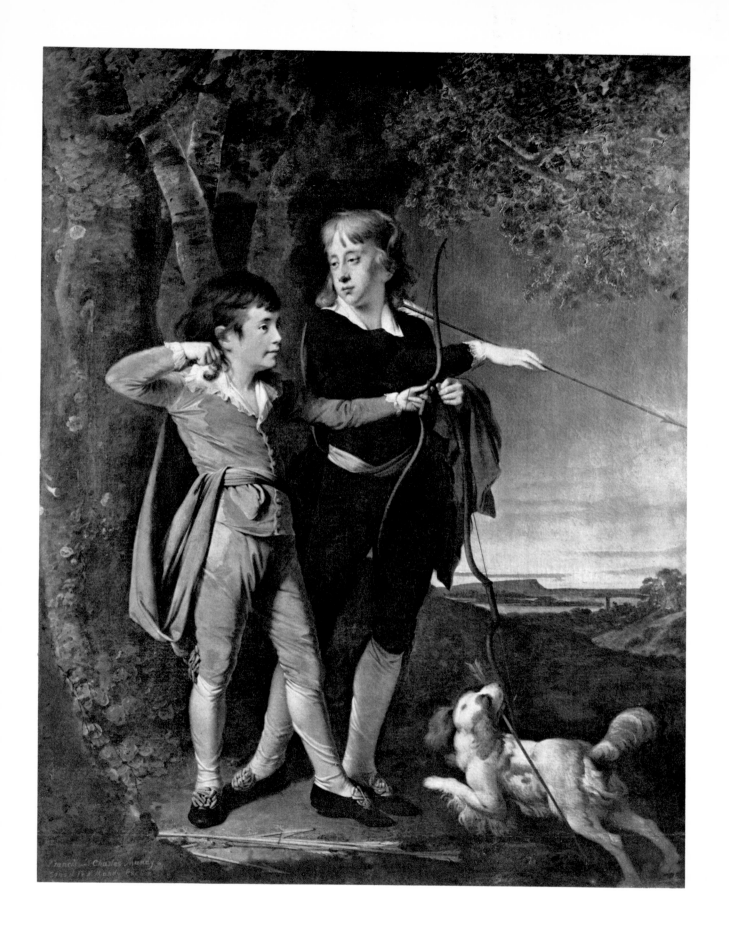

Plate 222 *Two Young Gentlemen in the character of Archers*
c 1781–82
71½ x 54 in / 181.6 x 137.2 cm
Oscar & Peter Johnson Ltd. Cat 111

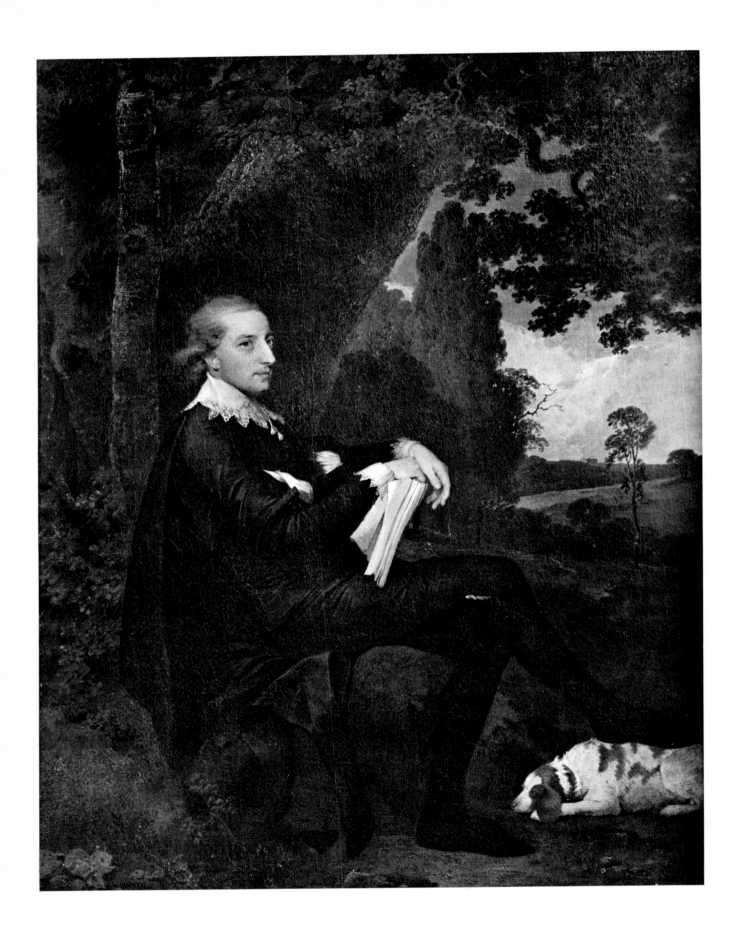

Plate 223 *Rev. Henry Case (afterwards Case-Morewood)* 1782
50 x 40 in / 127 x 101.6 cm
Palmer-Morewood Collection: on loan to Brighton Art
Gallery Cat 108

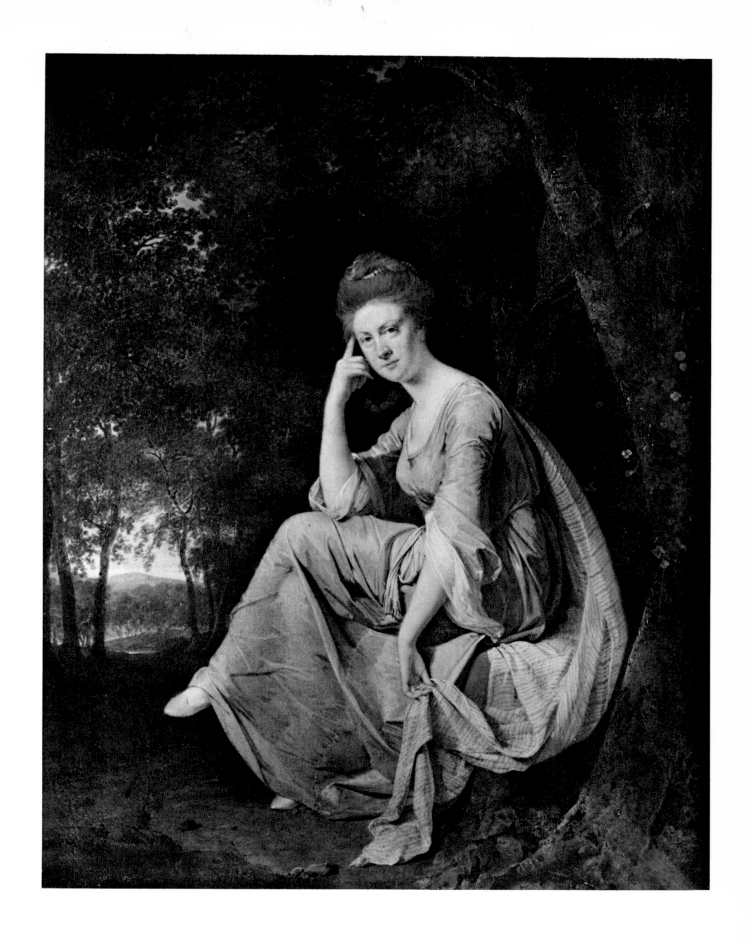

Plate 224 *Helen Morewood* 1782
50 x 40 in / 127 x 101.6 cm
Palmer-Morewood Collection: on loan to Brighton Art
Gallery Cat 109

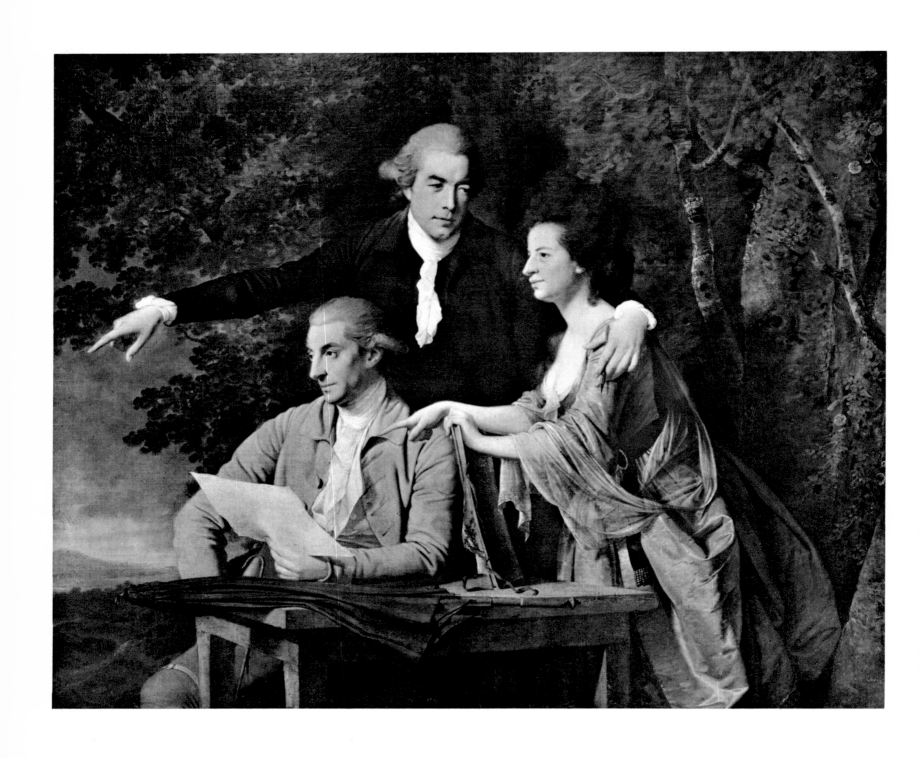

Plate 225 *Rev d'Ewes Coke, his wife Hannah and Daniel*
Parker Coke, M.P. c 1780–82
60 x 70 in / 152.4 x 177.8 cm
Derby Museum and Art Gallery Cat 40

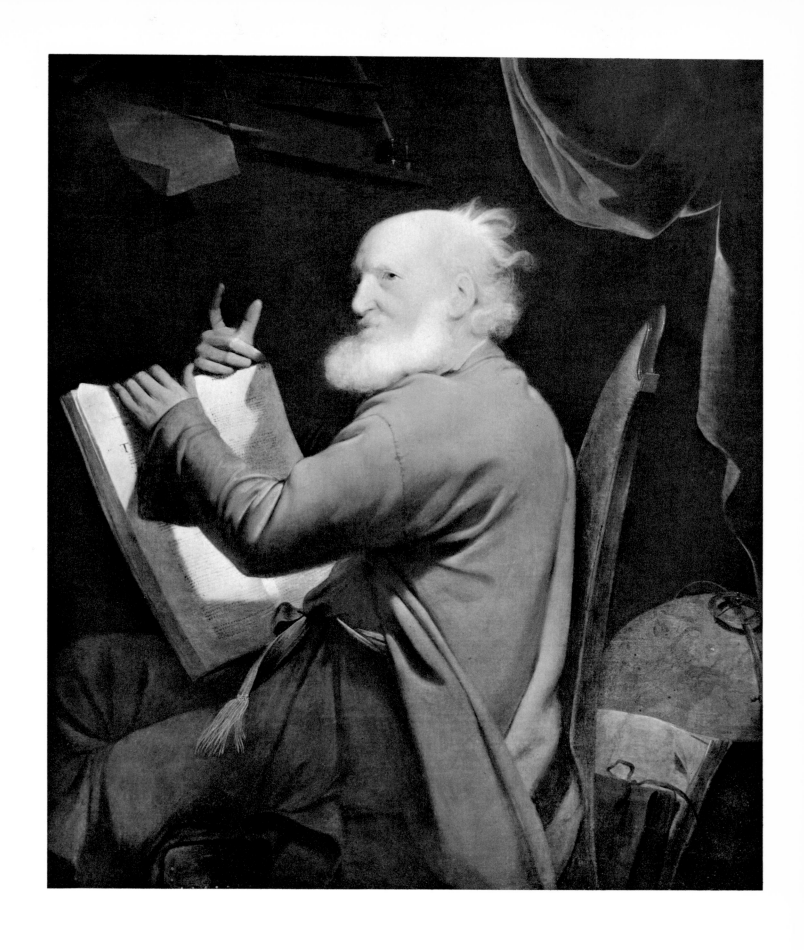

Plate 226 *A Philosopher by Lamplight* c 1778–81
50 x 40 in / 127 x 101.6 cm
Private collection U.K. Cat 194

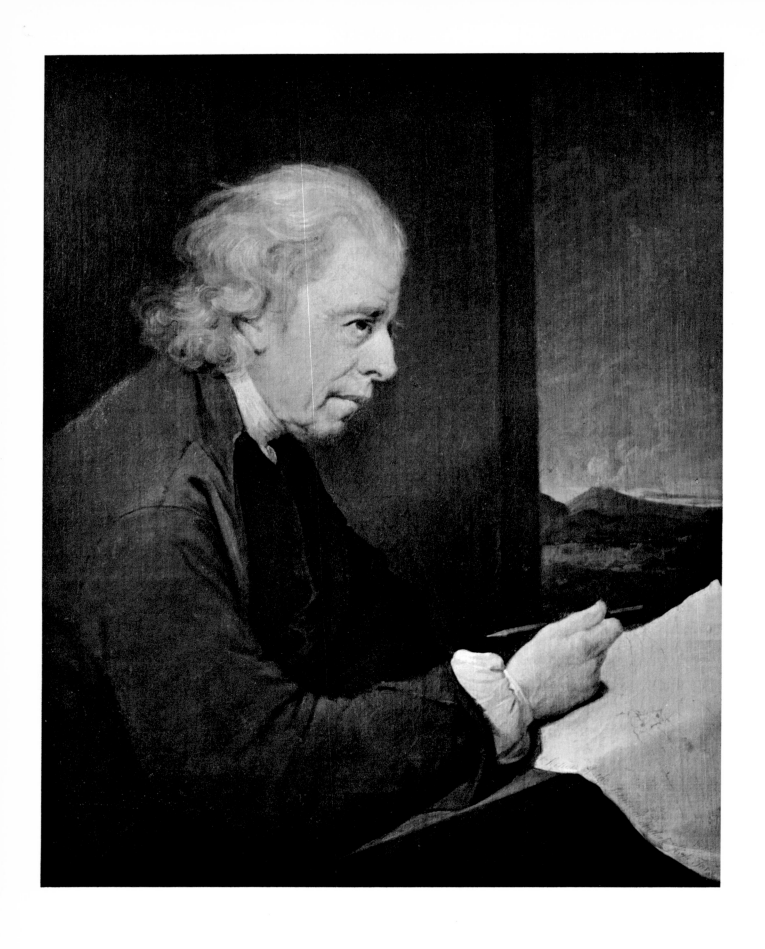

Plate 227 *John Whitehurst, F.R.S.* c 1782–83
$36\frac{1}{4}$ x 28 in / 92.1 x 71.1 cm
John Smith & Sons, Derby Cat 141

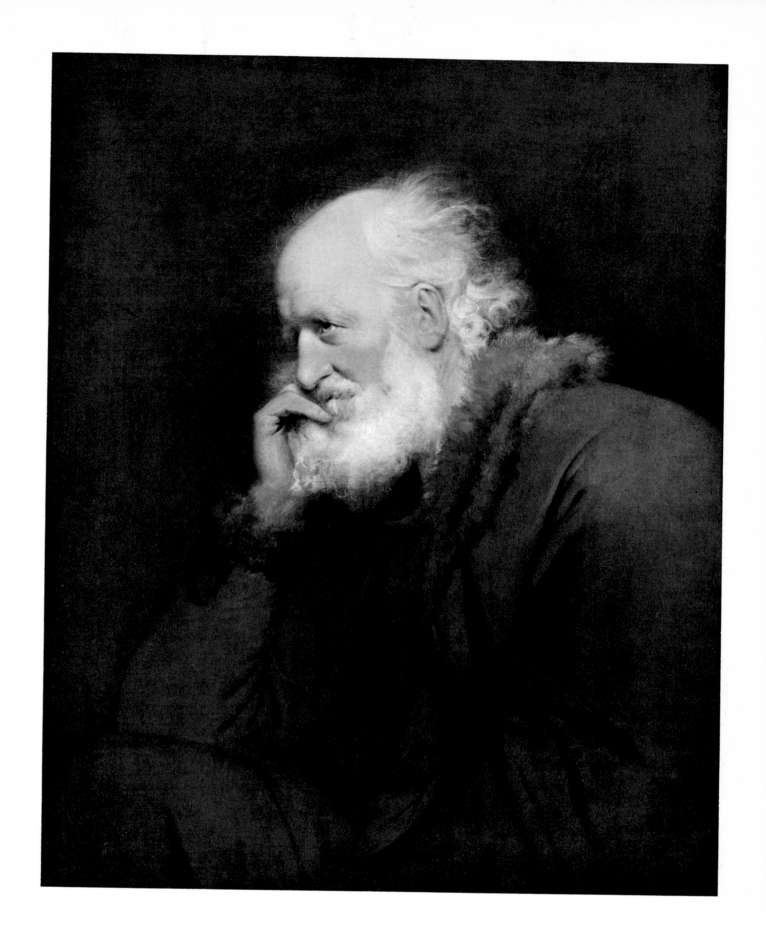

Plate 228 *Head of Old Man* c 1780–81
36⅛ x 27⅞ in / 91.7 x 70.8 cm
Mrs Edward Maclean Stewart Cat 181

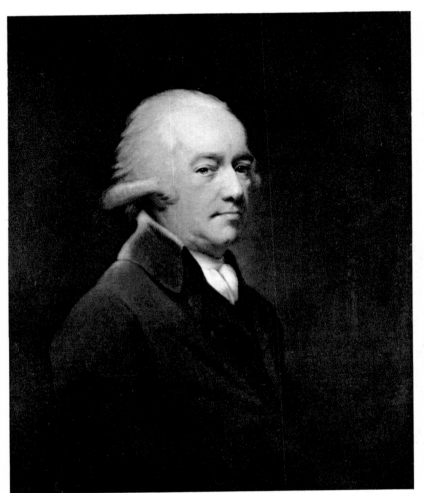

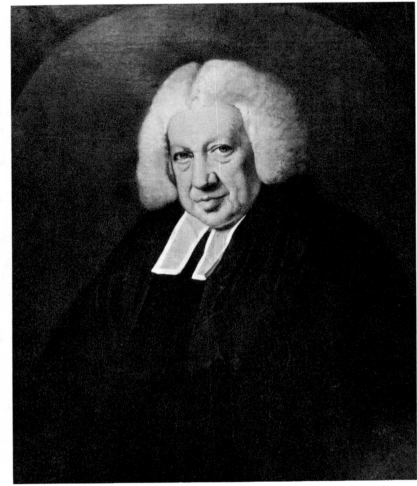

Plate 229 *Samuel Ward* c 1782–83 or later
30 x 25 in / 76.2 x 63.5 cm
Derby Museum and Art Gallery Cat 137

Plate 230 *Rev. Thomas Seward* c 1782–83
30 x 25 in / 76.2 x 63.5 cm
Untraced Cat 128

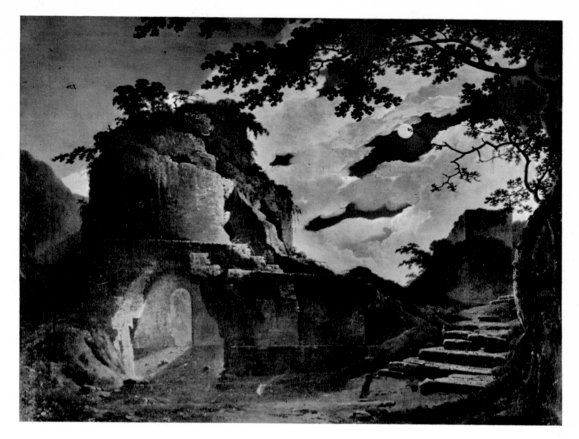

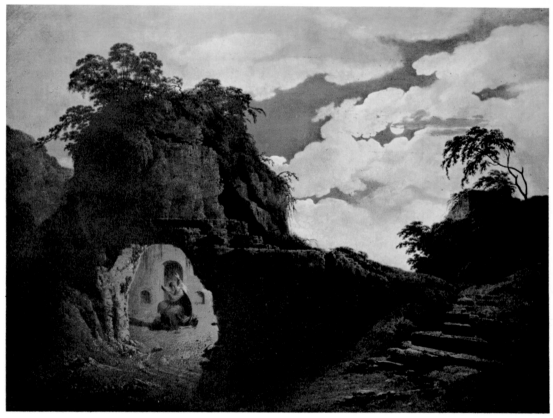

Plate 231 *Virgil's Tomb* 1782
40 x 50 in / 101.6 x 127 cm
Private collection U.K. Cat 288

Plate 232 *Virgil's Tomb* 1779
40 x 50 in / 101.6 x 127 cm
Colonel Sir John Crompton-Inglefield Cat 287

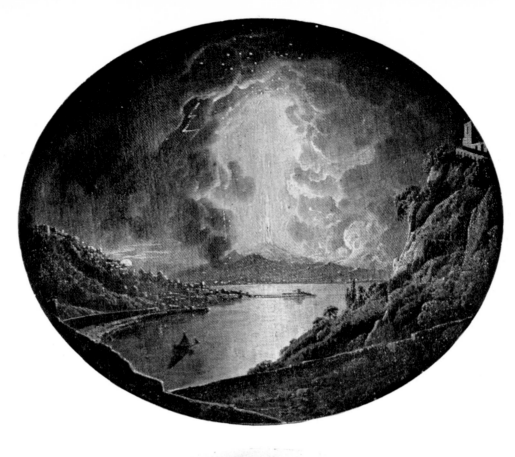

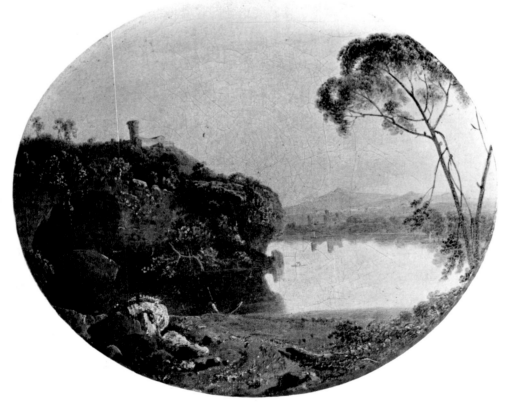

Plate 233 *Vesuvius* ? early '80's
12 x 14 in / 30.5 x 33.5 cm
Private collection U.K. Cat 270

Plate 234 *Lake of Nemi* 1782
12 x 14 in / 30.5 x 33.5 cm
Private collection U.K. Cat 254

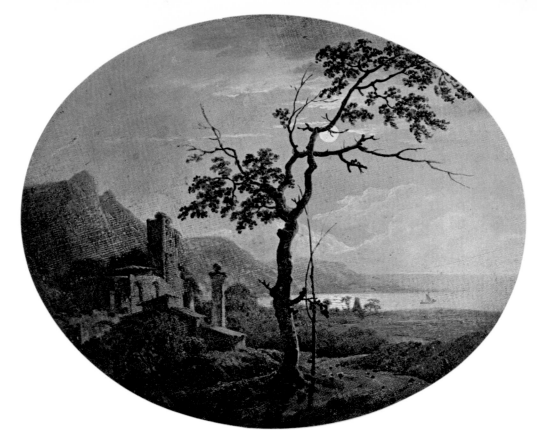

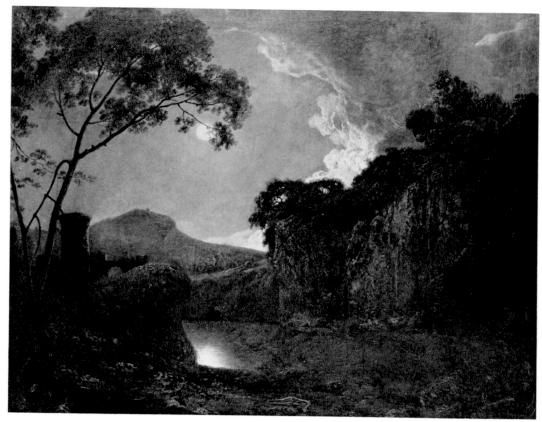

Plate 235 *Classical Villa by sea shore* 1782
12 x 14 in / 30.5 x 33.5 cm
Private collection U.K. Cat 255

Plate 236 *Landscape with ruins, by moonlight*
? c 1780–82
25 x 30 in / 63.5 x 76.2 cm
Miss D. M. R. Cade Cat 305

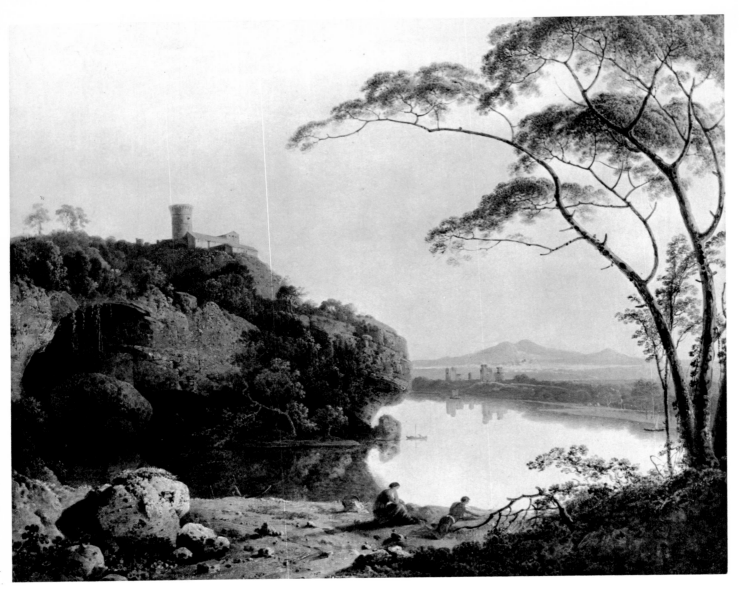

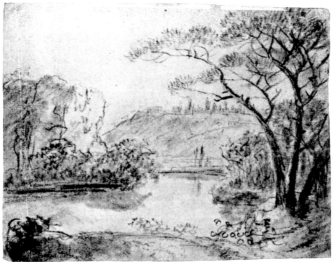

Plate 237 *Lake of Nemi, Sunset* c 1780–82
24¼ x 29¾ in / 61.6 x 75.5 cm
Private collection U.K. Cat 252

Plate 238 Study for Plate 237 c 1780–81
Black chalk with white heightening and wash
on light green paper
7¼ x 9 in / 18.4 x 22.8 cm
Derby Museum and Art Gallery

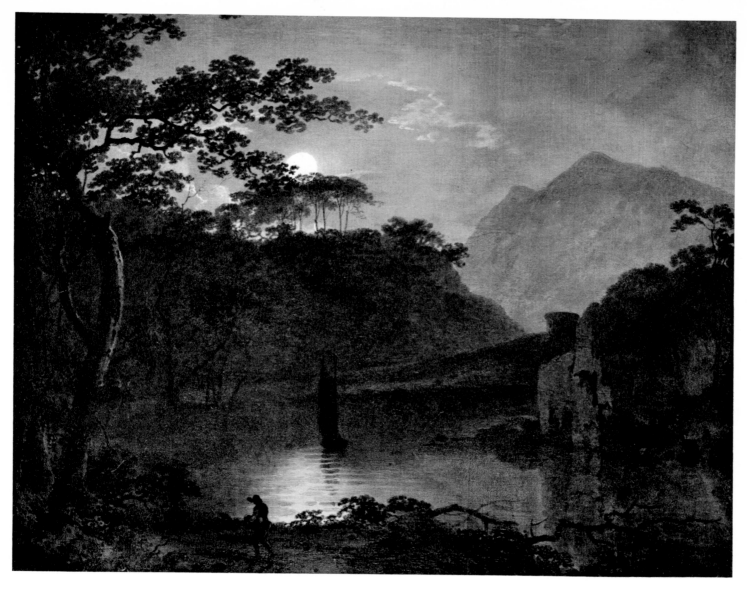

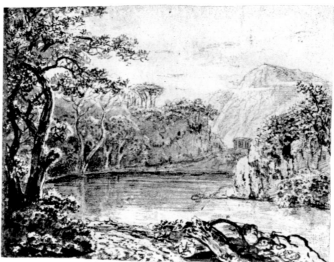

Plate 239 *Lake by Moonlight* c 1780–82
24¼ x 29¾ in / 61.6 x 75.5 cm
Mr and Mrs Paul Mellon Cat 253

Plate 240 Study for Plate 239 ? c 1780–81
Pen and wash with white heightening on light
green paper
7¼ x 9 in / 18.4 x 22.8 cm
Derby Museum and Art Gallery

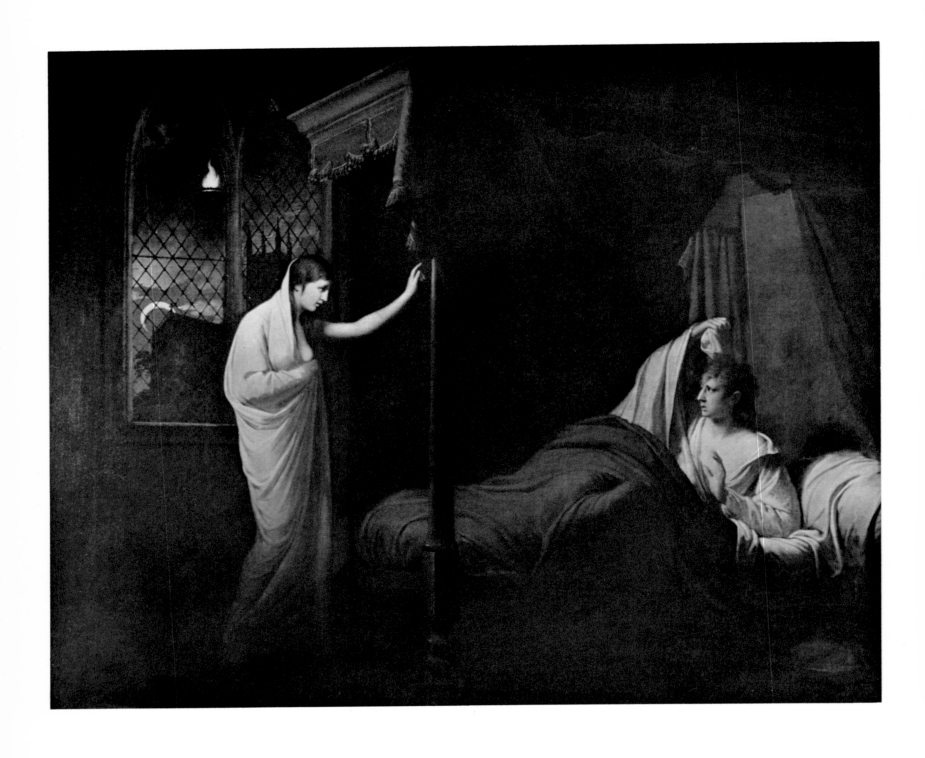

Plate 241 *William and Margaret* c 1784–85
48 x 56 in / 121.9 x 142.2 cm
Colonel Sir John Crompton-Inglefield:
on loan to Judges' Lodgings, Derby Cat 226

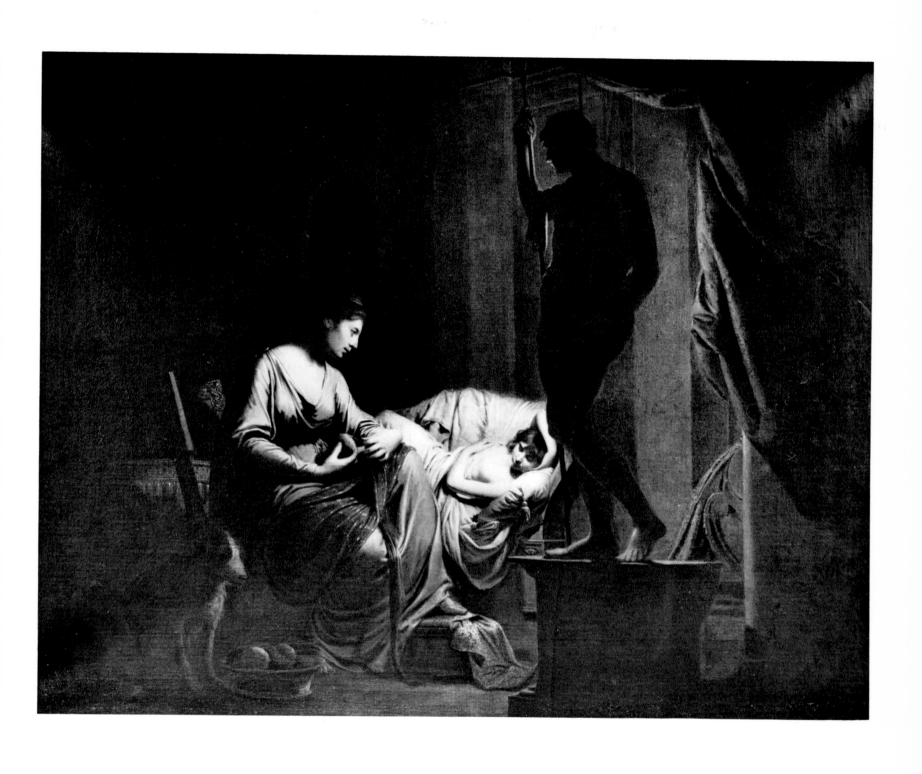

Plate 242 *Penelope unravelling her Web* 1783–84
40 x 50 in / 101.6 x 127 cm
Mr and Mrs Hensleigh Wedgwood Cat 225

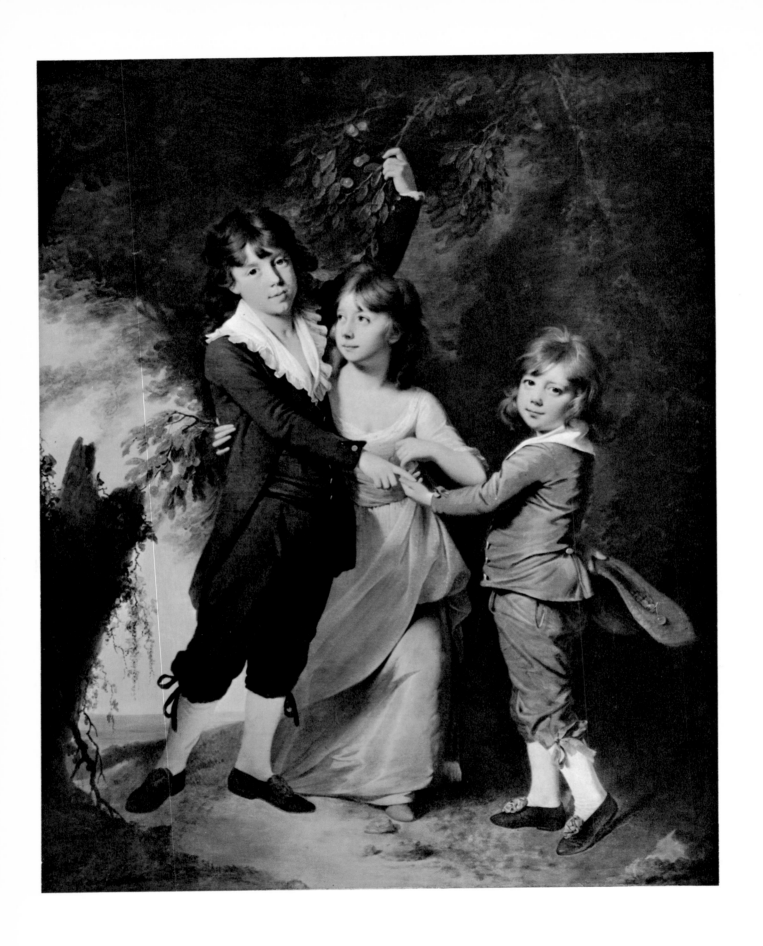

Plate 243 *Leaper Children* c 1785
68 x 54 in / 172.7 x 137.2 cm
Private collection U.K. Cat 100

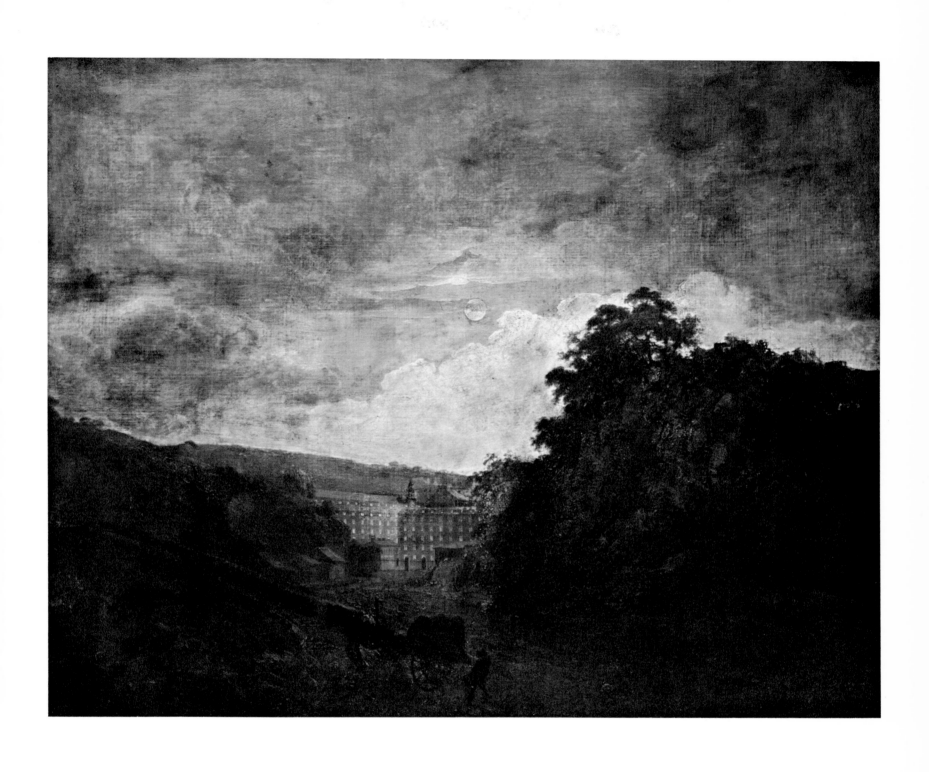

Plate 244 *Arkwright's Cotton Mills, by night* c 1782–83
34 x 45 in / 86.3 x 114.3 cm
I. M. Booth Cat 311

155

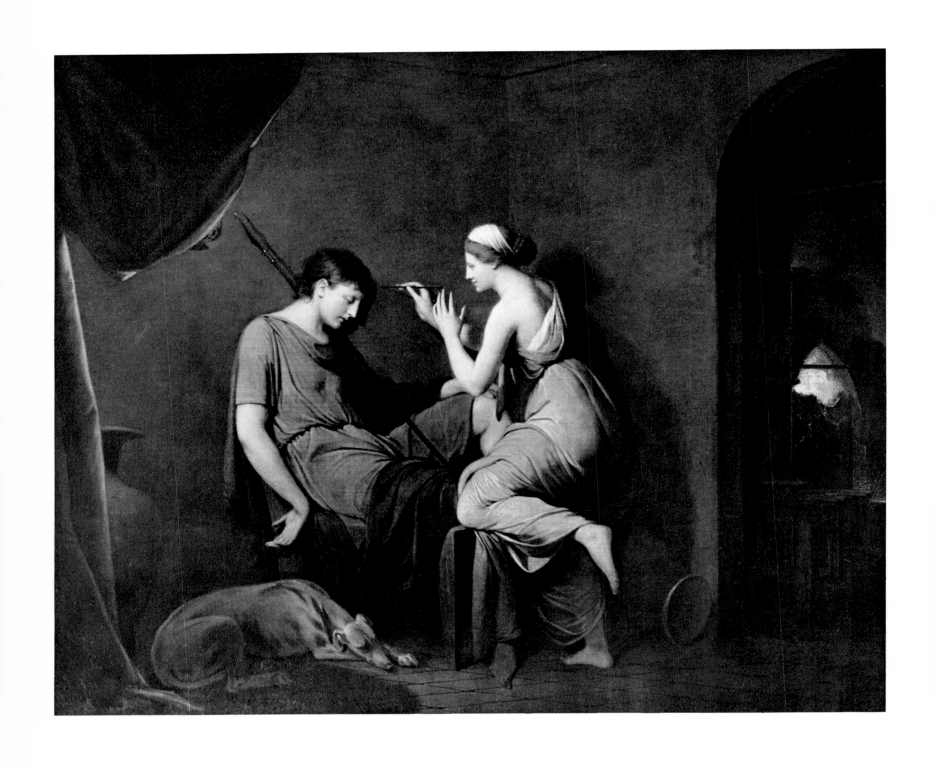

Plate 245 *The Corinthian Maid* c 1783–84
42 x 50 in / 106.7 x 127 cm
Mr and Mrs Paul Mellon Cat 224

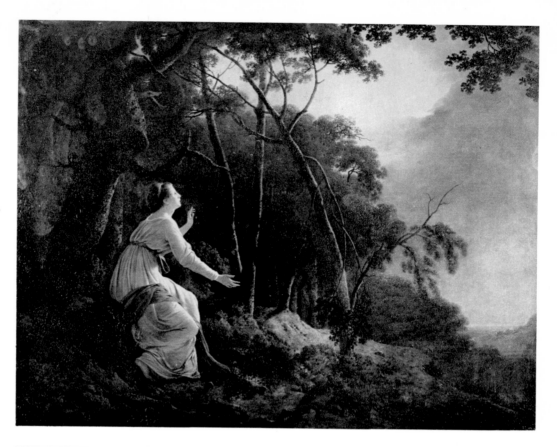

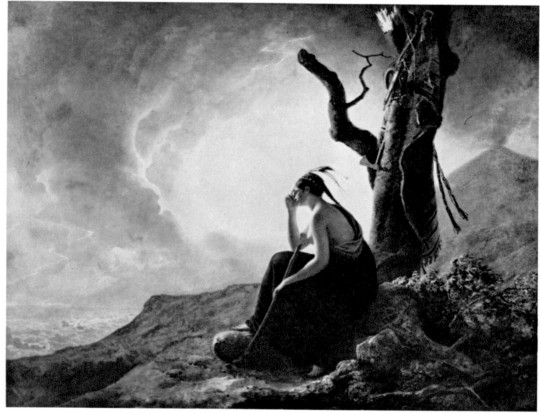

Plate 246 *The Lady in Milton's 'Comus'* 1784
40½ x 50¾ in / 102.8 x 128.9 cm
Walker Art Gallery, Liverpool Cat 234

Plate 247 *The Indian Widow* 1783–85
40 x 50 in / 101.6 x 127 cm
Derby Museum and Art Gallery Cat 243

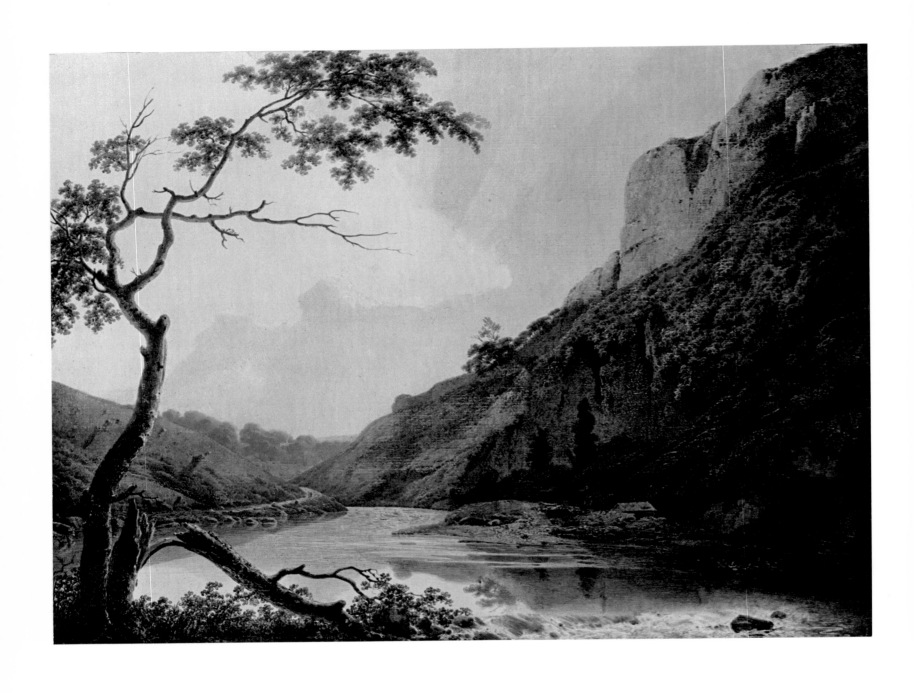

Plate 248 *Matlock Tor, daylight* mid-'80's
28½ x 38½ in / 72.4 x 97.8 cm
Fitzwilliam Museum, Cambridge Cat 310

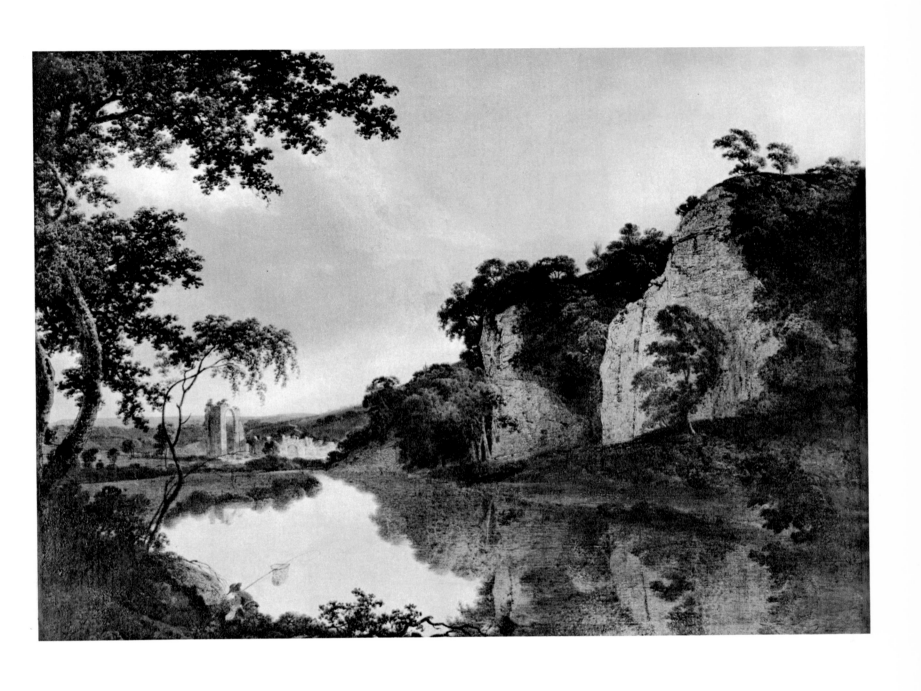

Plate 249 *Landscape with Dale Abbey* c 1785
$28\frac{1}{2}$ x 39 in / 72.4 x 99 cm
Sheffield City Art Galleries Cat 331

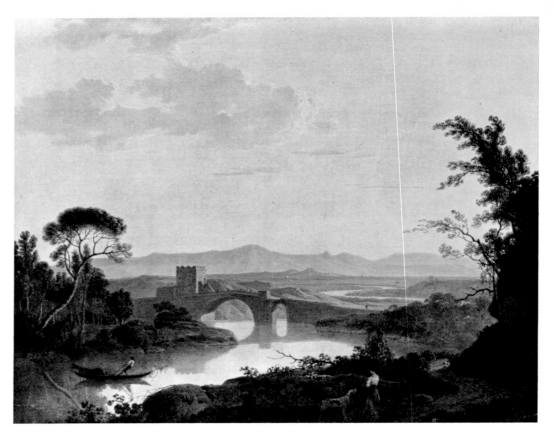

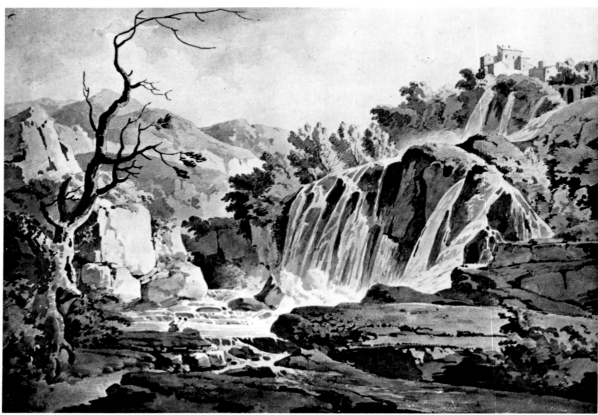

Plate 250 *Bridge with Turret over Winding River* 1785
30 x 38 in / 76.2 x 96.5 cm
Royal Borough of Kensington and Chelsea Public Libraries
(Leighton House) Cat 291

Plate 251 *Cascade at Tivoli* ? c 1786
Pencil and watercolour, sight size $14\frac{1}{2}$ x $20\frac{1}{4}$ in / 36.8 x 51.4 cm
Derby Museum and Art Gallery

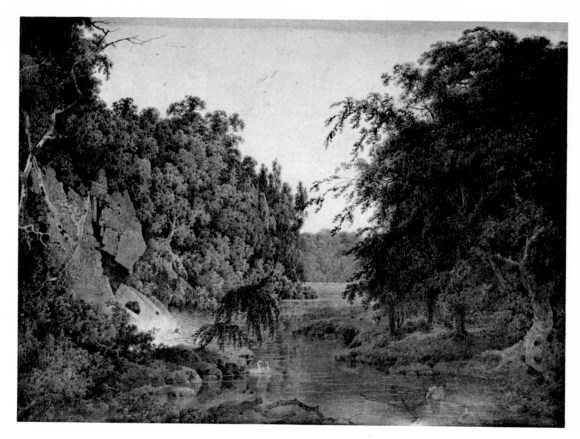

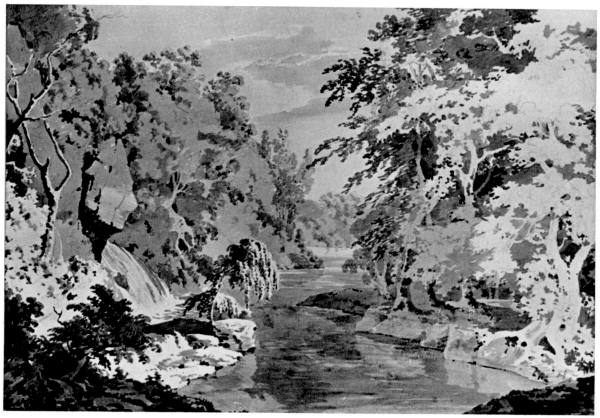

Plate 252 'Dovedale' 1786
25 x 33 in / 63.5 x 83.8 cm
Mrs George Anson Cat 319

Plate 253 Study for Plate 252 c 1786
Wash 14¼ x 21 in / 36 x 53 cm
Derby Museum and Art Gallery.

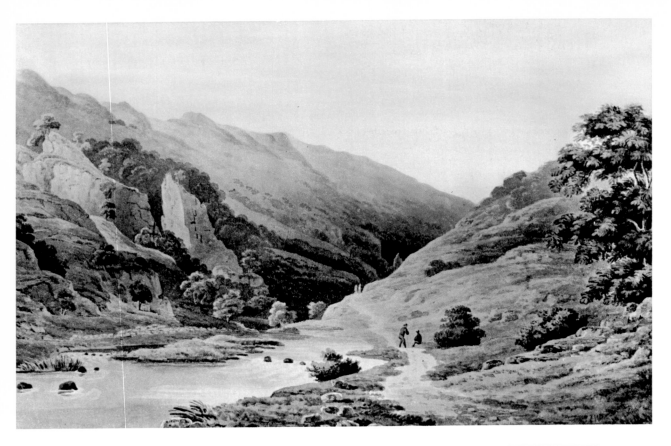

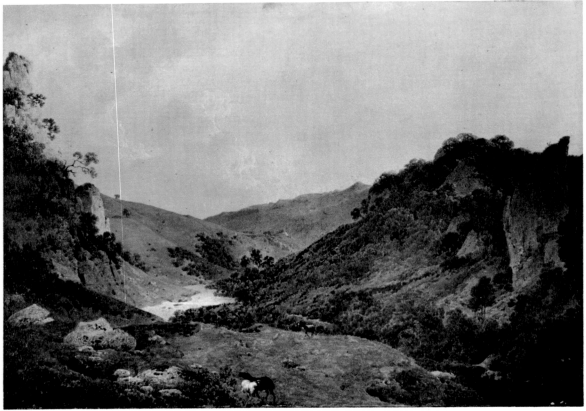

Plate 254 'Dovedale' ? early to mid-'80's
Watercolour 17 x 10 in / 43.2 x 25.4 cm
Derby Museum and Art Gallery

Plate 255 *View in Dovedale* 1786
18 x 25 in / 45.7 x 63.5 cm
Viscount Scarsdale Cat 315

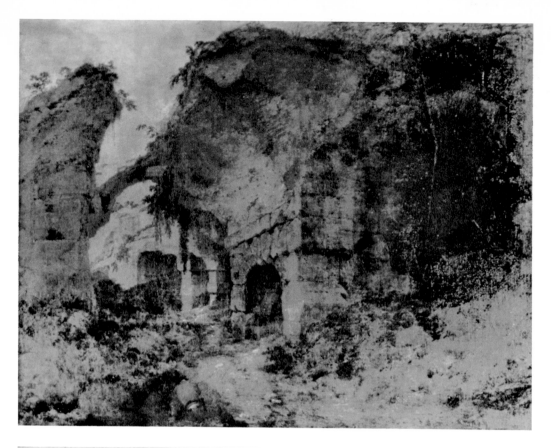

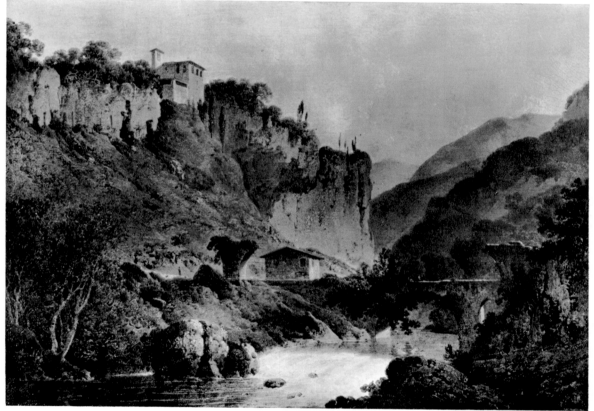

Plate 256 *The Colosseum, daylight* ? mid-'80's
41 x 51 in / 104 x 129 cm
Derby Museum and Art Gallery Cat 246

Plate 257 *Convent of S. Cosimato* 1786
18 x 25 in / 45.7 x 63.5 cm
Viscount Scarsdale Cat 262

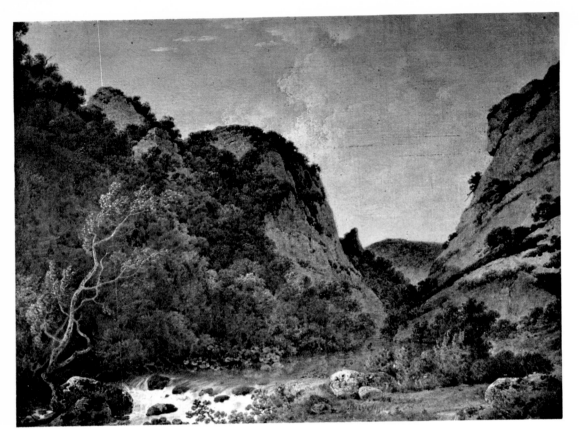

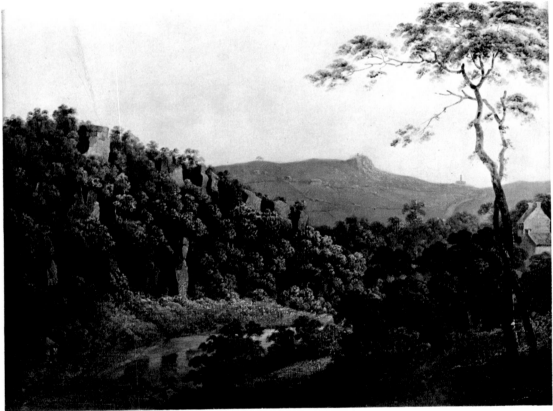

Plate 258 *Dovedale in Sunlight* c 1784–88
25 x 31 in / 63.5 x 78.7 cm
Colonel Sir John Crompton-Inglefield Cat 316

Plate 259 *View of the Boathouse near Matlock*
? mid-'80's
23 x 30 in / 58.5 x 76 cm
Mr and Mrs Paul Mellon Cat 303

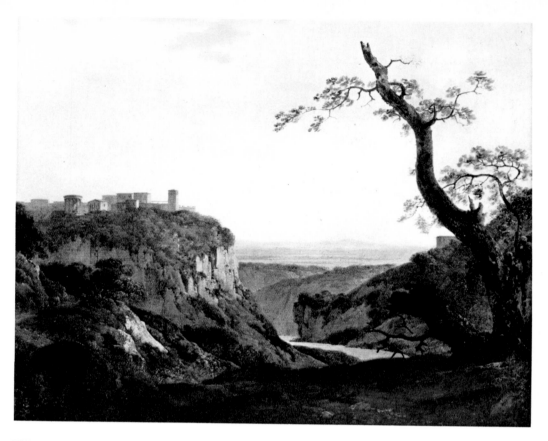

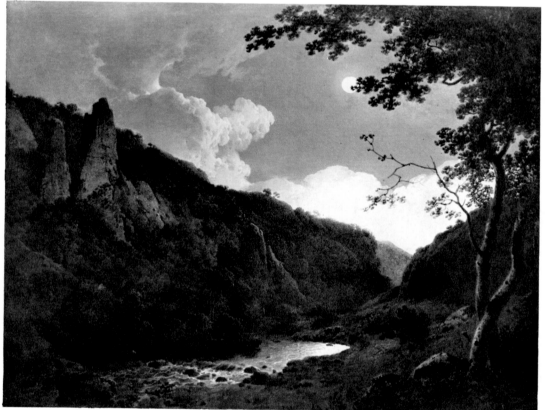

Plate 260 *View of Tivoli* ? c 1783–86
30 x 38 in / 76.2 x 96.5 cm
Derby Museum and Art Gallery Cat 265

Plate 261 *Dovedale by Moonlight* c 1784–88
25 x 31 in / 63.5 x 78.7 cm
Allen Memorial Museum, Oberlin College
Cat 317

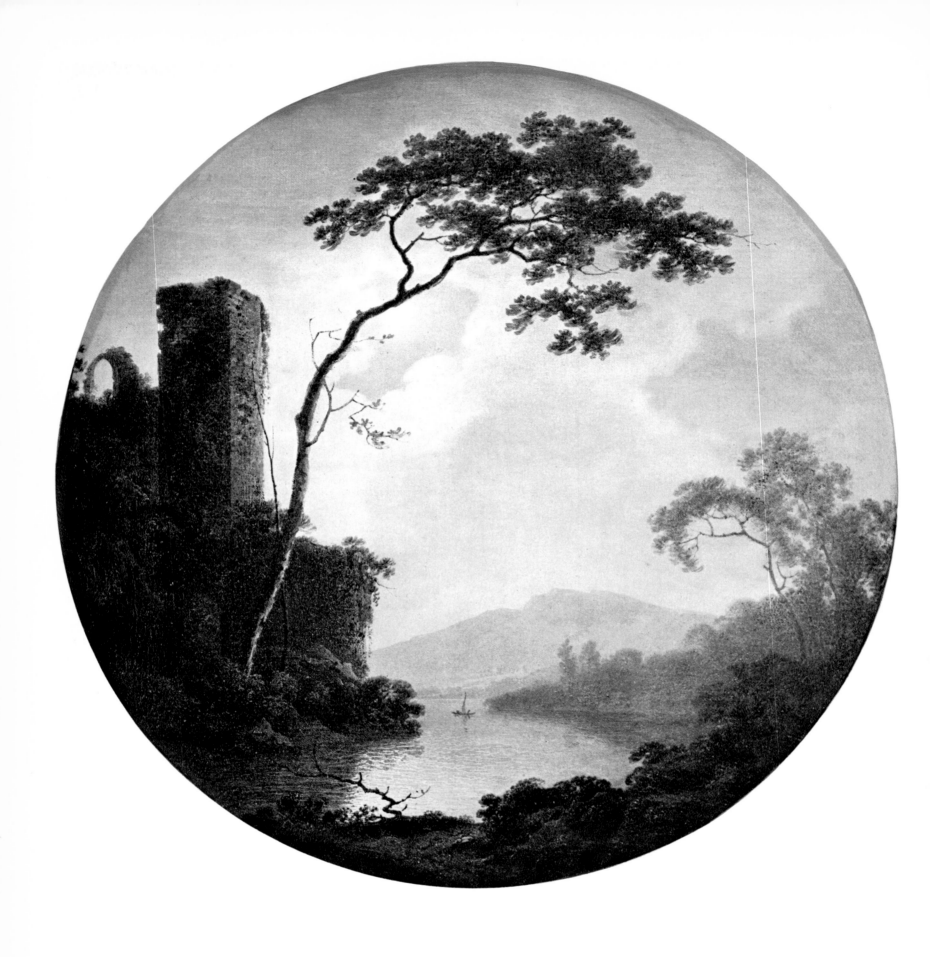

Plate 262 *Lake with Castle on a Hill* 1787
Diameter 24 in / 60.9 cm
Gooden & Fox Ltd Cat 330

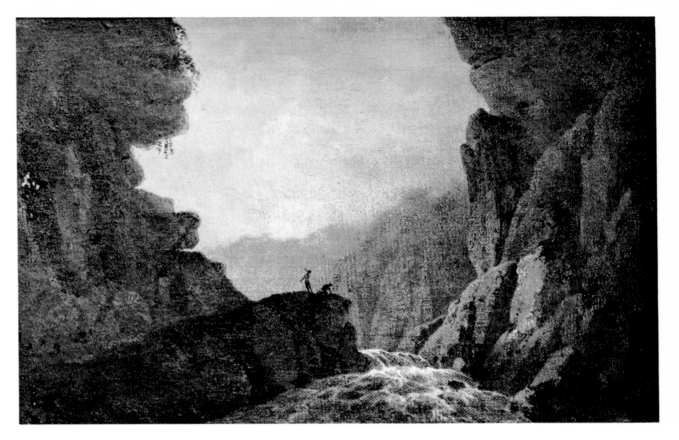

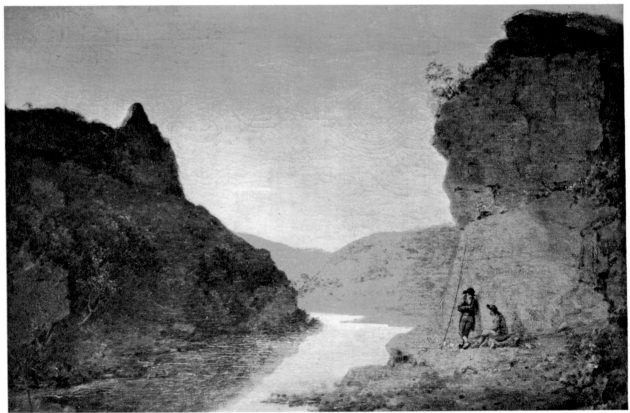

Plate 263 *River in a Rocky Gorge* 1787
11½ x 17 in / 29.2 x 43.2 cm
Private collection U.K. Cat 327

Plate 264 *Dovedale, morning* c 1787–90
20 x 29 in / 50.8 x 73.6 cm
H. R. Edwards Cat 318

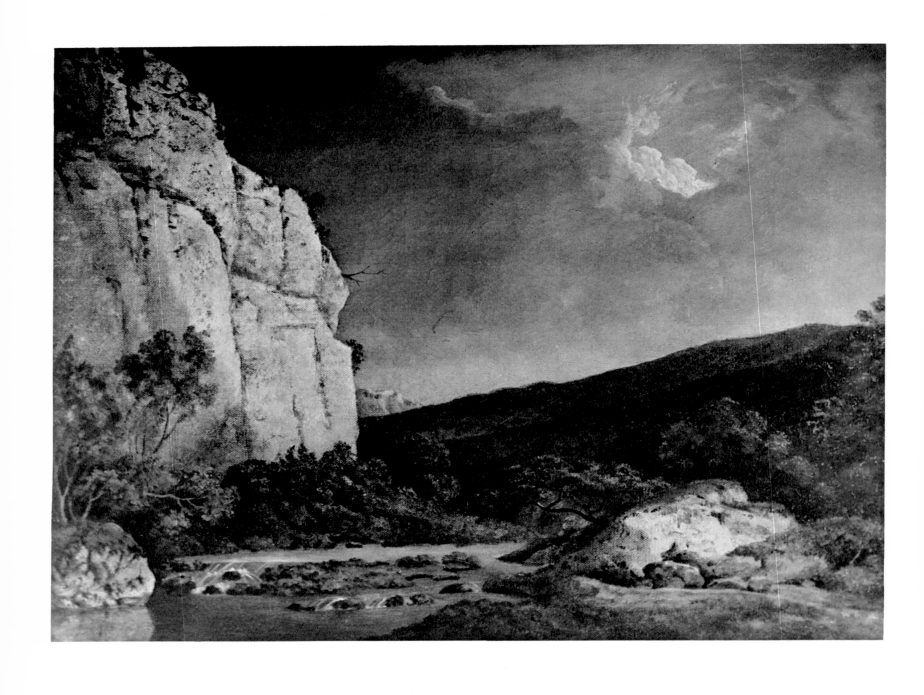

Plate 265 *Chee Tor* ? late '80's
17 x 23 in / 43.1 x 58.4 cm
Colonel Sir John Crompton-Inglefield Cat 302

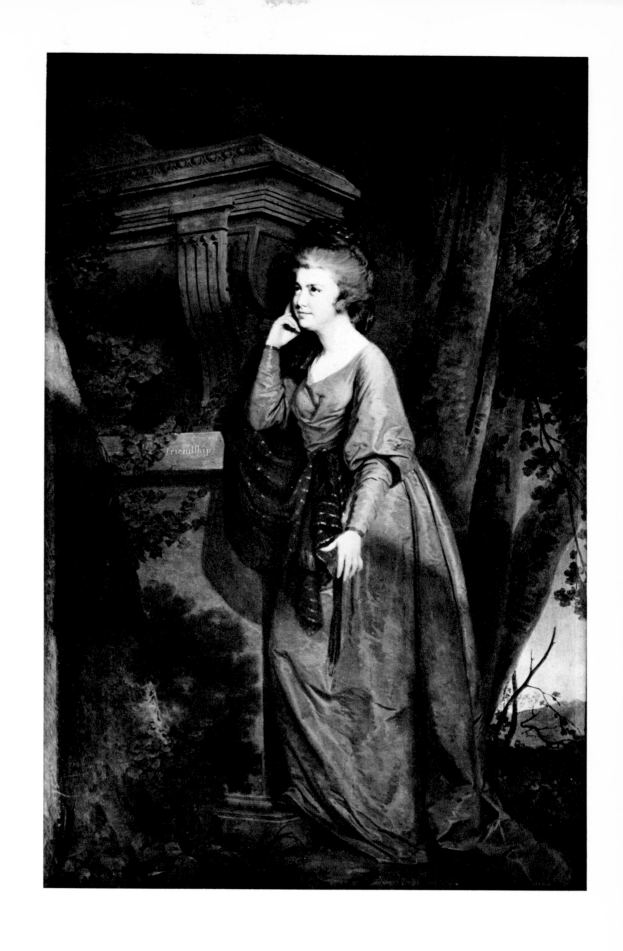

Plate 266 *Dorothy Gell of Hopton* 1786
93½ x 57 in / 236.8 x 144.8 cm
Lieut Colonel John Chandos-Pole O.B.E. Cat 65

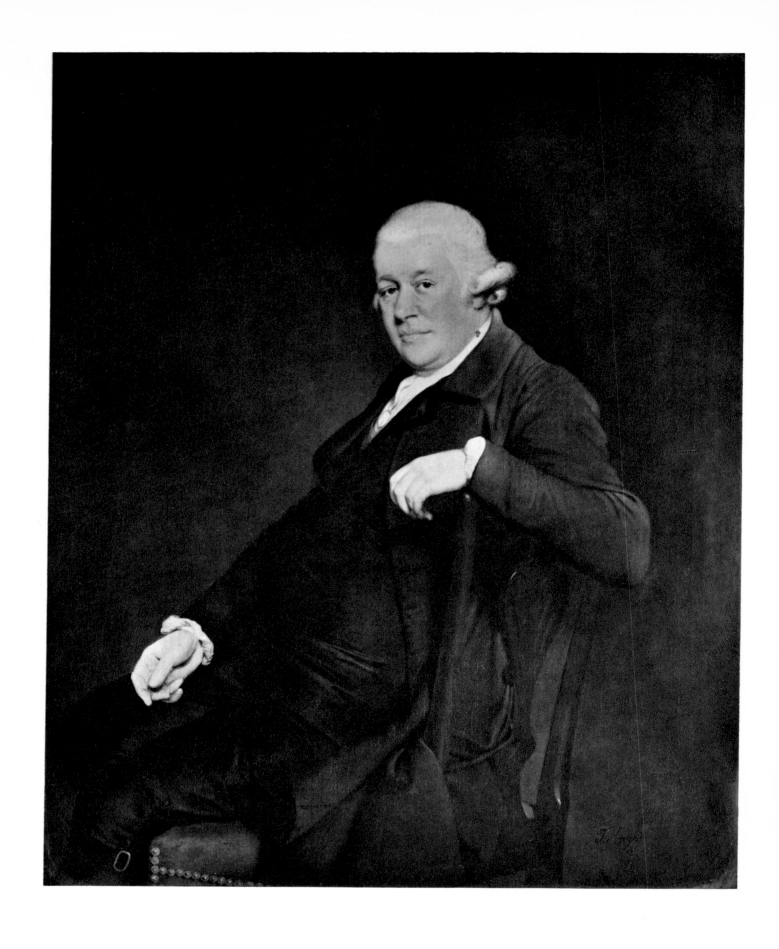

Plate 267 *Rev Basil Bury Beridge* c 1785
50 x 40 in / 127 x 101.6 cm
Kunsthistorisches Museum, Vienna Cat 17

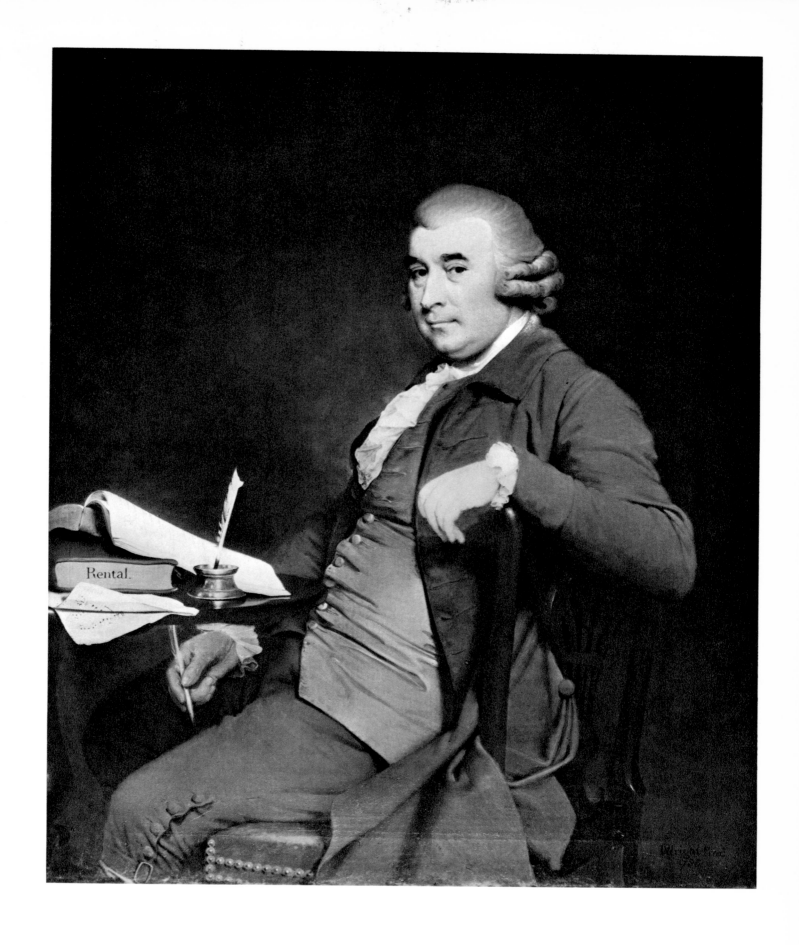

Plate 268 'Stephen' Jones 1785
50 x 40 in / 127 x 101.6 cm
Sir Gilbert Inglefield Cat 97

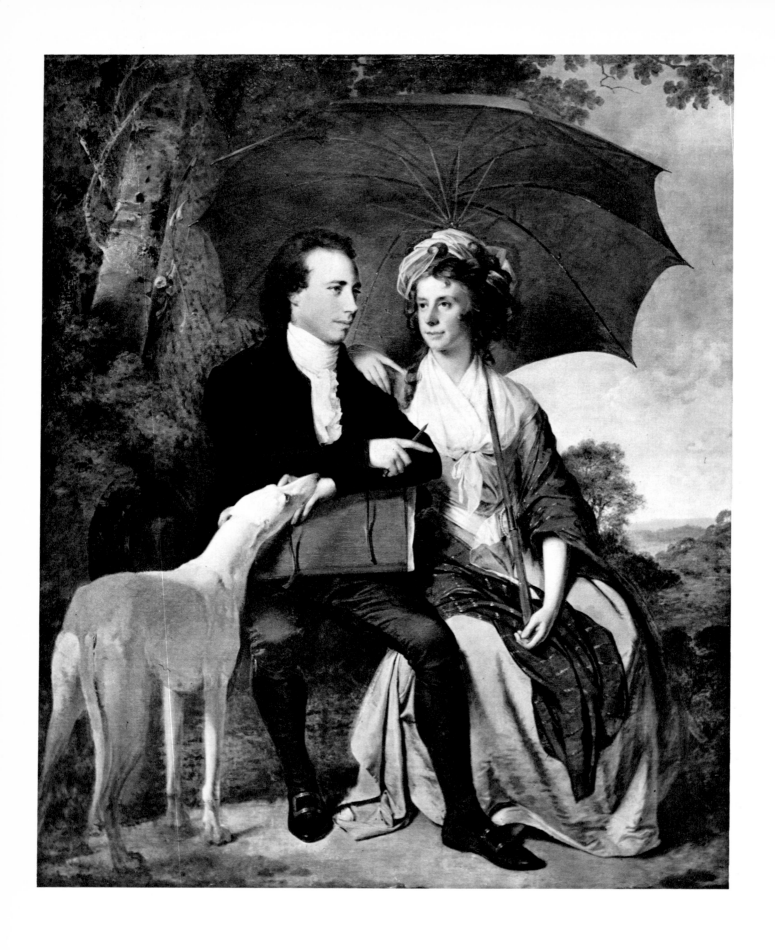

Plate 269 *The Rev and Mrs Thomas Gisborne* 1786
74 x 60 in / 188 x 152.4 cm
Mr and Mrs Paul Mellon Cat 67

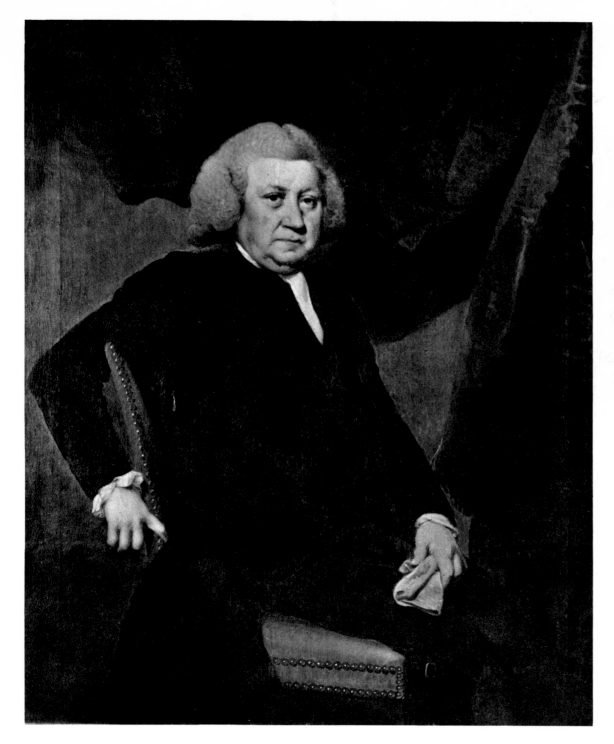

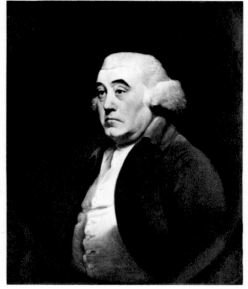

Plate 271 'Dr Richard Wright'
c 1785–87
30 x 25 in / 76.2 x 63.5 cm
Mr and Mrs Paul Mellon Cat 173

Plate 270 Thomas Pares c 1785–88
50 x 40 in / 127 x 101.6 cm
Major J. Pares Cat 116

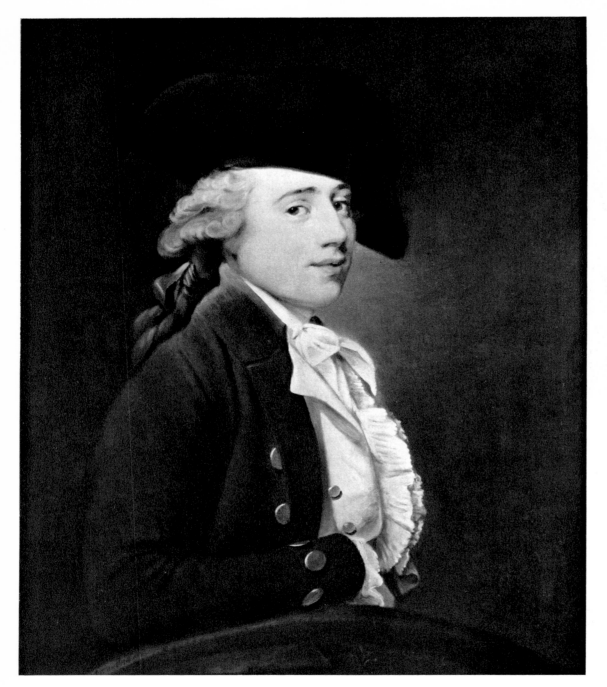

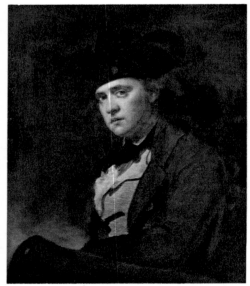

Plate 273 *Richard Wright* c 1786–88
30 x 25 in / 76.2 x 63.5 cm
Private Collection U.K. Cat 179

Plate 272 Copy after Joseph Wright *Captain Salmon* c 1787–88
30 x 25 in / 76.2 x 63.5 cm
Private Collection U.K. See page 218

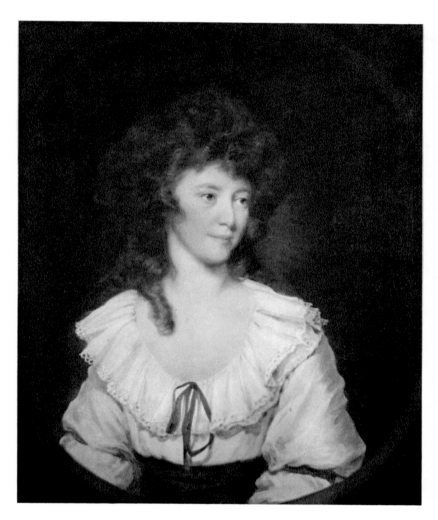

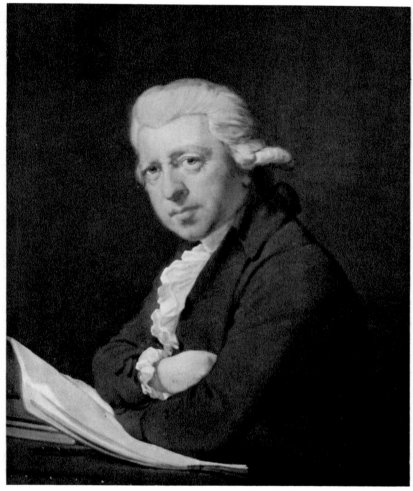

Plate 274 *Mrs Holland of Ford* c 1787
30 x 25 in / 76.2 x 63.5 cm
Gladwyn Turbutt Cat 86

Plate 275 *John Holland of Ford* 1787
30 x 25 in / 76.2 x 63.5 cm
Gladwyn Turbutt Cat 85

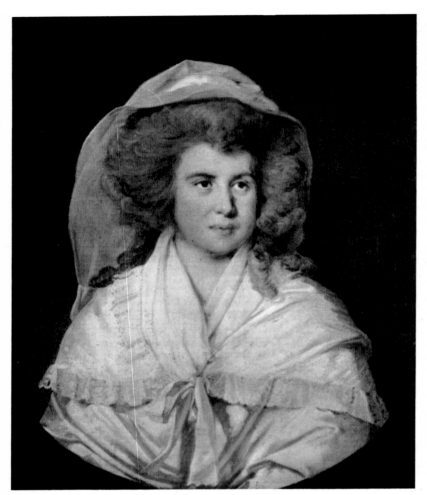

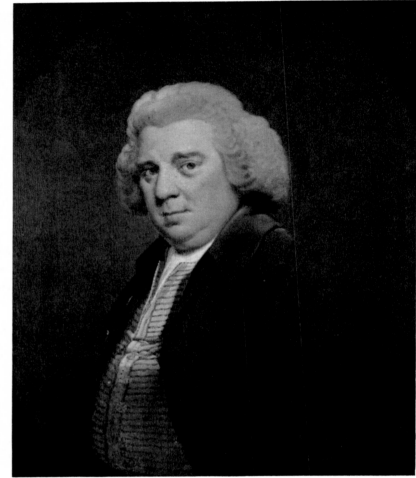

Plate 276 *Sarah Wood* c 1789
30 x 25 in / 76.2 x 63.5 cm
Private Collection U.K. Cat 153

Plate 277 *Hugh Wood* c 1789
30 x 25 in / 76.2 x 63.5 cm
Private Collection U.K. Cat 152

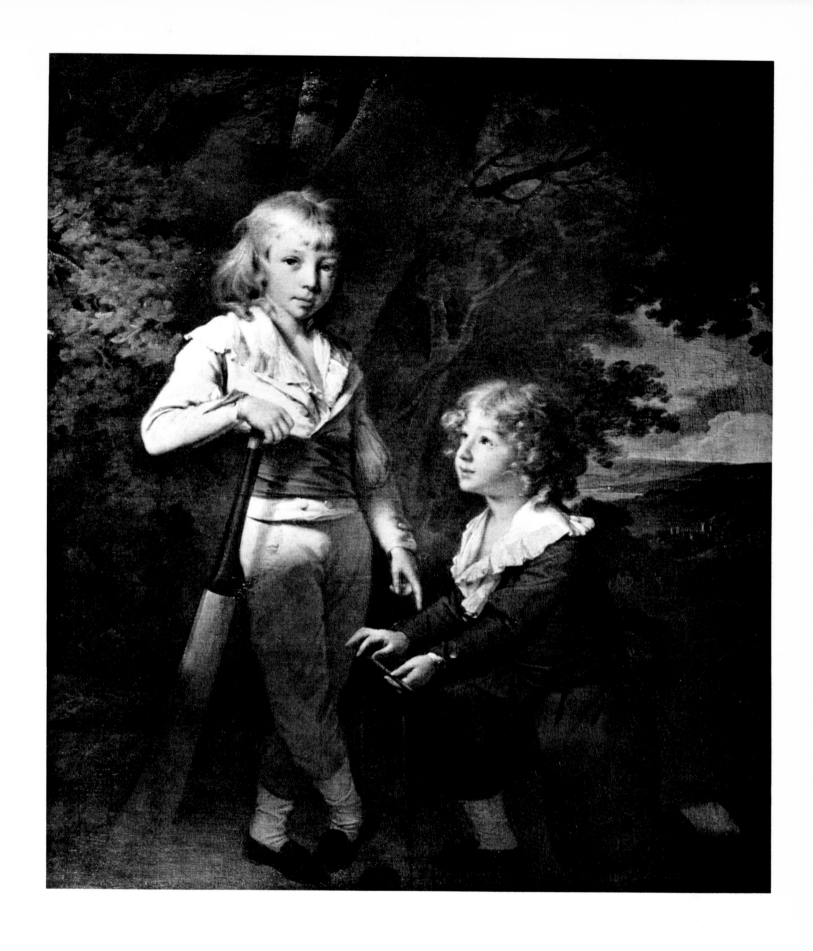

Plate 278 *Thornhill Children* c 1789–90
57 x 48½ in / 144.8 x 123.2 cm
Private Collection U.K. Cat 136

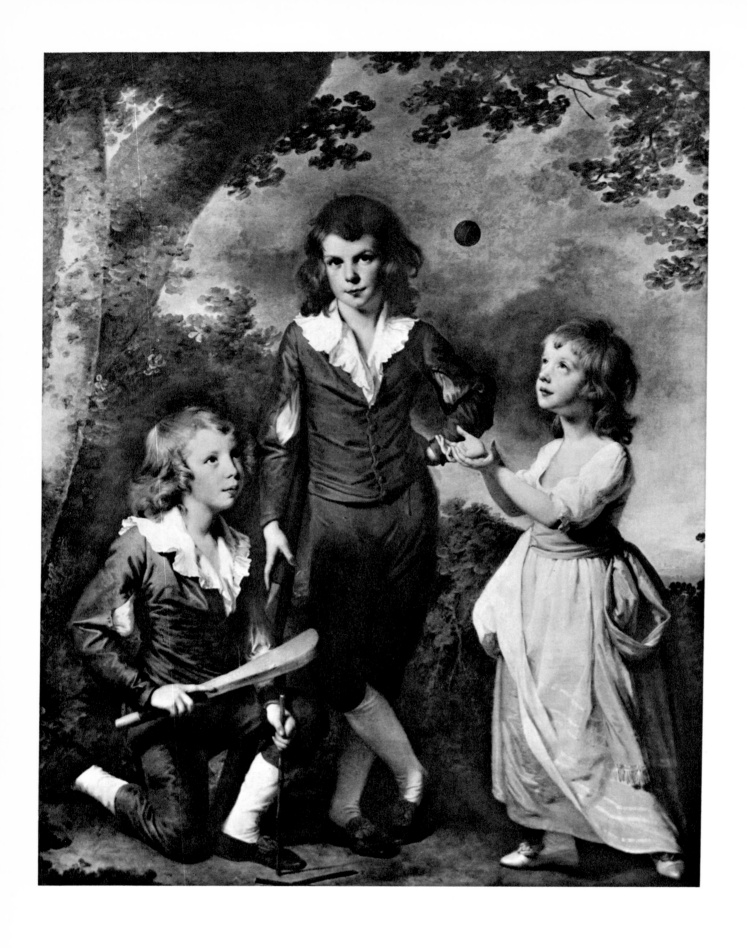

Plate 279 *Wood Children* 1789
66 x 53 in / 167.7 x 134.7 cm
Derby Museum and Art Gallery Cat 151

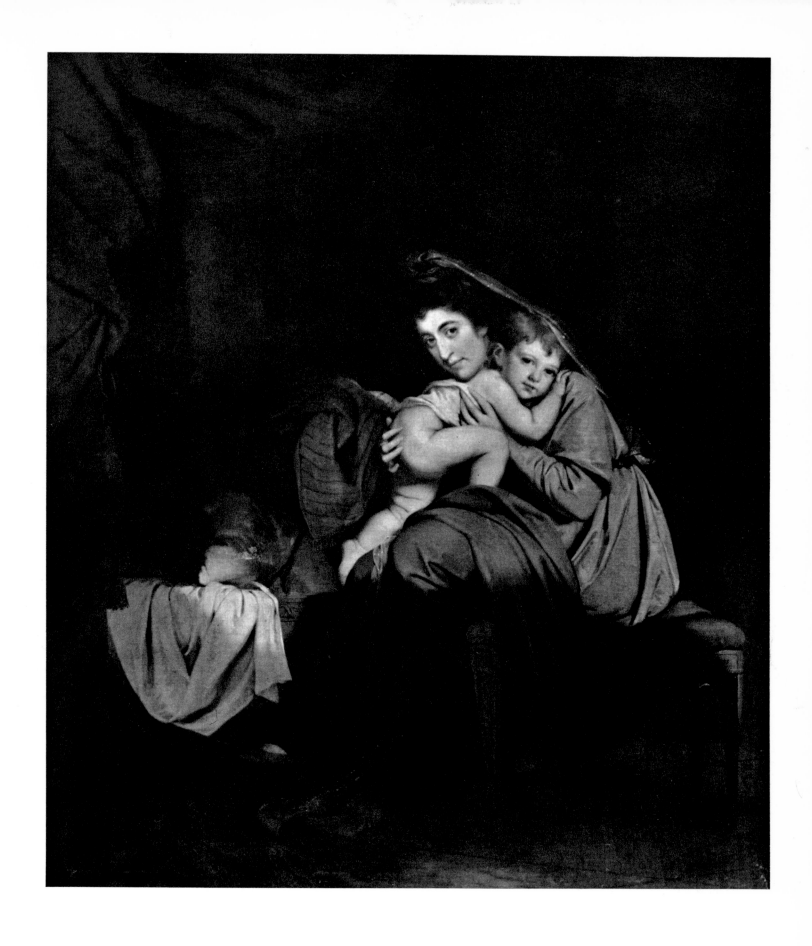

Plate 280 *Lady Wilmot and her Child* 1788
c 79 x 66 in / 200 x 167.7 cm
Mrs George Anson Cat 149

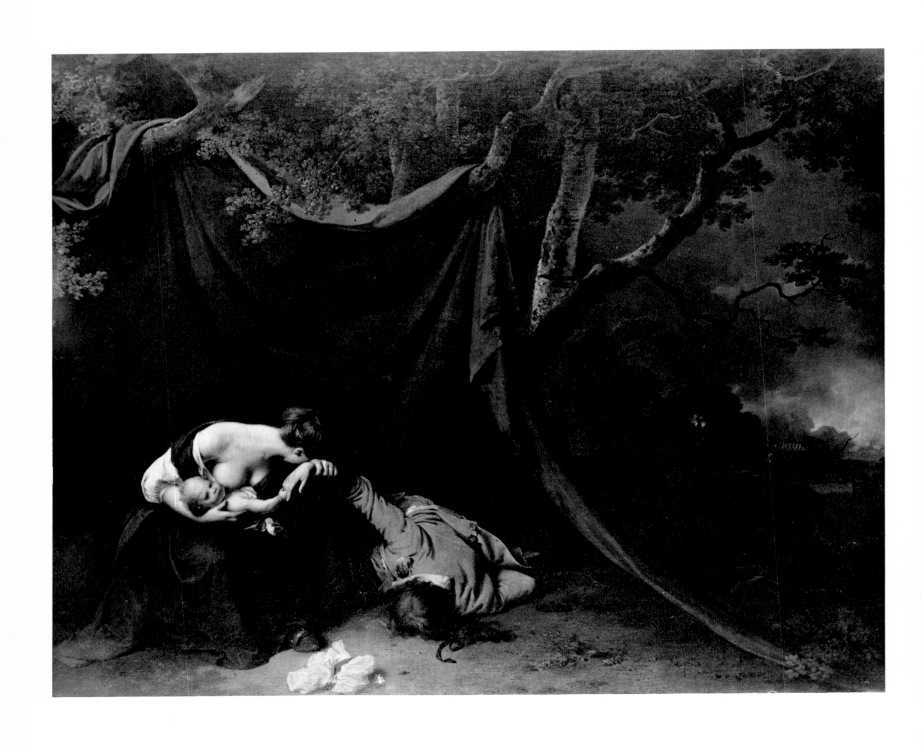

Plate 281 *The Dead Soldier* 1789
40 x 50 in / 101.6 x 127 cm
James Ricau Cat 240

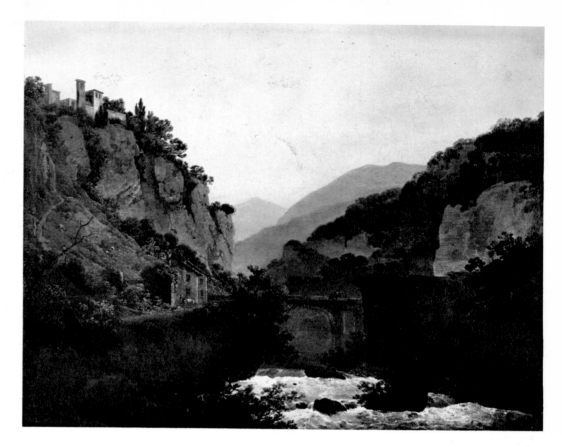

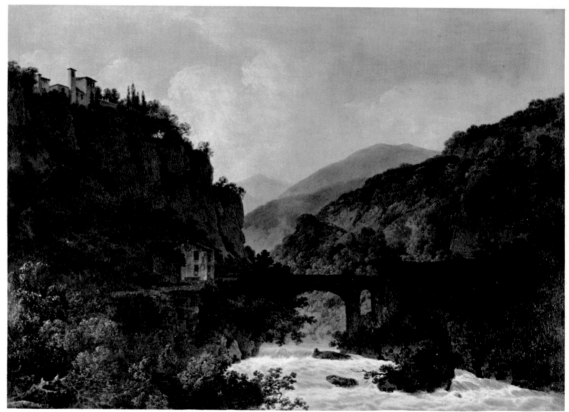

Plate 282 *Convent of S. Cosimato* c 1787–90
19⅞ x 25 in / 50.5 x 63.5 cm
Walker Art Gallery, Liverpool Cat 264

Plate 283 *Convent of S. Cosimato* 1789
24 x 32 in / 60.9 x 81.3 cm
J. T. Blundell-Turner on loan to Derby Museum and Art
Gallery Cat 263

181

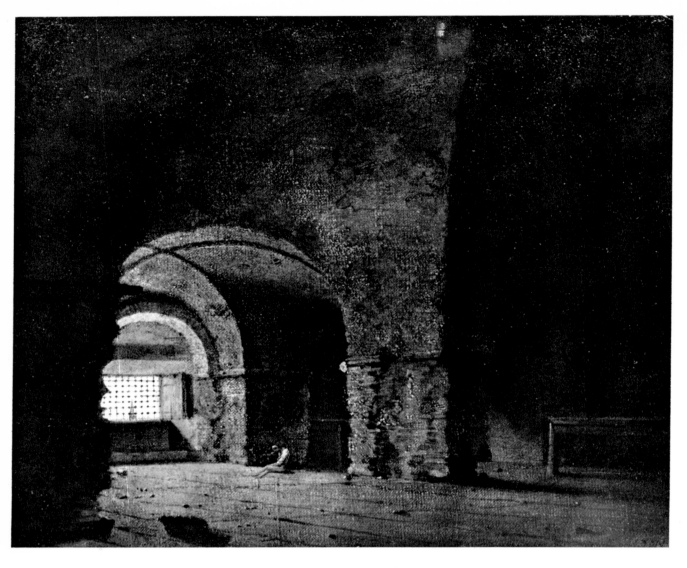

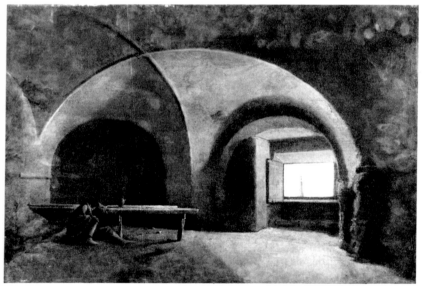

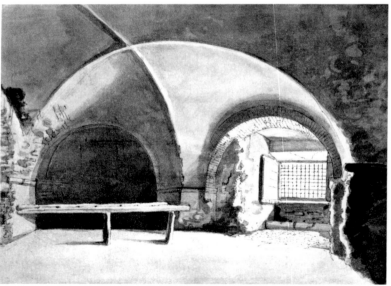

Plate 284 *Small Prison Scene* c 1787–90
15½ x 18½ in / 39.4 x 47 cm
Mr and Mrs Paul Mellon Cat 218

Plate 286 *Interior of a prison*
Grey wash with brown ink, touches of pencil under drawing
13 x 17½ in / 33 x 44.4 cm
H. Cornish Torbock

Plate 285 *Small Prison scene*
19 x 27 in / 48.2 x 68.5 cm
Private Collection U.K. Cat 219

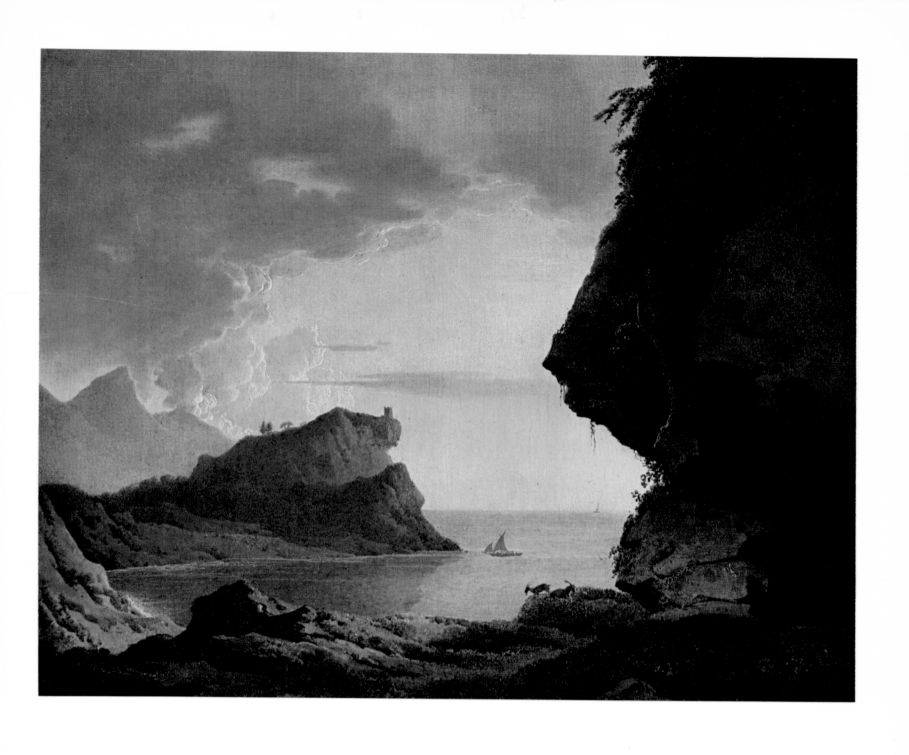

Plate 287 *Sunset on the Coast near Naples* ? mid to late '80's
25 x 29$\frac{7}{8}$ in / 63.5 x 75.9 cm
Sir Gilbert Inglefield Cat 284

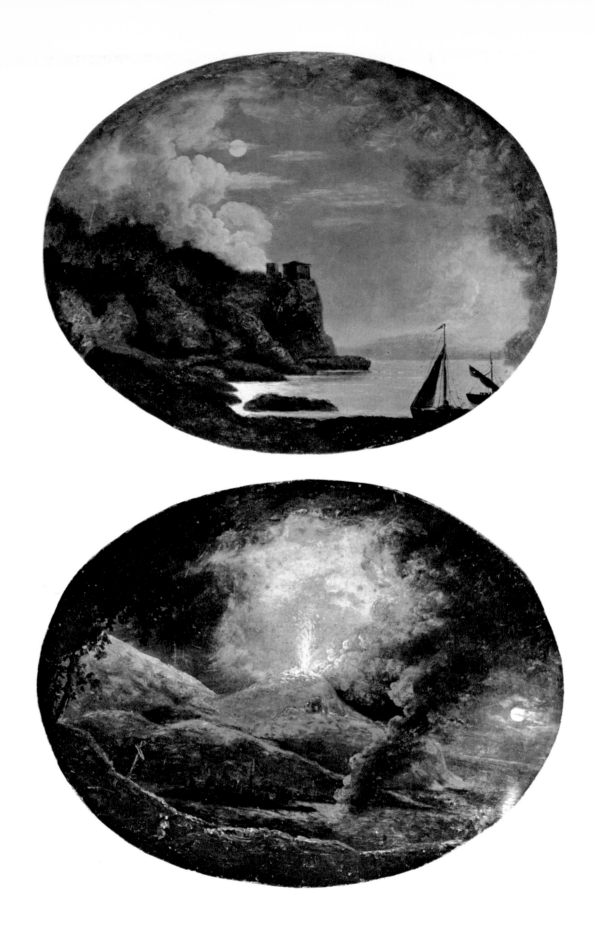

Plate 288 *Vesuvius from Posillipo* ? late '80's
Copper 7½ x 9 in / 19 x 22.8 cm
Christopher Norris Cat 271

Plate 289 *Vesuvius in eruption* ? late '80's
Copper, 7½ x 9 in / 19. x 22.8 cm
Christopher Norris Cat 272

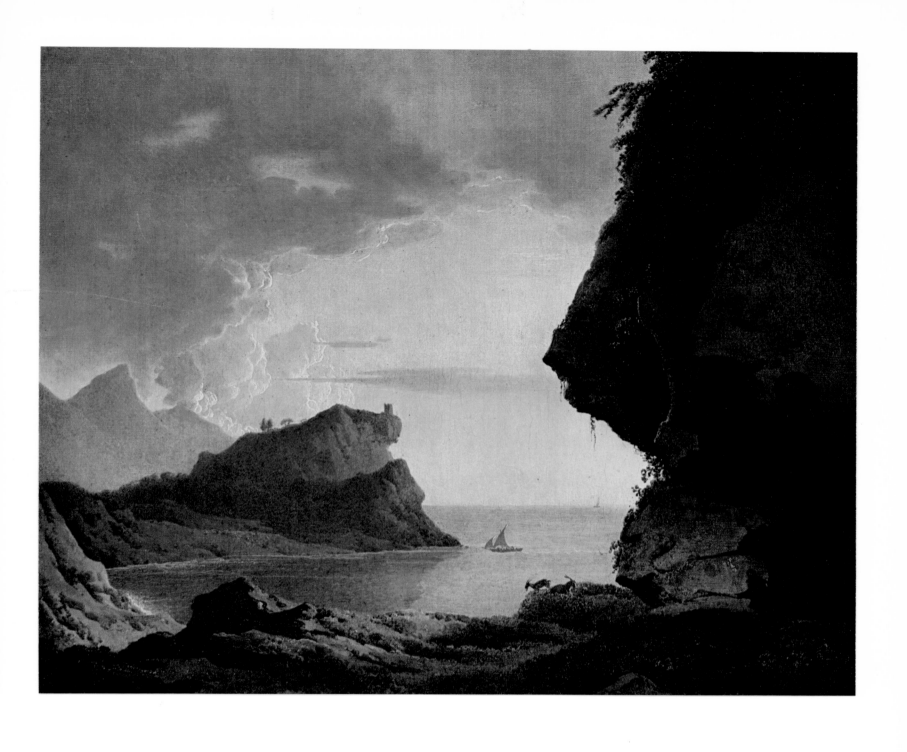

Plate 287 *Sunset on the Coast near Naples* ? mid to late '80's
25 x 29⅞ in / 63.5 x 75.9 cm
Sir Gilbert Inglefield Cat 284

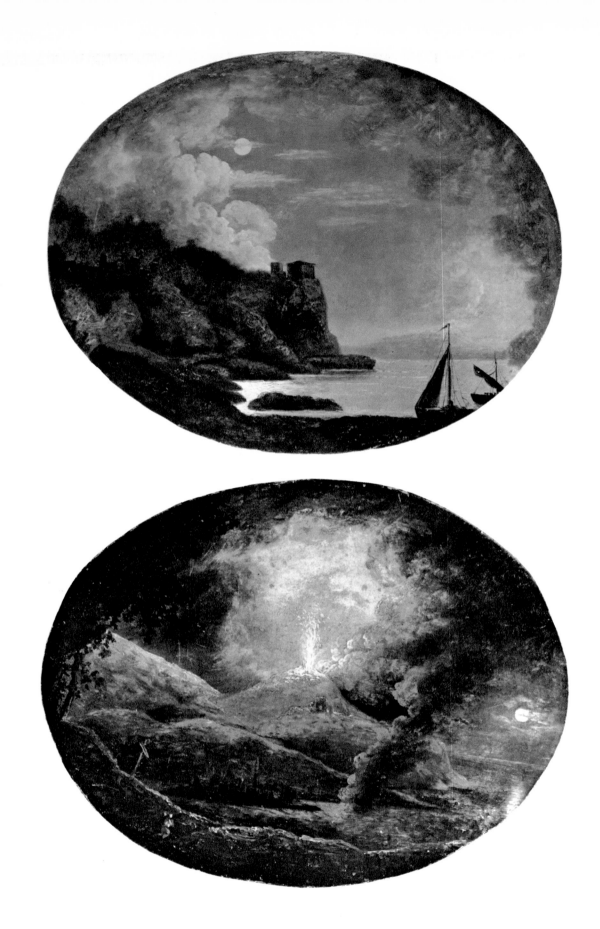

Plate 288 *Vesuvius from Posillipo* ? late '80's
Copper 7½ x 9 in / 19 x 22.8 cm
Christopher Norris Cat 271

Plate 289 *Vesuvius in eruption* ? late '80's
Copper, 7½ x 9 in / 19. x 22.8 cm
Christopher Norris Cat 272

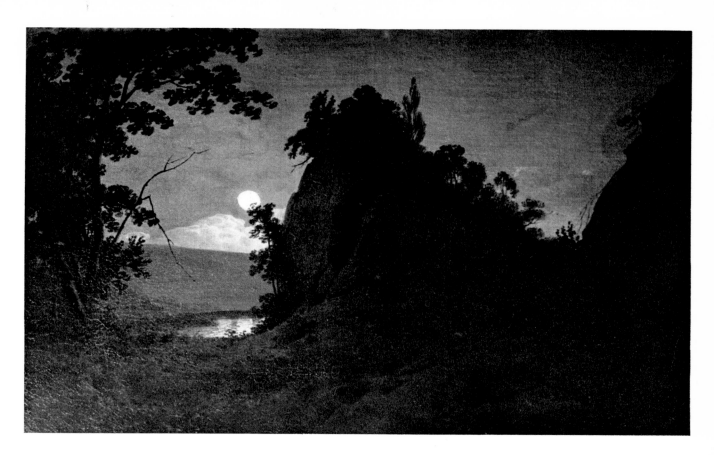

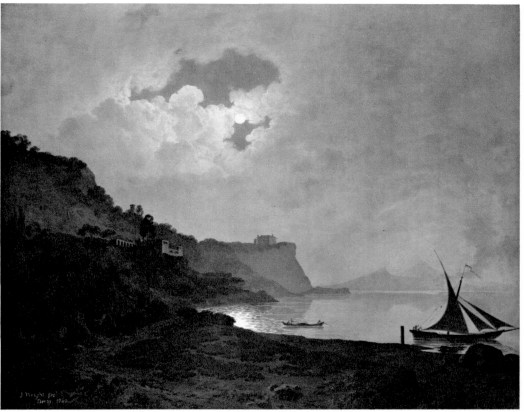

Plate 290 *View near Matlock by moonlight*
? c 1788–90
15 x 23⅛ in / 38.1 x 58.7 cm
Colonel Sir John Crompton-Inglefield;
on loan to the Judges' Lodgings, Derby
Cat 306

Plate 291 *Vesuvius from Posillipo* 178(9?)
40½ x 50½ in / 102.8 x 128.2 cm
Major Peter Miller Mundy Cat 267

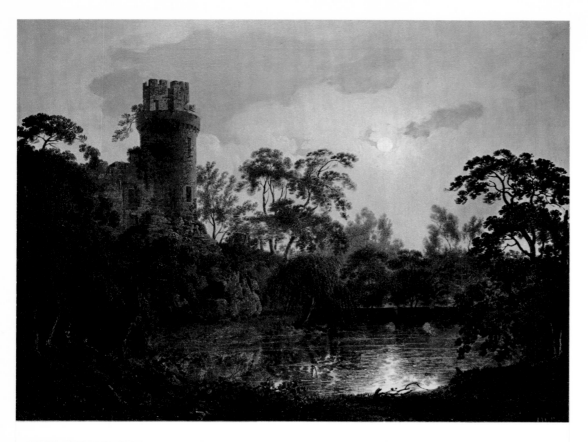

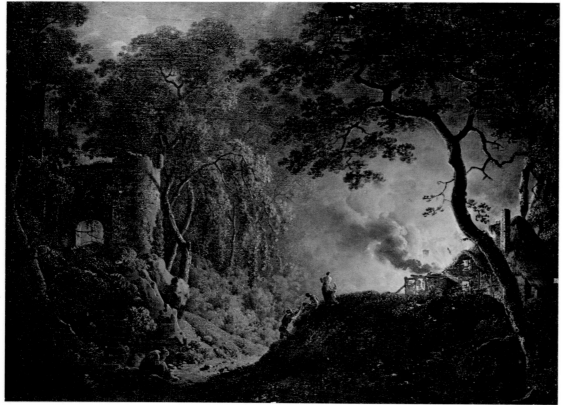

Plate 292 *Lake by Moonlight with Castle on Hill* 178(8?)
22⅞ x 30 in / 58 x 76.2 cm
Palmer–Morewood Collection;
on loan to Brighton Art Gallery Cat 333

Plate 293 *Cottage on Fire* c 1787–88
22⅞ x 30 in / 58 x 76.2 cm
Palmer–Morewood Collection;
on loan to Brighton Art Gallery Cat 334

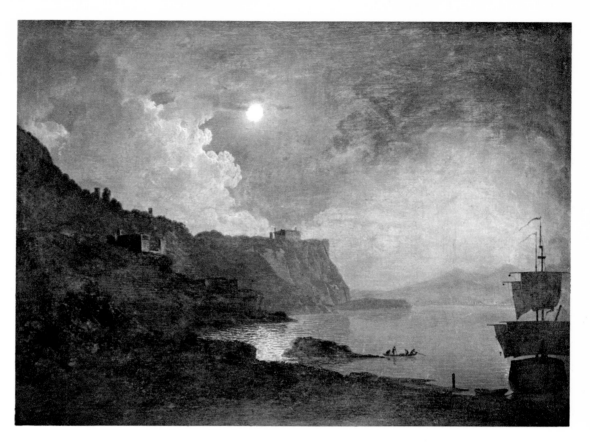

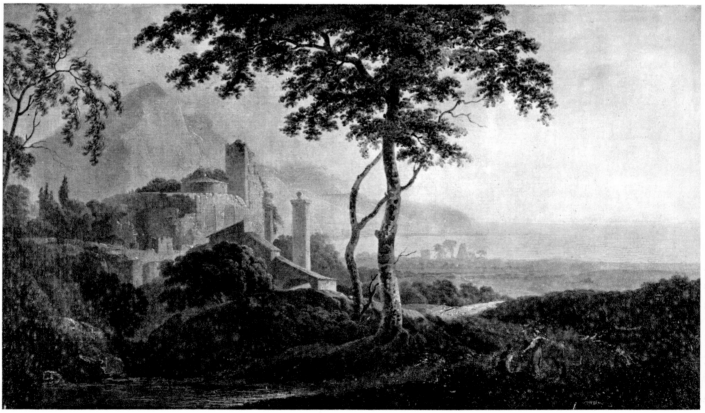

Plate 294 *Vesuvius from Posillipo* c 1788
Panel 25 x 33 in / 63.5 x 83.8 cm
Mrs George Anson Cat 269

Plate 295 *Classical Villa by sea shore* ? c 1787–90
21 x 36 in / 53.3 x 91.4 cm
Mrs V. Martin Cat 294

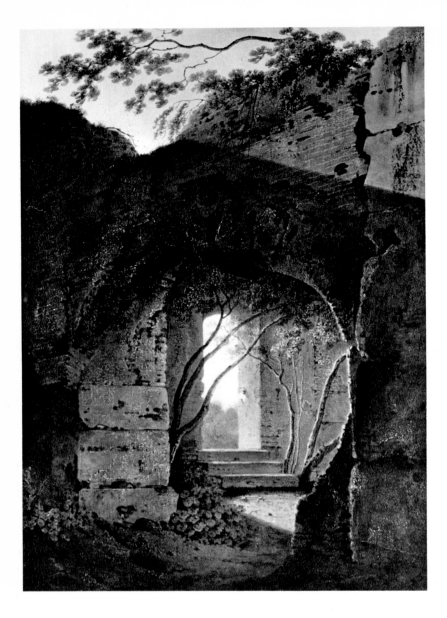

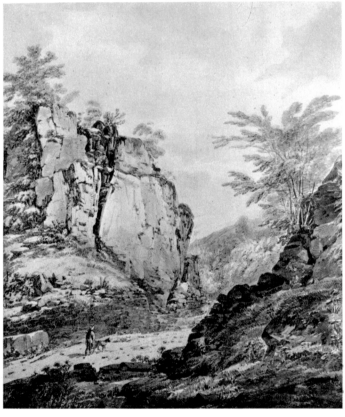

Plate 296 *Ruined Archway* ? 1790
24½ x 17½ in / 62.2 x 44.4 cm
Private Collection U.S.A. Cat 297

Plate 297 *View near Cromford* 1789
Pencil and watercolour 16⅝ x 13 in /
42.2 x 33 cm
Derby Museum and Art Gallery

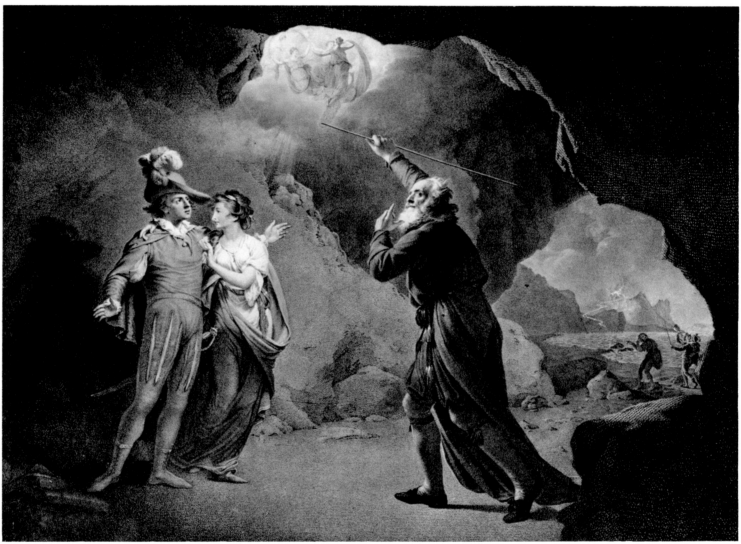

Plate 298 Drawing for *Romeo and Juliet* c 1787–88
Pencil 7¼ x 8¾ in / 18.4 x 22.2 cm
Derby Museum and Art Gallery

Plate 299 Engraving by Robert Thew after
Joseph Wright (1800)
Ferdinand and Miranda in Prospero's Cell
Original painting 102 x 144 in / 259 x 365.8 cm
Cat 233

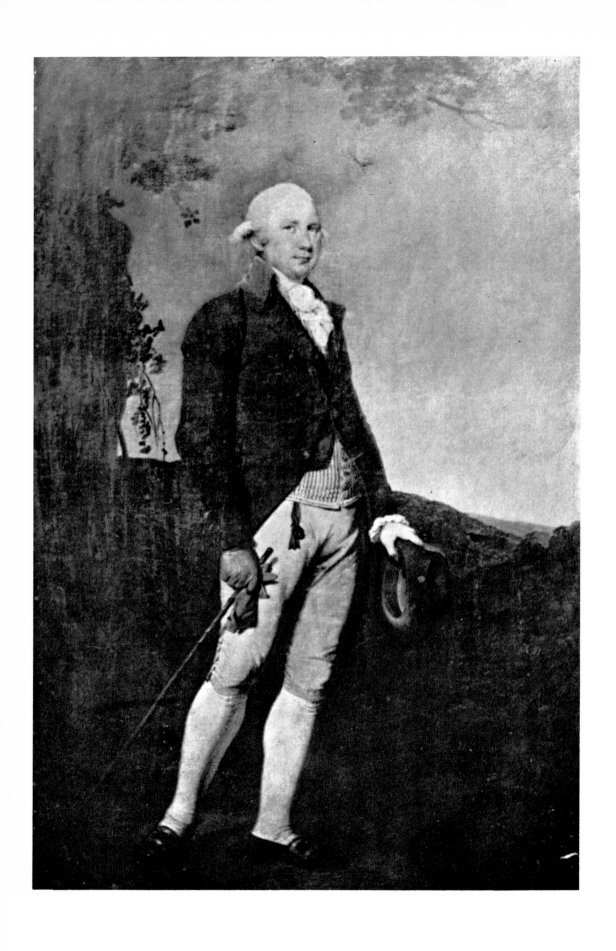

Plate 300 *Charles Hurt of Wirksworth* c 1788
$90\frac{1}{3}$ x $54\frac{1}{2}$ in / 229.9 x 138.5 cm
Formerly Hurt Collection Cat 94

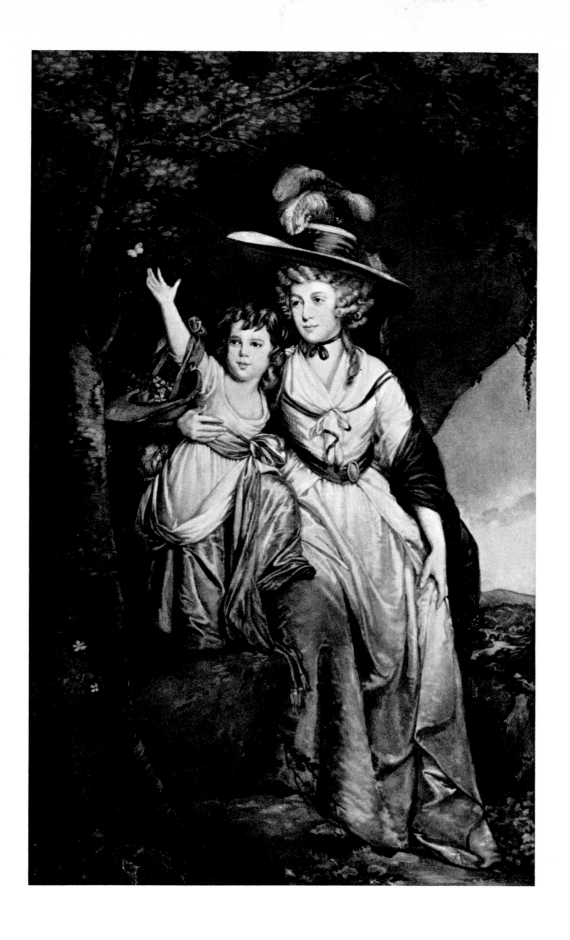

Plate 301 Mezzotint (1911) after an
untraced Wright
*Susannah, wife of Charles Hurt and daughter of Sir
Richard Arkwright* c 1788 See Cat 95

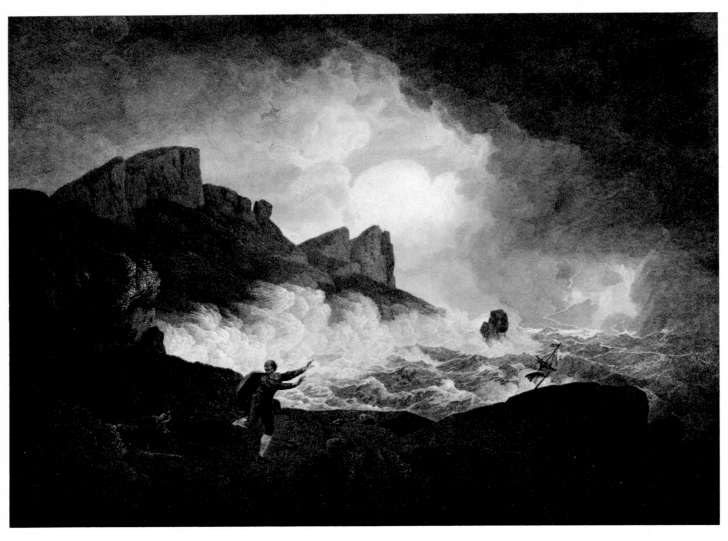

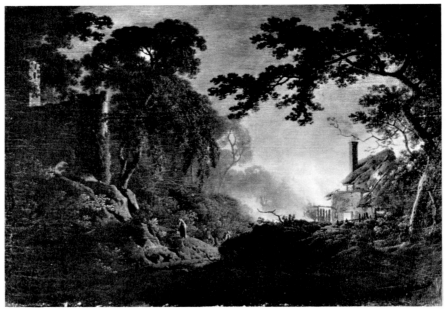

Plate 302 Engraving by S. Middiman (1794) after
Joseph Wright
Antigonus in the Storm, from The Winter's Tale
Original painting c 70 x 95 in /
177.8 x 241.3 cm Cat 230

Plate 303 *Cottage on Fire* c 1790
25 x 30 in / 63.5 x 76.2 cm
Derby Museum and Art Gallery Cat 336

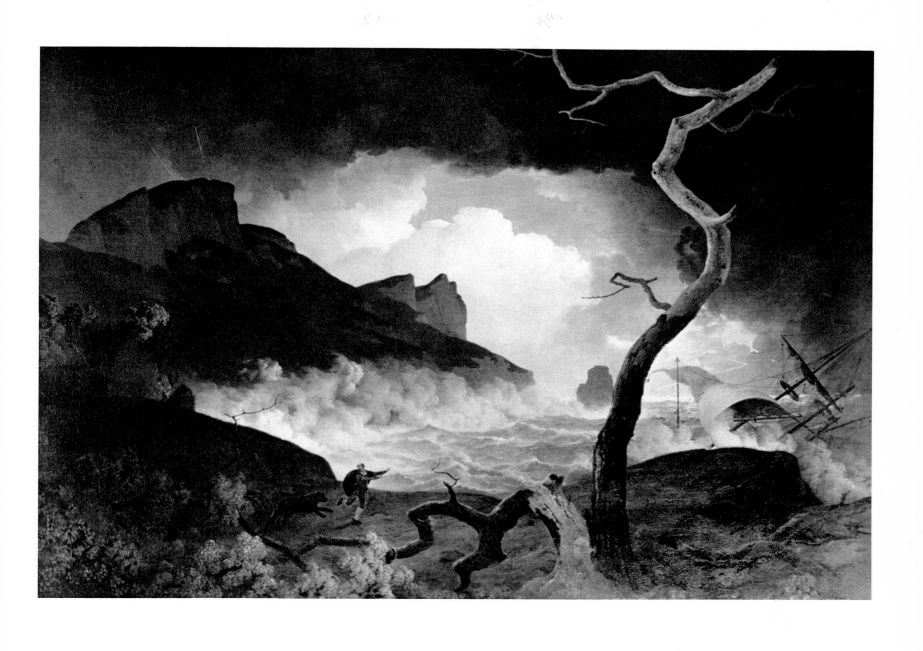

Plate 304 *Antigonus in the Storm, from The Winter's Tale* 1790
61 x 85 in / 154.9 x 215.9 cm
Viscount Scarsdale Cat 231

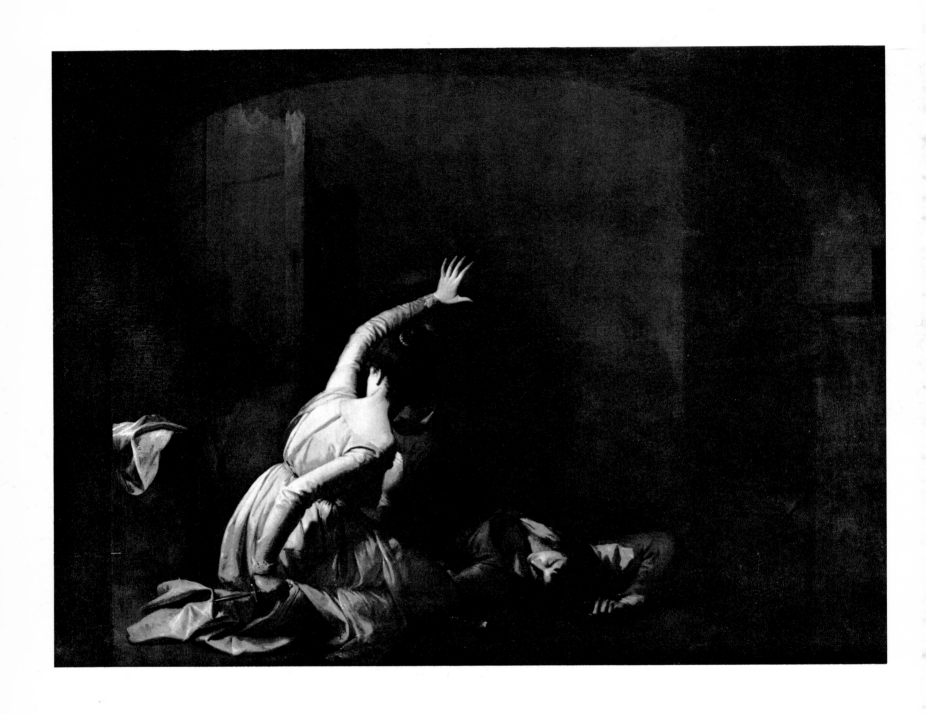

Plate 305 *Romeo and Juliet* c 1787–91
70 x 95 in / 177.8 x 241.3 cm
J. M. Oakes Cat 232

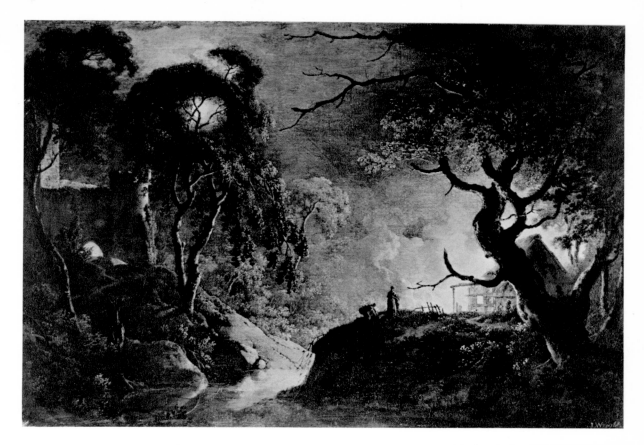

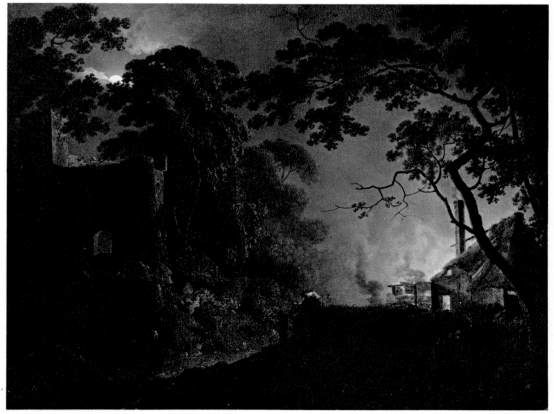

Plate 306 *Cottage on Fire* c 1790
$22\frac{1}{4}$ x $31\frac{1}{2}$ in / 56.5 x 80 cm
Mr and Mrs Paul Mellon Cat 338

Plate 307 *Cottage on Fire* c 1790
$22\frac{3}{4}$ x $29\frac{1}{2}$ in / 57.8 x 74.3 cm
Mr and Mrs David Giles Carter Cat 337

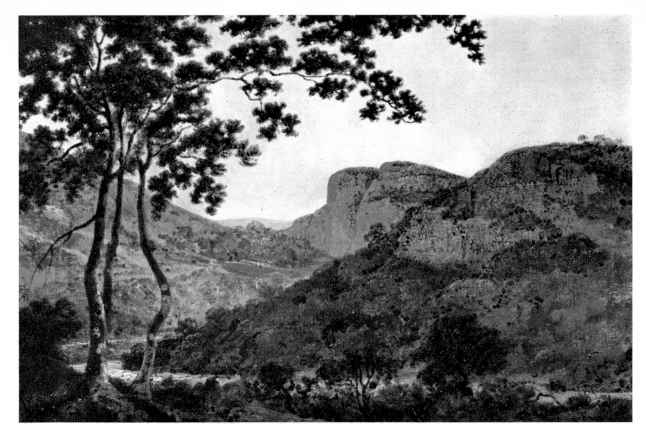

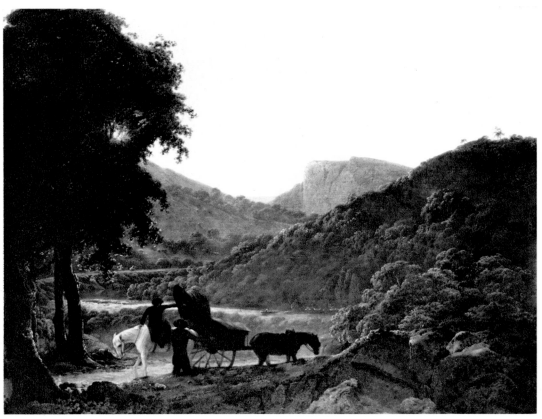

Plate 308 *River Valley (? Derbyshire)*
$11\frac{3}{4}$ x $17\frac{3}{4}$ in / 29.8 x 45 cm
Dr and Mrs William S. Dale Cat 300

Plate 309 *Landscape with Figures and Waggon* c 1790
40 x 50 in / 101.6 x 127 cm
Southampton Art Gallery Cat 299

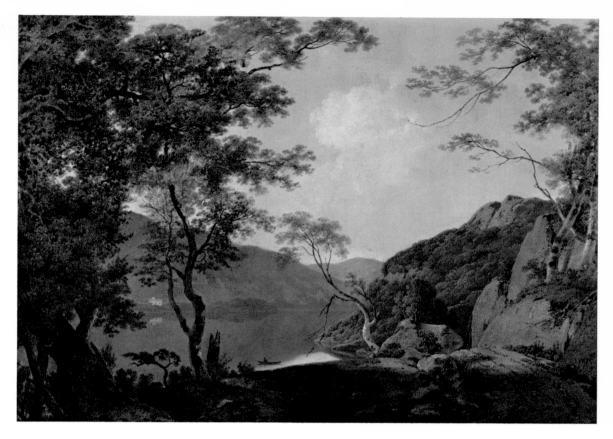

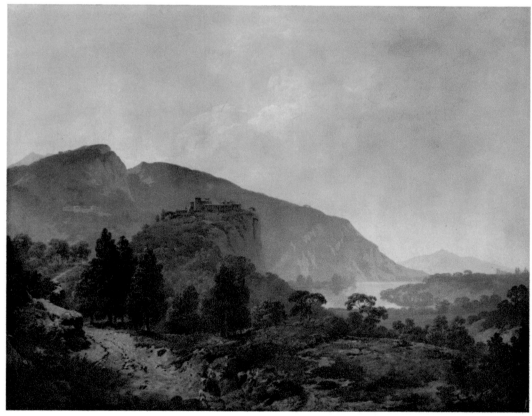

Plate 310 *Lake Scene* 1790
21½ x 30 in / 54.6 x 76.2 cm
Mr and Mrs Michael D. Coe Cat 301

Plate 311 *Italian Landscape* 1790
40½ x 51 in / 102.8 x 129.5 cm
Mr and Mrs Paul Mellon Cat 292

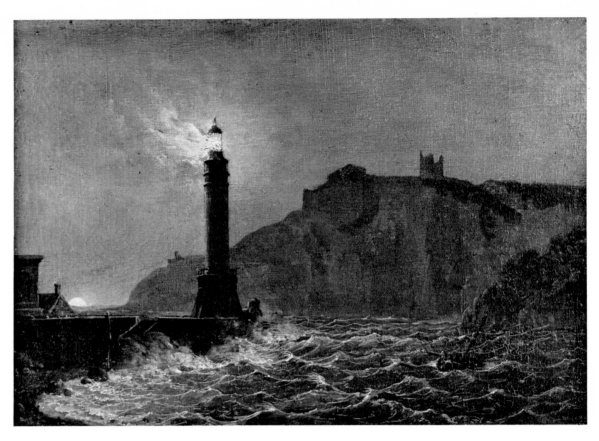

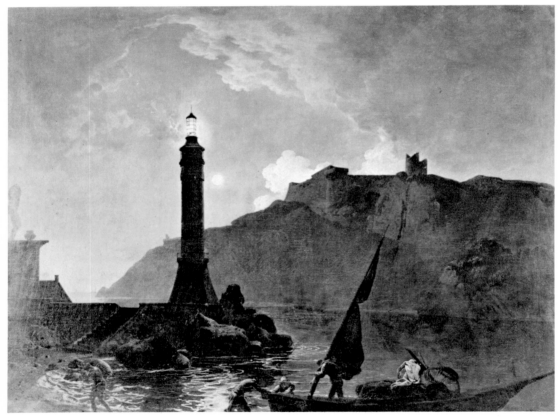

Plate 312 *Lighthouse in the Mediterranean* early '90's
$14\frac{1}{4}$ x 20 in / 36.2 x 50.8 cm
K. J. Blunt, on loan to Derby Museum and Art Gallery Cat 295

Plate 313 *Lighthouse on the Coast of Tuscany* ? 1789
40 x $50\frac{1}{2}$ in / 101.6 x 128.2 cm
Tate Gallery Cat 296

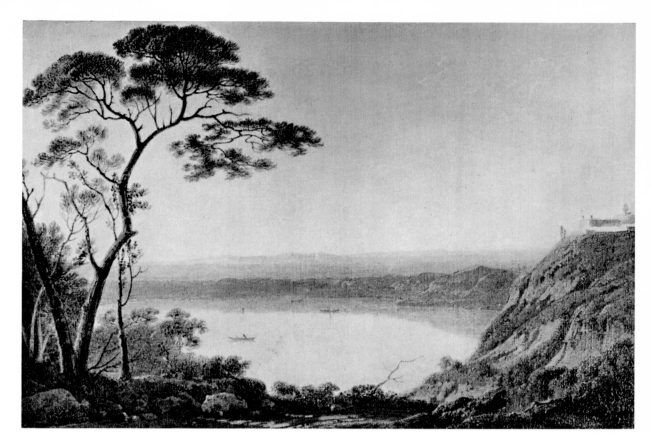

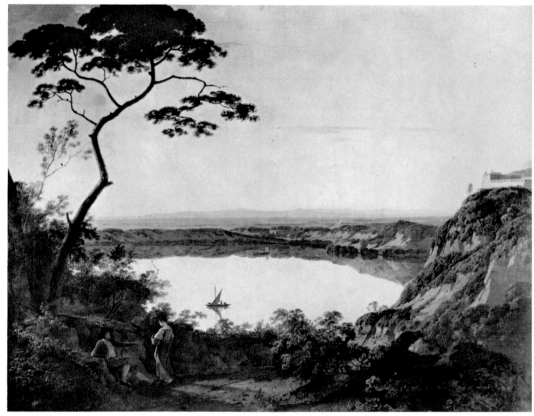

Plate 314 *Albano ?* c 1790–92
17½ x 25 in / 44.4 x 63.5 cm
Major J. W. Chandos-Pole Cat 259

Plate 315 *Albano* c 1790
39¼ x 48 in / 99.7 x 121.9 cm
National Museum of Wales Cat 260

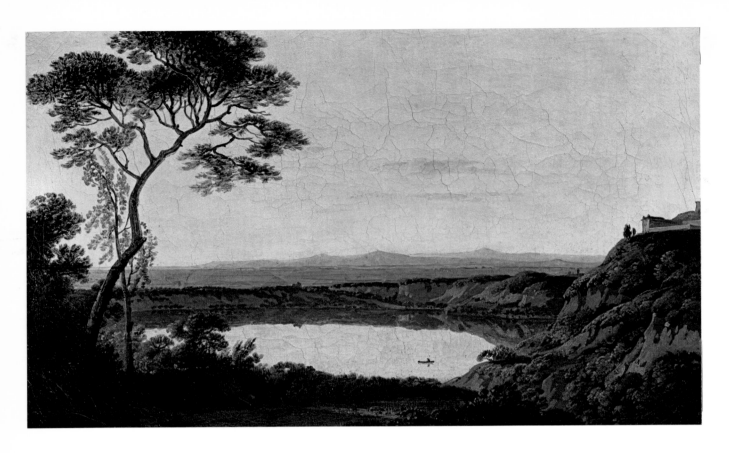

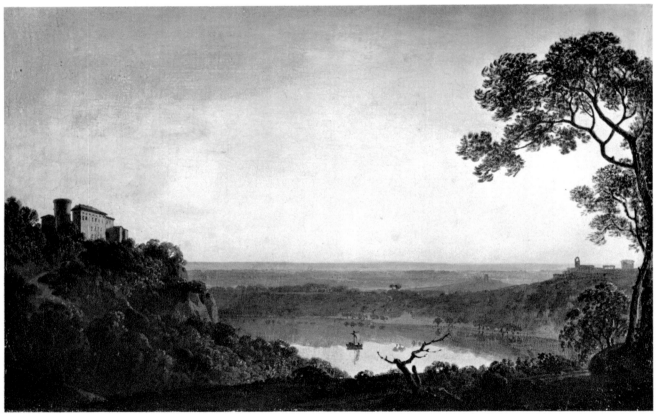

Plate 316 *Albano* c 1790–92
$14\frac{1}{4}$ x $21\frac{1}{2}$ in / 36.2 x 54.6 cm
Mr and Mrs Paul Mellon Cat 257

Plate 317 *Nemi* c 1790–92
$14\frac{1}{4}$ x $21\frac{1}{2}$ in / 36.2 x 54.6 cm
Mr and Mrs Paul Mellon Cat 258

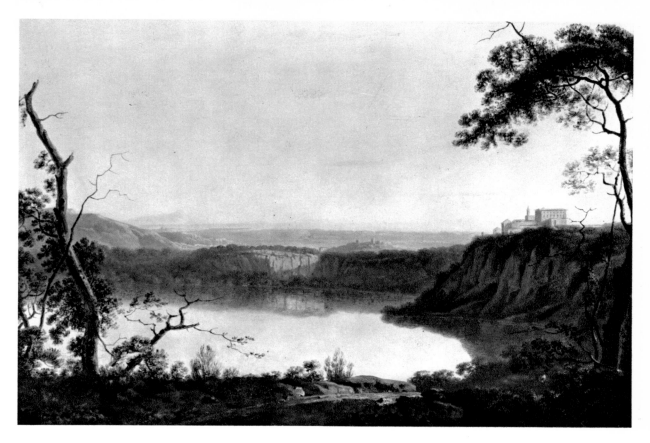

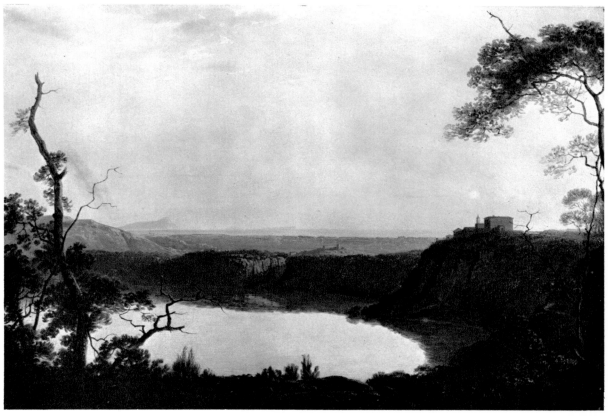

Plate 318 *Nemi*
17 x 24 in / 43.2 x 60.9 cm
Dr and Mrs William S. Dale Cat 256

Plate 319 *Nemi*
17¾ x 25½ in / 45 x 64.7 cm
Private Collection U.K. Cat 261

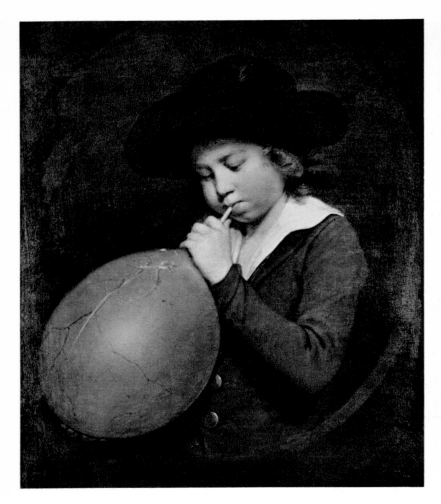

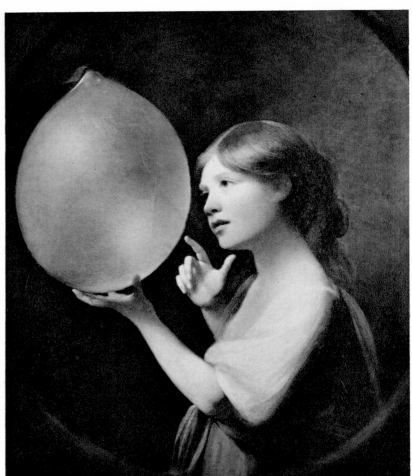

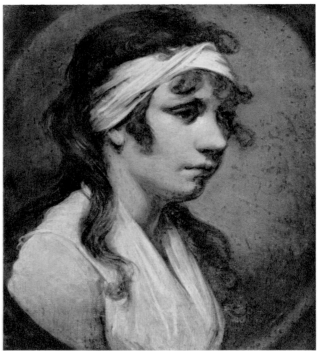

Plate 320 *Boy blowing Bladder* 1790
30 x 25 in / 76.2 x 63.5 cm
Colonel Peter Arkwright Cat 210

Plate 321 *Girl looking through Bladder* c 1790
30 x 25 in / 76.2 x 63.5 cm
Colonel Peter Arkwright Cat 211

Plate 322 *Harriet Wright (daughter of the artist)*
c 1790
Panel 10 x 8⅜ in / 25.4 x 21.3 cm
Derby Museum and Art Gallery Cat 178

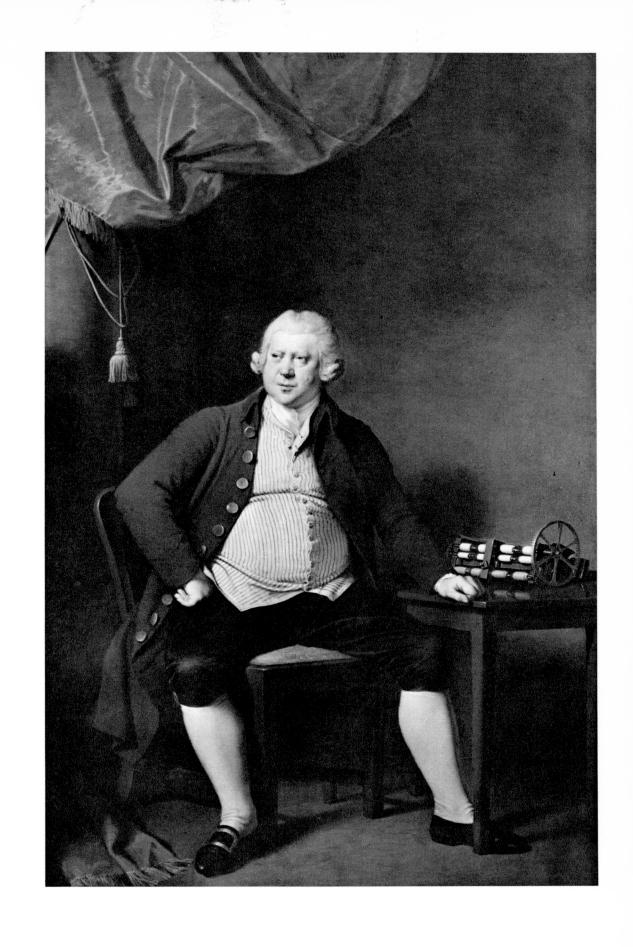

Plate 323 *Sir Richard Arkwright* 1789–90
95 x 60 in / 241.3 x 152.4 cm
Colonel Peter Arkwright Cat 1

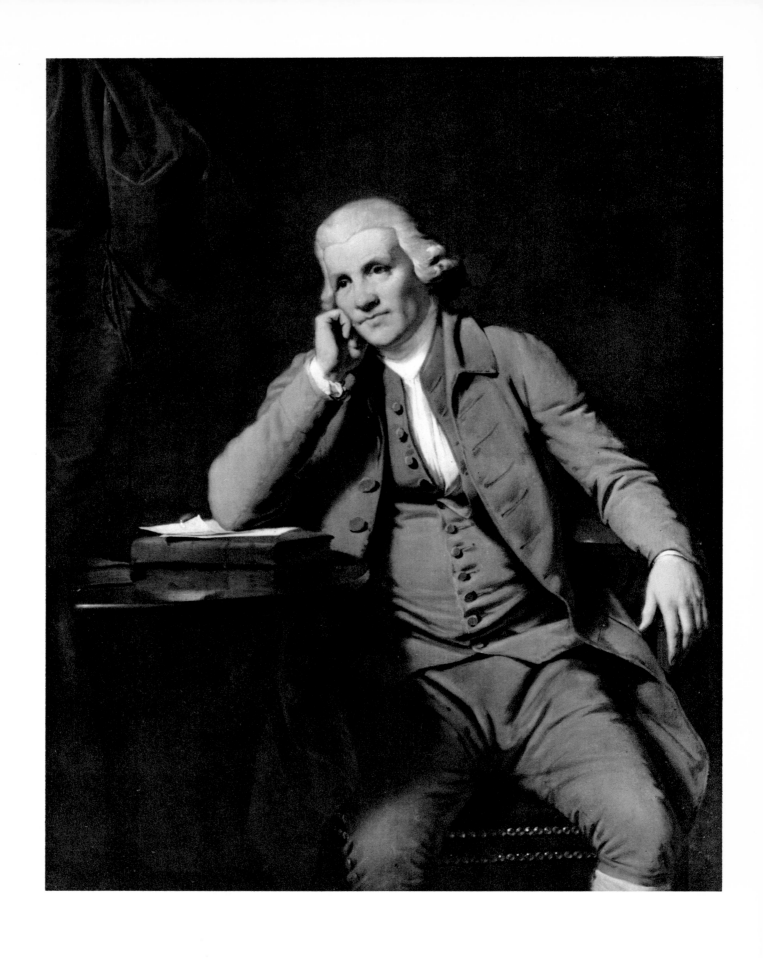

Plate 324 *Jedediah Strutt* c 1790
50 x 40 in / 127 x 101.6 cm
The Lord Belper Cat 133

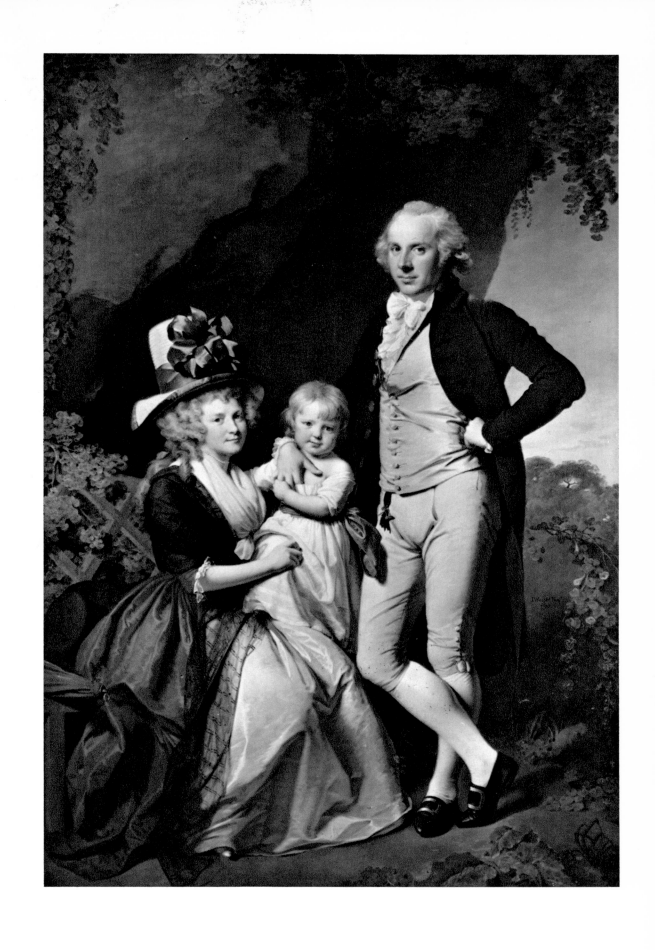

Plate 325 *Richard Arkwright, his wife Mary and Child* 1790
96 x 62½ in / 243.8 x 158.7 cm
Colonel Peter Arkwright Cat 3

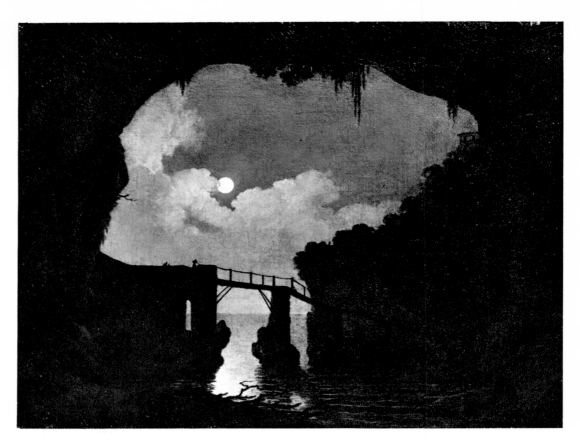

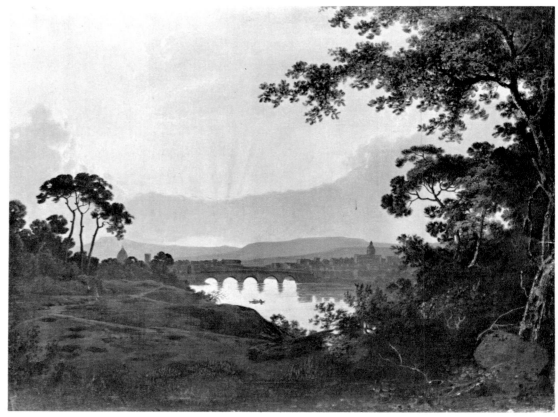

Plate 326 *Bridge through a Cavern, Moonlight* 1791
25 x 32 in / 63.5 x 81.2 cm
Derby Museum and Art Gallery Cat 276

Plate 327 *Distant view of Florence* c 1789–93
22½ x 29½ in / 57.1 x 74.9 cm
Art Institute of Chicago Cat 290

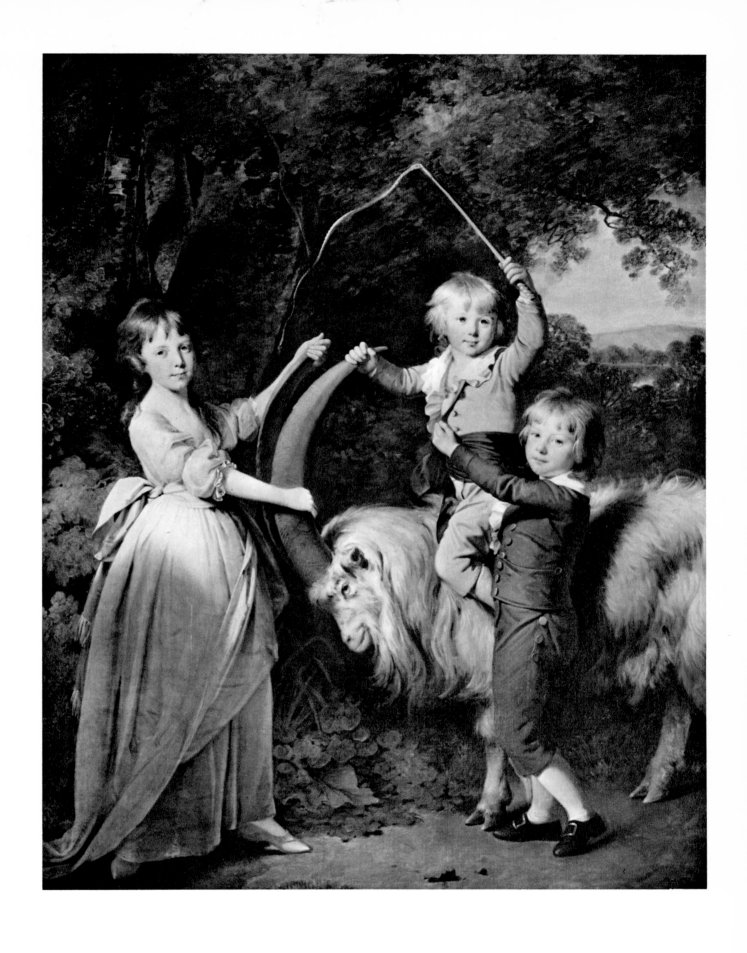

Plate 328 *Three Children of Richard Arkwright with a Goat* 1791
77 x 60 in / 195.6 x 152.4 cm
Colonel Peter Arkwright Cat 4

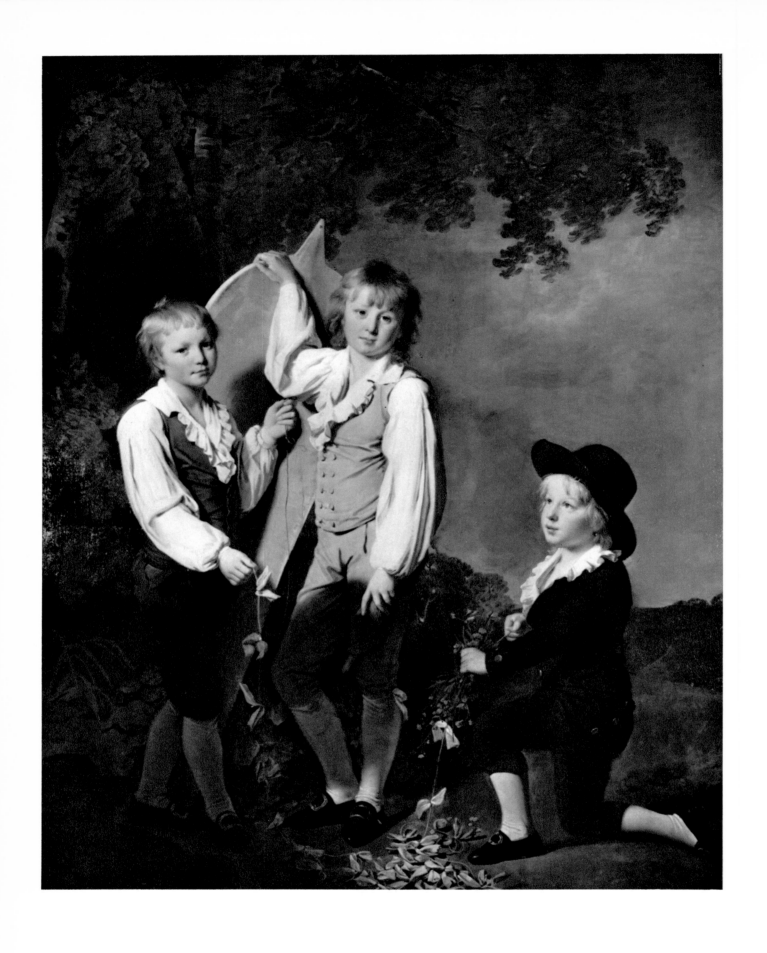

Plate 329 *Three Children of Richard Arkwright with a Kite* 1791
77 x 60 in / 195.6 x 152.4 cm
Colonel Peter Arkwright Cat 5

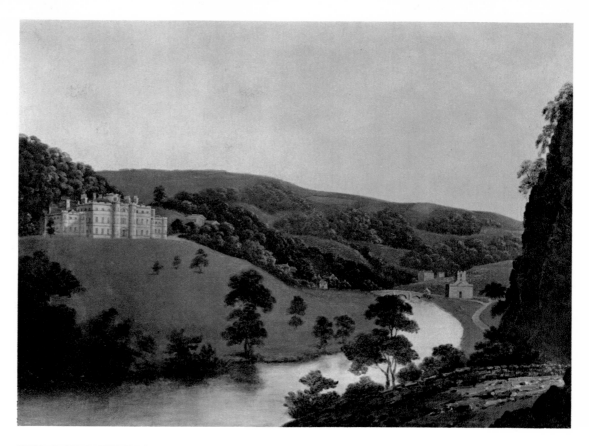

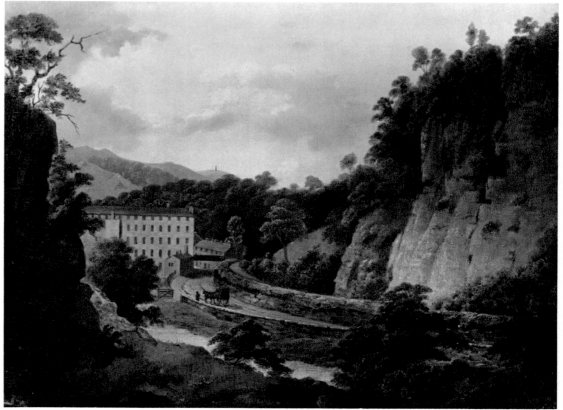

Plate 330 *Willersley Castle, Cromford* c 1790
23 x 30 in / 58.4 x 76.2 cm
Formerly Col M. H. Grant Cat 313

Plate 331 *Arkwright's Cotton Mills, by day* c 1790
23 x 30 in / 58.4 x 76.2 cm
Formerly Col M. H. Grant Cat 312

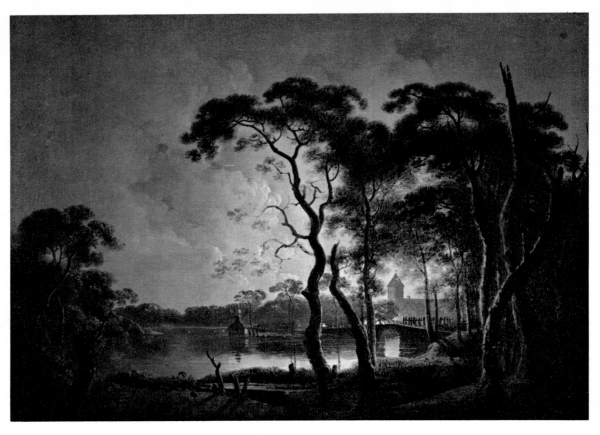

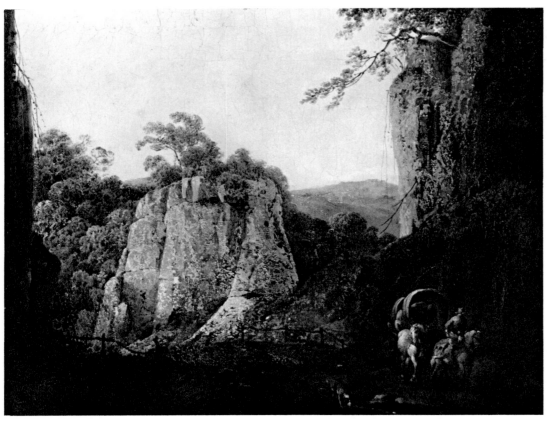

Plate 332 *Fire seen through Trees* 1793
16 x 21½ in / 40.6 x 54.6 cm
Dr and Mrs William S. Dale Cat 335

Plate 333 *Cut through the Rock, Cromford* c 1790
18⅛ x 22⅛ in / 46 x 56.2 cm
Dr and Mrs William S. Dale Cat 314

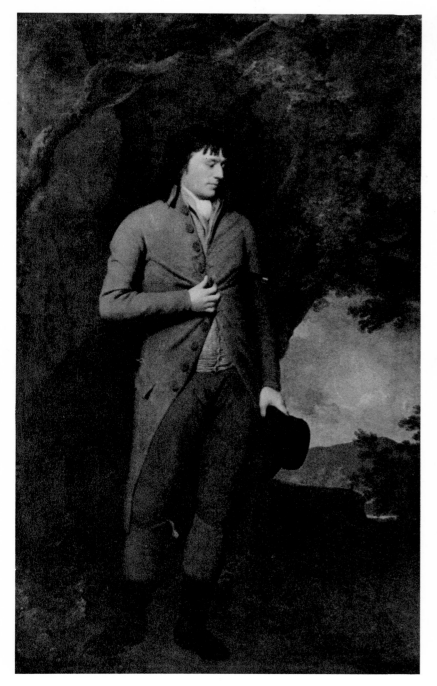

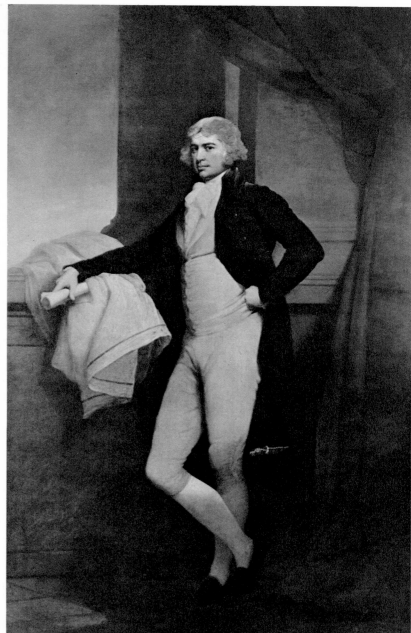

Plate 334 *Thomas Oldknow* c 1790–91
86 x 56½ in / 218.4 x 143.5 cm
D. R. Sherborn F.S.A. Cat 114

Plate 335 *Samuel Oldknow* c 1790–92
c 85 x 55 in / 215.9 x 139.5 cm
Leeds City Art Gallery Cat 115

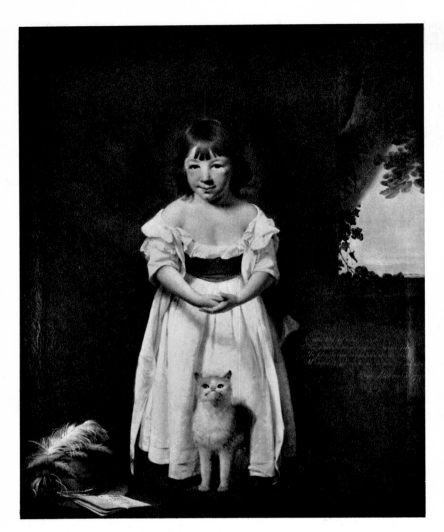 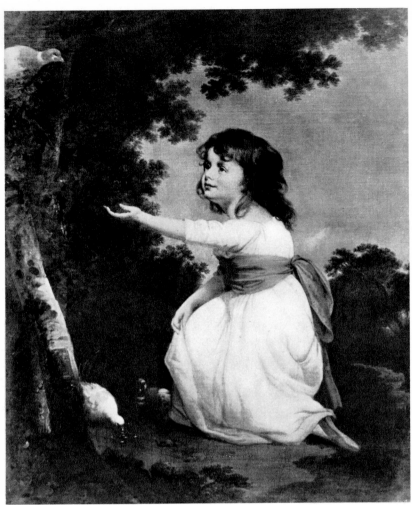

Plate 336 *Richard Sacheverell Bateman as a boy* c 1792–94
50 x 40 in / 127 x 101.6 cm
Mrs F. E. Fitz Herbert Wright Cat 13

Plate 337 *Miss Sally Duesbury* c 1790–95
50 x 40 in / 127 x 101.6 cm
Untraced (U.S.A.) Cat 59

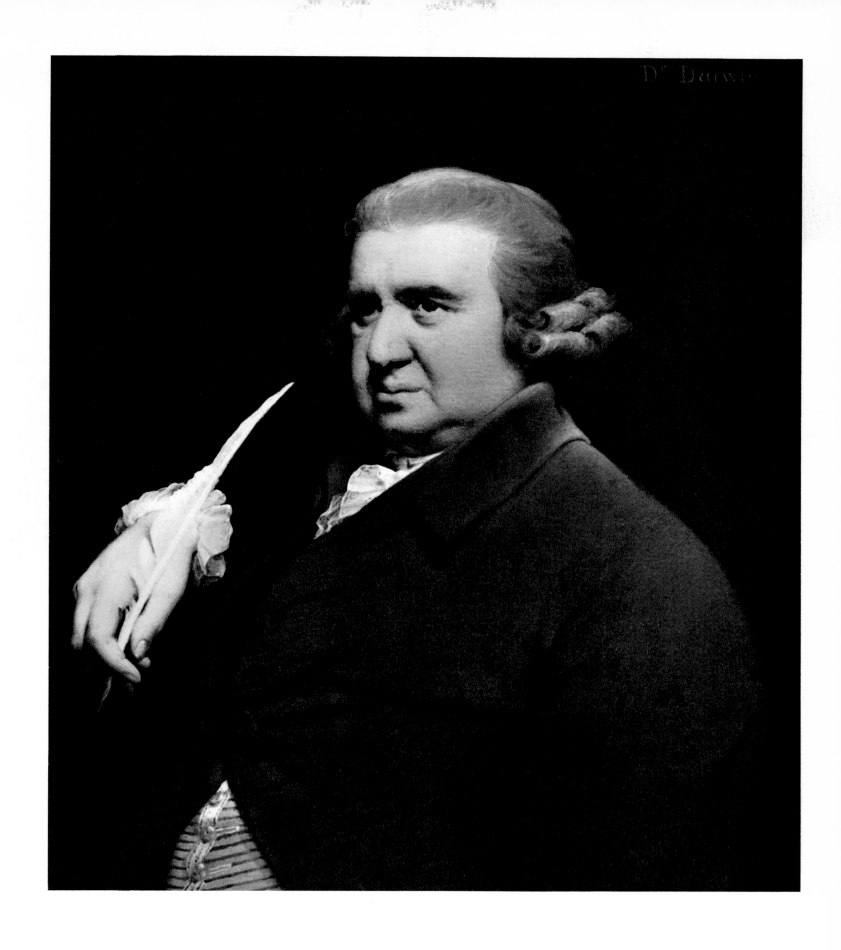

Plate 338 *Erasmus Darwin* 1792–93
30 x 25 in / 76.2 x 63.5 cm
Major J. W. Chandos-Pole Cat 52

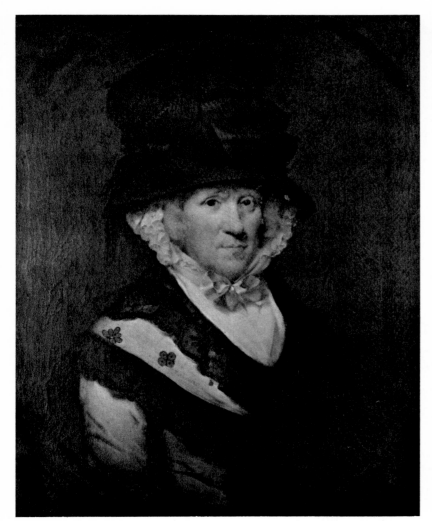

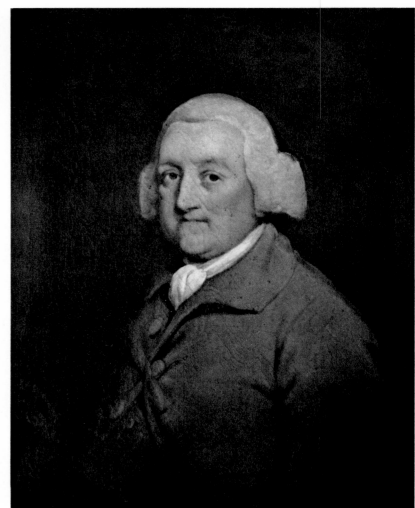

Plate 339 'Dorothy Hunt, wife of Francis Fox' 1793–97
30 x 25 in / 76.2 x 63.5 cm
Mrs D. Hamilton Cat 63

Plate 340 'Francis Fox' 1793–97
30 x 25 in / 76.2 x 63.5 cm
Mrs D. Hamilton Cat 62

214

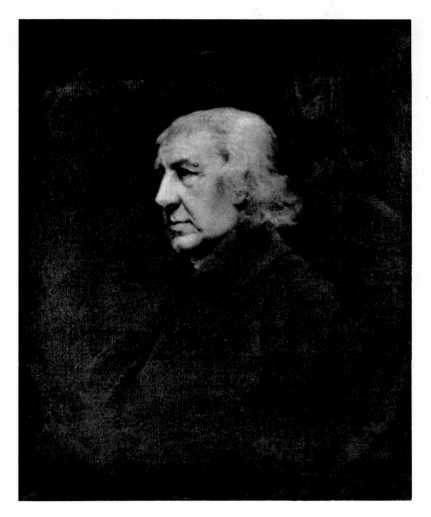

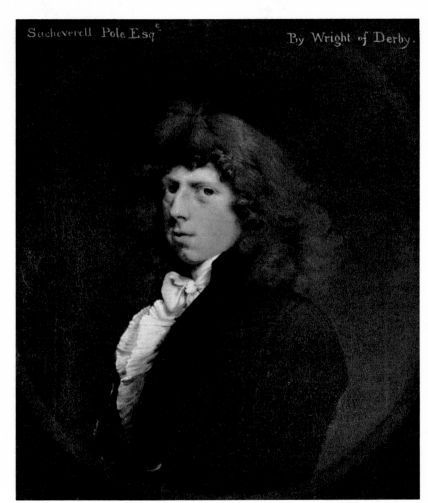

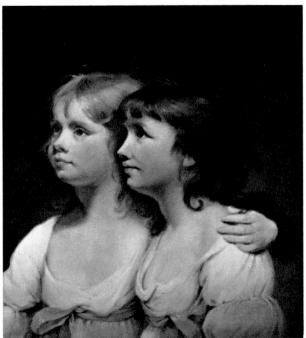

Plate 341 *George Buckston* c 1795
30 x 25 in / 76.2 x 63.5 cm
Private Collection U.K. Cat 26

Plate 342 *Sacheverell Pole* c 1794
30 x 25 in / 76.2 x 63.5 cm
Major J. W. Chandos-Pole Cat 124

Plate 343 *The Twins – Sarah and Anne Haden* c 1795
$21\frac{1}{2}$ x $18\frac{1}{2}$ in / 54.6 x 47 cm
Private Collection U.K. Cat 70

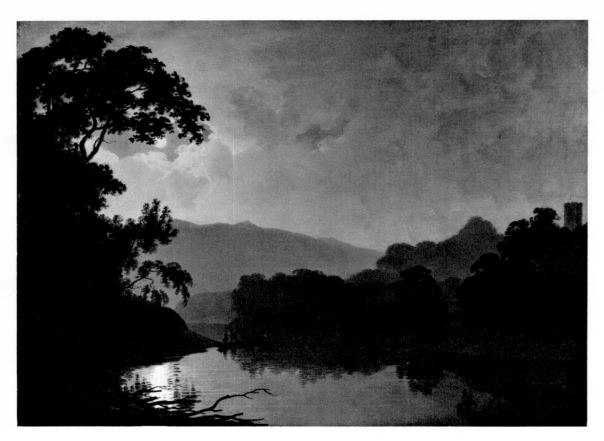

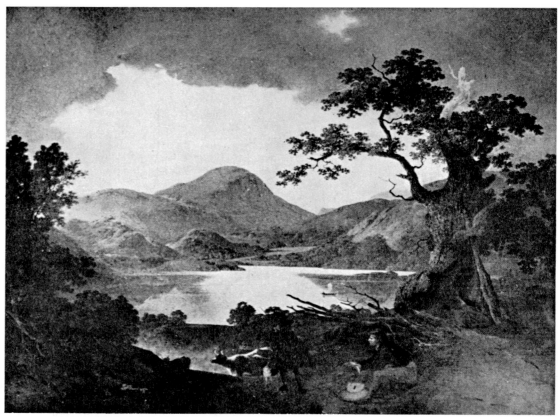

Plate 344 *Moonlight* 1792
36⅛ x 50 in / 91.7 x 127 cm
The University of Liverpool; loan to the Walker Art Gallery
Cat 342

Plate 345 *View of the Head of Ullswater Lake* c 1794–95
c. 63 x 70 in / 160 x 177.8 cm
Formerly Arkwright collection Cat 321

216

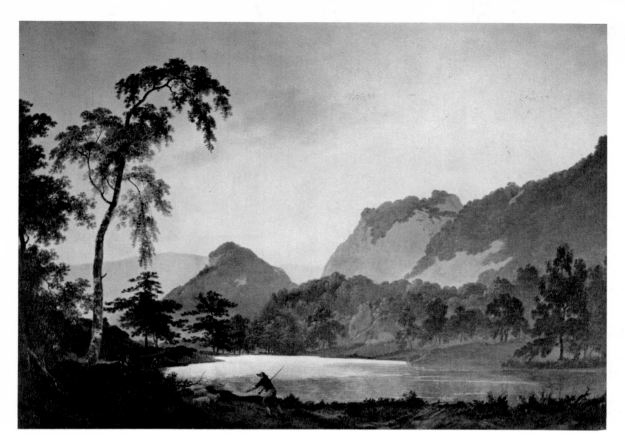

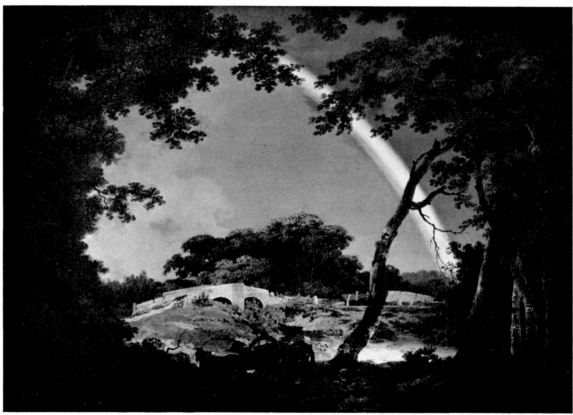

Plate 346 *Lake District Landscape* 1794
25 x 48 in / 63.5 x 121.9 cm
Private collection U.K. Cat 326

Plate 347 *Landscape with a Rainbow – 'View near Chesterfield'*
c 1794–95
32 x 42 in / 81.2 x 106.7 cm
Derby Museum and Art Gallery Cat 298

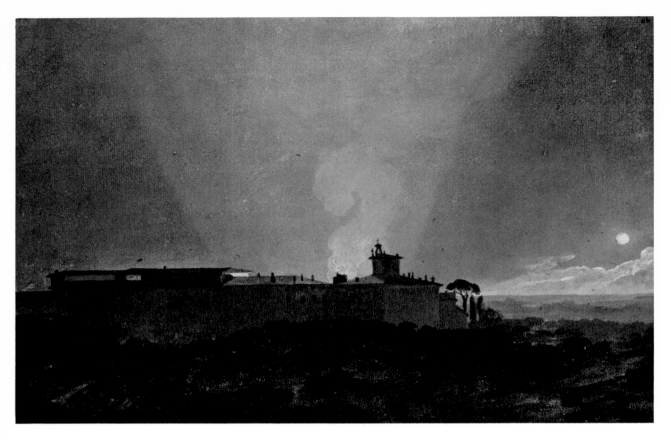

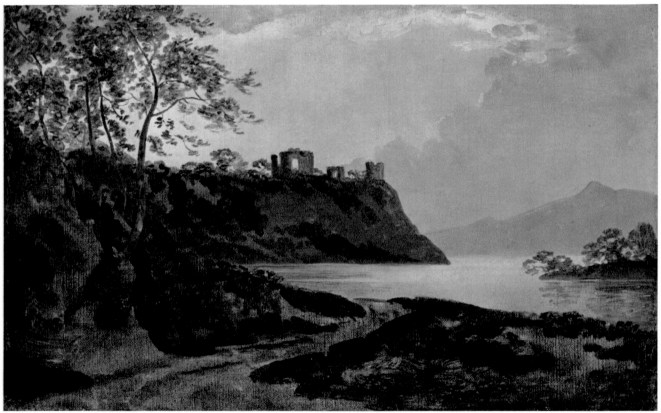

Plate 348 *Quirinal (?) by Moonlight*
10½ x 15½ in / 26.7 x 39.4 cm
Dr and Mrs William S. Dale Cat 248

Plate 349 *Landscape with Ruined Castle* c 1794–95
12 x 18 in / 30.5 x 45.7 cm
Dr and Mrs William S. Dale Cat 332

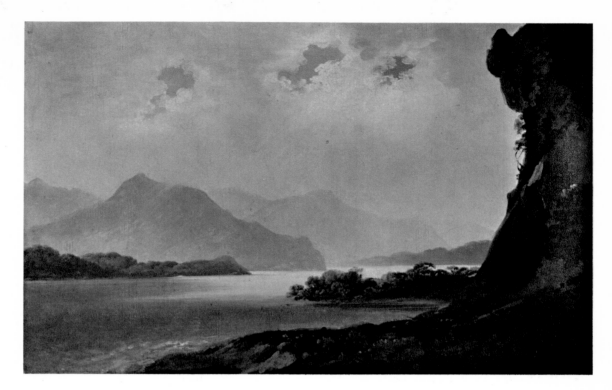

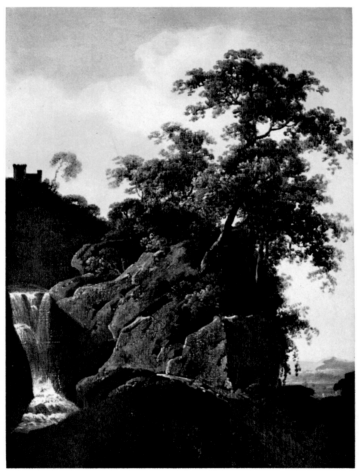

Plate 350 *(English) Lake landscape* c 1794–95
$12\frac{1}{4}$ x $18\frac{1}{4}$ in / 31.1 x 46.3 cm
Dr and Mrs William S. Dale Cat 339

Plate 351 *Rocky landscape with a waterfall*
$19\frac{1}{4}$ x $13\frac{1}{2}$ in / 48.9 x 34.3 cm
Private Collection U.S.A. Cat 329

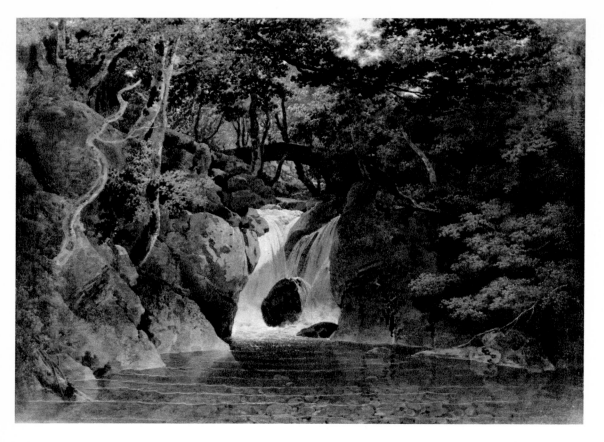

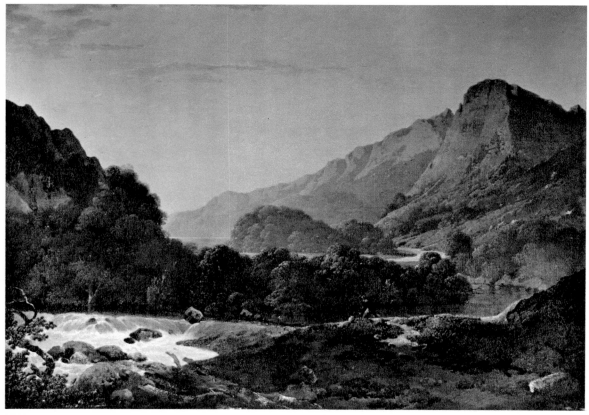

Plate 352 *Rydal Waterfall* 1795
22½ x 30 in / 57.1 x 76.2 cm
Derby Museum and Art Gallery Cat 324

Plate 353 *Outlet of Wyburne Lake* ? 1796
22¼ x 30½ in / 56.5 x 77.5 cm
Formerly London art market Cat 325

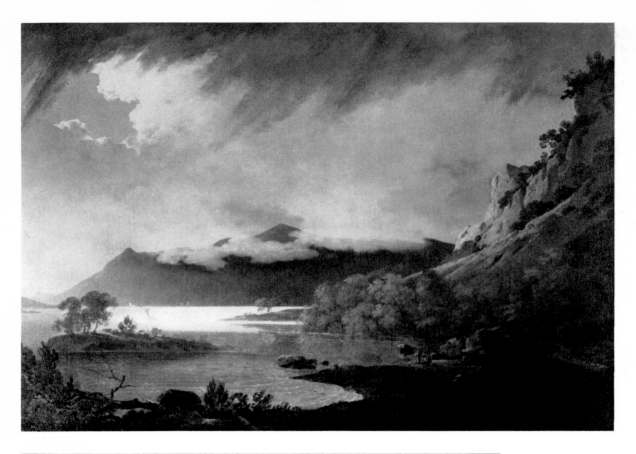

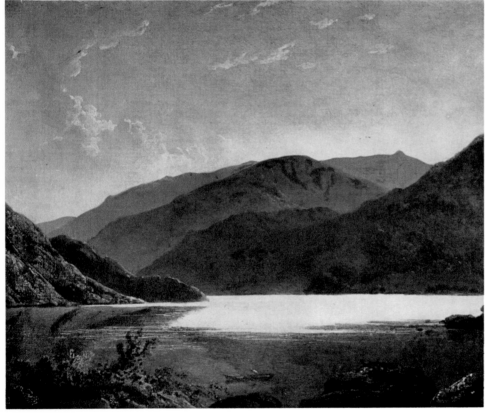

Plate 354 *Derwent Water, with Skiddaw in the Distance* 1795–96
22 x 31½ in / 55.8 x 80 cm
Mr and Mrs Paul Mellon Cat 320

Plate 355 *Ullswater* c 1794–95
20½ x 17½ in / 52.2 x 44.4 cm
R. D. Plant Cat 323